DATE			

Consumer Culture Reborn

How does the organisation of our economy affect our everyday culture? Why does the commodity find itself at the heart of modern social life? *Consumer Culture Reborn* examines the relationship between the economy and culture in contemporary society. Focusing upon consumption as the point at which economic activity and cultural practice combine, Martyn Lee draws together the often polarised areas of political economy and cultural studies in order to understand our social situations as we approach the end of the millenium.

Taking as his central theme the idea that capitalism is compelled to transform the material and social world which sustains it, Lee traces the impact of key twentieth-century economic and political developments upon many of the ways in which ordinary people reproduce their life and their patterns of life. He charts the rise and fall of the 'first' mass consumption society of the post-war years and assesses the evidence supporting the emergence of a new form of sonsumer society today, arguing that such a change may hold profound consequences for the formation of everyday cultural life.

Neither simply a descriptive history, nor purely theoretical, *Consumer Culture Reborn* brings together the work of a wide range of thinkers – most notably Marx, Pierre Bourdieu, David Harvey and Stuart Hall – in an attempt to fuse some of their theoretical insights with concrete historical occurences.

Martyn Lee teaches courses in Cultural and Communication Studies at Coventry University.

Consumer Culture Reborn

The cultural politics of consumption

Martyn J. Lee

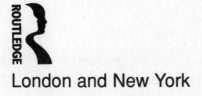

London and New York

First published in 1993
by Routledge
11 New Fetter Lane, London EC4P 4EE

Simultaneously published in the USA and Canada
by Routledge
29 West 35th Street, New York, NY 10001

Typeset in 10/12pt Times by
Ponting–Green Publishing Services, Chesham, Bucks
Printed and bound in Great Britain by Clays Ltd, St Ives plc

British Library Cataloguing in Publication Data
Lee, Martyn J.
 Consumer Culture Reborn: Cultural Politics of Consumption
 I. Title
 339.47

Library of Congress Cataloging in Publication Data
Lee, Martyn J.
 Consumer culture reborn : the cultural politics of consumption /
 Martyn J. Lee.
 p. cm.
 Includes bibliographical references and index.
 1. Consumption (Economics) 2. Culture. I. Title.
 HB801.L33 1993
 339.4'7–dc20 92-34903

 ISBN 0–415–08413–x ISBN 0–415–08414–8 (pbk)

For my Mother and Father

Contents

Preface
The soul of things

All objects which surround us have souls of their own, have human
qualities because they only exist in a human world . . . There are no raw
inhuman objects. The moment furniture, houses, bread, cars, bicycles, or
other products appear in our life, they are related to us, they are human.

(Dichter 1960:93)

This is a book about consumption, a book about the ways in which we
reproduce our life and our patterns of life.

For me consumption became an important issue at some point during the
mid-1980s. The time is significant, for the 1980s seemed to be a period in
which old, familiar social and physical landscapes were being transformed.
Simultaneously at global, national and local levels the world appeared to be
changing in quite dramatic ways. This was the decade, for example, which
saw the disintegration of an autocratic and often brutal communism through-
out much of Eastern Europe and which was said by many to mark the triumph
of capitalism as *the* world system of economic organisation. It was also the
decade of micro-computer technologies and of the ability to convey informa-
tion around the globe at the speed of light. It was a decade of a new
internationalised system of trade and commerce, and of the staggering flow
of invisible currencies between the world money markets; a decade where,
backed by a powerful rhetoric of 'enterprise' and 'individualism', a new form
of free-market politics appeared to be sweeping away the old orthodoxies of
state intervention, welfarism and consensus.

This was also the decade where the image attained an unprecedented pre-
eminence: it was, for example, the decade of video technology, computer
graphics and of media production generally; a decade which placed a new
emphasis on questions of style, design and fashion, and which seemed to
herald a shift away from notions of substance and content and towards
packaging, aesthetic form and 'the look'.

It was a decade also characterised by new forms of work, of a great
diminution of the powers of labour organisations, and of the dramatic
introduction of new technologies into the production process. This has led

some leading commentators to proclaim the birth of the 'post-capitalist society' while others waved farewell to the working classes. Beyond the sphere of work, a new 'leisure society' had begun to take shape. This saw the rise of the theme park, the heritage industry, new types of pubs, clubs and other entertainments, and more exotic forms of tourism and travel.

The 1980s also witnessed the emergence of new social groupings and their stereotypes, new social values and ideologies: a decade that saw the rise of the yuppie, the new man, the career woman and the lager lout; the decade of a shameless pecuniary greed and an unchecked veneration of materialism and affluence.

In the arts and academic circles, the fervour of the streets was matched by the excitement generated by a new intellectual concept: that of post-modernism. Extraordinarily multi-faceted and highly adaptable, postmodern-ism, with its emphasis on the ephemeral, the eclectic, the aesthetic and the rhetorical, seemed to capture for many of the 'chattering classes' the same sense of feverish activity and flux that was evident in so many other areas of everyday life.

But it seemed to me that at the centre of all of these developments was consumption. At the most visible level, consumption was responsible for the remarkable transformation of the physical environment. There were, for example, new cathedrals of consumption: new shopping malls, precincts and consumer centres that were sometimes the size of small towns. There was also the rise of the niche retail outlet: the specialist shop that forsook the old retailing practices of bulk buying and selling for a new emphasis on product diversity and quality. More often than not this would be coupled with new forms of advertising and marketing which were usually aimed at the small but highly profitable 'market segment'. There were also more sophisticated methods of reaching consumers: tactically targeted mail shots, the birth of tele-shopping and a rebirth of mail-order retailing. All of these forms were fuelled by a new socialisation of finance: in-store credit facilities and credit cards generally, personal loans and hire-purchase schemes, all became for many perfectly acceptable methods of payment. In short, the 1980s saw an increasingly elaborate infrastructure of selling, providing more diverse settings and means for the moment of economic exchange.

However, none of the above developments in particular, or even a combination of them, initially drew my attention to the subject of con-sumption and social change as an area for investigation. What seemed to be of primary importance here, and in some ways to provide a common, but by no means obvious, thread between all of the changes taking place during the 1980s, was one thing: *the commodity*. In a manner that I could not easily explain, the commodity – the object of consumption and of exchange – appeared to hold a privileged and almost magical status in contemporary life. On two very different social levels – an economic and a cultural – the commodity presented itself as a vital touchstone, at once being the focus of

national economic prosperity as well as providing an important material and symbolic resource by which ordinary people could, both materially and culturally, reproduce their life. Commodities were used to help construct a wide variety of identities, to confirm memberships of particular cultural communities and, increasingly it seemed, to signify invidious and often antagonistic social and cultural differences between groups. Endorsed by their advertising and marketing, commodities were used as objects to make visible personal affluence, to suggest sexual potency and physical attraction and, perhaps more than ever before, to function as the index of intelligence, education and social literacy.

It is important to stress at this point that I am not speaking here about specific consumer goods, about this brand of perfume or that make of car, about this type of training shoe or that brand of cigarette. To distinguish between individual commodities in this way would be to invite comparisons and value judgements that are in many ways misleading. It would also be to suggest unnecessarily the very dubious dichotomy between 'useful' and 'useless' goods, and therefore invoke the equally dubious dichotomy between true and false needs. On the contrary, my initial interest in consumption and the commodity was not inspired by a desire to distinguish between 'good' and 'bad' forms of consumption, or between 'good' and 'bad' commodities. The true essence of all consumer goods does not lie in their function, their economic value or their physical and aesthetic appearance, nor does it lie in the ways in which those consumer goods are sold or contextualised in advertising, marketing or other forms of promotion. Rather, the essence of all consumer goods can be found in the fact that they are, first and foremost, commodities. It is thus the *commodification* of products, or the fact that they are first produced in order to be exchanged for profit, that gives them their distinctive character or, to borrow Dichter's term for a moment, their 'soul'. In short, consumer goods have a social meaning, and that social meaning is, in the first instance, always contingent upon their status as commodities.

Of course the fact that commodities have a variety of cultural uses in a variety of social contexts is a phenomenon by no means unique to the 1980s. Uses similar to the ones described above can be dated as far back as the eighteenth century. But it appeared to me that the influence of the commodity and its power to touch so many discrete areas of our social life had, by the mid-1980s, reached a hitherto unparalleled intensity. Amongst other things, this led me to consider my own private responses and relationship to consumption and commodities. The more I thought about my own relationship to consumption, the more ambiguous my reaction to it seemed to become. On the one hand commodity consumption often provided a source of genuine pleasure and enjoyment which I was reluctant, and indeed saw no reason to deny. On the other hand, I knew that no form of commodity was socially neutral. I was, for example, well aware of the all-too-easy temptation to use commodity consumption as a weapon of 'cultural terrorism', as a

means of reproducing social differences and inequalities at a cultural level. This ambiguous response to consumption was compounded by another, far less visible, dimension to the commodity: the fact that while commodities may become vital utilities in reproducing everyday life they have also had another existence, that is, as objects in production. What appeared initially as a rather 'common sense' and trivial observation – that commodities are produced by people under particular industrial circumstances – slowly began to assume quite profound dimensions. Why, for example, when the commodity arrives in our shops, should it show no manifest trace at all of the labour that was invested in it during its production? Similarly, why does the commodity rarely display any evidence of the social conditions under which that labour occurred? These facts about the commodity were surely no accident, and they suggested to me that there was a certain hidden or mysterious logic which oversaw the production and exchange of commodities. These and other questions about consumption, which always seemed to find a final focus in the commodity, did not seem to yield any easy answers.

It was from these very personal considerations that the inquiry presented in this book slowly began to take shape. However, this was to prove anything but a straightforward task. For one thing there was a relative paucity of literature on the subject of consumption to be found upon the shelves of the academic libraries. Many of those books which did exist seemed to offer little more than fairly obvious statements. Alternatively, the theoretical and analytical value of some other books was rendered relatively limited by a highly moralising, indignant and condemnatory tone which suggested that, as a social activity, consumption was something that was undertaken by people other than the authors concerned. However, there was one book that did seem to provide a solid foundation from which to begin to consider the complex issues raised by contemporary consumption. Ironically, this was a book which, throughout its 820 pages, said almost nothing about consumption itself. That book was Marx's *Capital*.

Although written over 100 years ago, the initial premise put forward by Marx in chapter one of *Capital* seemed irresistible. The first sentence of *Capital* begins thus: 'The wealth of societies in which the capitalist mode of production prevails appears as an immense collection of commodities.' From this opening statement Marx goes on to show how the social relations of production and, therefore, the dominant social relations of capitalist society as a whole can, in the final analysis, be traced back to the commodity-form. For encased within the commodity, Marx argues, is the essential information about the ways in which those social relations are configured. If we can understand what it is that gives the commodity this essential character then we can also understand the fundamental basis of modern social relations.

This book is written from the same premise. It is a book which takes as its central theme the commodity as the primary index of the social relations of modern capitalist societies. Using some of the insights into the workings of

capitalism that were left to us by Marx, I take as my starting-point the fact that any significant change to the nature of modern society can ultimately be seen reflected in the commodity-form. Moreover, any changes to the commodity-form itself, that is, any changes to the ways in which we produce, distribute and exchange commodities, will have important implications for the composition of our social needs and of society generally. To explain the nature of changes to the commodity-form is therefore the primary goal of this book. Consequently, I do not work from a premise which attempts to draw together, in any piecemeal fashion, the whole array of discrete changes that have occurred throughout the 1980s, but rather, by considering the ways in which changes to the nature of commodities may have possibly impacted upon social life, often in quite diverse and sometimes unexpected ways. Such an approach necessarily draws together economy and culture, two areas of social life so often treated as autonomous and distinct from one other. That is why this book is about consumption, for consumption is *the* social activity which, above all others, unites economy and culture. It is therefore partly a book about the nature of human needs and about some of the ways in which human needs have changed over recent years. It is a book about a certain logic of capital which *requires* that human needs change over time and is, therefore, a book about the transformational nature of capital and its effects on everyday life. Finally, it is a book about the ways in which capital and the practices of everyday life, drawn together in the sphere of consumption, articulate a relationship to each other within this sphere, a relationship which is ultimately condensed into the form of the commodity.

The writing of this book has incurred several debts. I would like to express my thanks to Graham Murdock, whose critical eye and unstinting support made sure that I kept asking the right questions; to my colleagues at Coventry University, in particular David French, Philip Rice, Perry Hinton and Valerie Hill. Thanks are also due to Joanna Taylor, for reading and commenting upon earlier drafts of this book, to Caroline Battson, and to Rodney and Jane Mace for giving me access to their home in the quiet depths of the Herefordshire countryside so that I could complete my work without distraction. I would also like to thank Claire L'Enfant and Rebecca Barden of Routledge for their support. My greatest thanks, however, are reserved for Sarah, for her patience, love and just being there.

Finally, I feel it necessary to offer what psychoanalysis calls a seductive defence. Any credit which this book may accrue is to a large extent owed to the people mentioned above. Any errors and inconsistencies are of course all mine.

Part I

Preliminaries: perspectives on capital, consumption and culture

Chapter 1

Capital, labour and the commodity-form

PRODUCTION, CONSUMPTION AND NEEDS

Any study of consumption must inevitably begin with a recognition of the fact that, whatever else it may represent to us in contemporary society, the consumption of mass-produced commodities constitutes a vital dimension of the modern capitalist economy. Consumption is the final link in a chain of economic activity in which capital, existing in the form of money, is transformed through a process of material production into commodity capital. It is the exchange and consumption of commodities which allows for the realisation of profits, which, when returned back to the money-form, can be reinvested into further production and so begin the circulation of capital once again. This process represents the primary characteristic of capitalist enterprise, and it is from this basic process that a vast social environment begins to take on its distinctive character.

Since by far the most thoroughgoing and detailed analysis of capitalism has been undertaken in the work of Marx, it would seem to be appropriate to begin this study of consumption with a consideration of some of the important issues he identifies. However, before it is possible to explore Marx's critique of capitalism *per se*, let alone some of the implications that this may have for modern practices of consumption, it is first necessary to outline some of the central principles expressed in materialist philosophy and which inform most of Marx's ideas. These were to be firmly established in many of Marx's earlier writings, but can be seen principally in the *Economic and Philosophical Manuscripts* written in 1844 (Marx 1975) and *The German Ideology* of 1846 (Marx and Engels 1974).

One of the central questions addressed by Marx in these early works focused upon the ontological difference that marked out humanity from the rest of the animal world. What was it, asked Marx, that made human beings not merely a highly advanced form of animal life, but a unique species-being? For Marx the answer to this question lay in the nature of human needs and the manner in which they were satisfied. To be sure, humans, in common with all other forms of animal life, must appropriate materials from the

resources of nature in order to satisfy their needs and secure their means to life. Nature therefore provided the means by which all animals could reproduce themselves and their species. Unlike other animals, however, humans actively and consciously *produce* their means to life from nature. It is this act of material production, of adapting and working upon the resources of nature through conscious activity, that signalled the distinctive essence of human species-being. In an often cited passage from *Capital* Marx comments:

> A spider conducts operations which resemble those of a weaver, and a bee would put many a human architect to shame by the construction of its honeycomb cells. But what distinguishes the worst architect from the best of bees is that the architect builds the cell in his mind before he constructs it in wax. At the end of every labour process, a result emerges which has already been conceived by the worker at the beginning, hence already existed ideally. Man not only effects a change of form in the materials of nature; he also realises his own purpose in those materials.
>
> (Marx 1976:284)

But for Marx production represented something more than merely the production of the means to life, for in the production of its means to life humanity also possesses the unique potential for its own ontological self-realisation and advancement. Unlike the rest of the animal world, humanity is not chained solely to its basic physiological and subsistence needs, but is capable of adapting the resources of nature far in excess of those needs. In Marx's schema, human ontological development corresponds directly to the development of needs. In turn, the development of needs is historically contingent upon the development of ontological potentialities. In a dynamic and mutually dependent relationship of evolution, needs and the processes of satisfying them through the mastery of nature and the development of new modes of material production allow humanity to achieve real self-advancement.

Implicit in this early formulation of needs is the concept of culture. But this is a view of culture seen from the basis of material production: through their material production, or through the production of their means to life, humans develop 'a definite form of expressing their life, a definite *mode of life*' (Marx and Engels 1974:42). This makes culture much more than some mere 'symbolic echo' of economic activity or, for that matter, far more than a social concept representing those 'residual activities' that are left over after material production has occurred. In this schema, culture is seen as the meaningful expression of human life and social relations, and the real foundation of all human life and social relations is to be found in material production. This makes culture neither an isolated, independent or autonomous sphere of spiritual and idealistic contemplation, nor some neutral 'by-product' of material production, but an inseparable dimension of productive activity. As Marx and Engels were to argue: 'As individuals express their

life, so they are. What they are, therefore, coincides with their production, both with *what* they produce and with *how* they produce' (Marx and Engels 1974:42). Given this, the formation of human cultures and cultural activity is dependent directly upon the material and historical conditions that daily confront individuals and with which those individuals must engage in order to reproduce themselves. Elsewhere Marx was to write: 'Men make their own history, but not of their own free will; not under circumstances they themselves have chosen but under the given and inherited circumstances with which they are directly confronted' (Marx 1973a:146).

From this basis it is not difficult to see why Marx was drawn to investigate the areas of labour and the products yielded by that labour. In the sphere of production there is found the critical site where human societies developed their distinctive characters. Indeed, it was through the activity of labour, through the utilisation and adaptation of the resources of nature in the process of satisfying needs that human consciousness came to be what it was. This meant that human consciousness was itself realised, that is to say *objectified*, in the material products of labour:

> Such production is his active species-life. Through it nature appears as *his* work and his reality. The object of labour is therefore the *objectification of the species-life of man:* For man reproduces himself not only intellectually, in his consciousness, but actively and actually, and he can therefore contemplate himself in a world he himself has created.
>
> (Marx 1975:329)

This is why the object of labour – the material artefact or product – holds a central space in the determination of the ontological health of individuals and society generally. Far more than being simply a functional utility useful in satisfying purely corporeal needs, the product of labour has, figuratively speaking at least, enshrined beneath its physical shell a metaphysical kernel that, as a result of the labour invested in its production, expresses the essential species-being of its creator and the social and historical conditions under which that product was created. In other words, this transformation of nature into culture through labour and material production becomes the vital process by which humanity is connected to its own species-being. Material culture is thus the *objectification of social consciousness*; that is, the meaningful expression of humanity as a *social* species. Through its appropriation, nature is therefore transformed into a series of cultural, as well as material utilities.

In the above context the concept of objectification appears to be used by Marx to describe a vital process of human ontological development. Here objectification would merely seem to indicate a process in which the creative and the free use of labour allows for the satisfaction and the free development of needs, and in doing so enables the full realisation of human potentialities. In this sense the concept of objectification simply describes the *materialisation* of essential species-being. However, Marx was also to use

the concept of objectification in a very different sense indeed; in discussing the estranged social conditions under which labour occurs in capitalism, objectification appears here as the *impoverished realisation* of essential species-being. In short, it comes to describe the manner in which the specific conditions under which labour occurs in capitalist production stultify the processes that would, under more positive circumstances, enable needs to develop freely. In this sense, objectification describes the process by which labour produces, not a vital and ontologically edifying utility, but a 'petrified' product appearing to its creator as alien to, or estranged from, the energies that have been invested in its production.

Under capitalism workers no longer retain control of the potential that is embodied in their labour. This potential, or what Marx terms *labour-power*, has been exchanged with the capitalist for the abstract token of value to be found in wages. Labour-power has thus become a commodity, its usefulness no longer to be found in its ability to produce objects for the satisfaction and development of the worker's needs, but in its capacity to function as a token of exchange for wages. The diminution of labour-power to the status of an article of exchange effectively means that the worker has simultaneously traded away the positive potential for self-realisation that is inherent within his or her labour-power. Hence, compounded by the division of labour, workers now see neither the fruits of their labour, nor any reason to work other than to obtain wages, nor the sum total of the social relations of which their labour forms a part. In this way workers become detached from the means of direct need satisfaction and from the appropriation of the object of labour as an instrument useful in positive human development.

Seen from this perspective, capitalism does not simply represent an impoverished mode of socio-economic organisation; far less does it embody the most efficient route to social emancipation that had, at the time of Marx's writing, been promised by bourgeois political economy; in short, capitalism is seen here as nothing but the critical historical rupture between labour and needs. Under capitalism, labour and needs have become detached and isolated, and each is now displaced into the independent spheres of production and consumption respectively. The system of wage-labour has therefore disunited labour from need so that labour is now no longer an act of need satisfaction but merely the *means* to need satisfaction:

> [It is] the fact that labour is *external* to the worker, i.e. does not belong to his essential being; that he therefore does not confirm himself in his work, but denies himself, feels miserable and not happy, does not develop free mental and physical energy, but mortifies his flesh and ruins his mind . . . His labour is therefore not voluntary but forced, it is *forced labour*. It is therefore not the satisfaction of a need but a mere *means* to satisfy needs outside itself.
>
> (Marx 1975:326)

In tearing away the object of his production from man, estranged labour therefore tears away from him his *species-life*, his true species-objectivity, and transforms his advantage over other animals into the disadvantage that his inorganic body, nature, is taken from him.

(Marx 1975:329)

The ontological rupture between labour and need, and the once organic unity between humanity and nature, now appears objectified as the petrified or dehumanised product of estranged labour:

The object that labour produces, its product, stands opposed to it as *something alien*, as a *power independent* of the producer. The product of labour is labour embodied and made material in an object, it is the *objectification* of labour. The realisation of labour is its objectification. In the sphere of political economy this realisation of labour appears as a *loss of reality* for the worker, objectification as *loss of and bondage to the object*, and appropriation as *estrangement*, as *alienation*.

(Marx 1975:324)

In order that essential species-being may be realised successfully there should exist a certain unity between labour (production) and needs (consumption), with the latter satisfied directly by the productive efforts of the former. Indeed, in all socio-economic formations prior to capitalism, be they communal or exploitative, such a unity has generally existed. In pre-capitalist social systems, such as feudalism, primitivism and nomadism, production is essentially the production of *use-values for consumption*. However, with the advent of market-capitalism and the widespread establishment of private-property relations as the dominant socio-economic form of the modern world, the unity between production and consumption is broken. With the production of use-values, not as an end in themselves, but simply as the means to achieve an exchange between private properties, production and consumption become isolated spheres of activity which are rendered discrete by the market-place. Through the dominance of exchange-value over use-value, therefore, producer is separated from the product of labour, and consumer is simultaneously denied any meaningful access to those means of production that are required to explore fully the potential of needs. In short, the product now confronts the producer as an unrecognisable form in the alien sphere of consumption.

For Marx it is this overriding sense of rupture that has become the undeniable hallmark of capitalist societies. It appears as that overwhelming feeling of estrangement and alienation experienced by ordinary people when confronted by a material and social environment that is profoundly unfamiliar. At its extreme, this sense of alienation is captured in the Marxist concept of *reification*. This concept refers to the transformation of human relations and activities into a state where such relations and activities appear

to assume the characteristics of an autonomous force governed by a logic that seems to be independent of human action. In essence, things, structures or organisational forms that are the direct product of human activity appear to function according to their own mysterious logic. For example, God, the circulation of money, the market, the state, bureaucracy and even capitalism itself are seen to possess some'inner' and deeper logic that transcends the logic of their initial formation. Of course the most systematic exploration of such a process that was undertaken by Marx concerns the analysis of the commodity-form. In *Capital*, first published in 1867, Marx was to undertake perhaps the most thoroughgoing and far-reaching analysis of capitalism to date. This was based in the first instance upon the analysis of the commodity. Pursuing many of the themes outlined in the early works, but especially the *Economic and Philosophical Manuscripts*, *Capital* cites the commodity as that primary focal point into which the major social relationships of capitalism are condensed. Some of these ideas are explored in the following section.

VALUE AND ABSTRACT LABOUR IN THE COMMODITY-FORM

All forms of society must produce their means to life. Under capitalism this productive activity materialises principally in the form of *the commodity*. Viewed from this stance, then, the commodity is straightforwardly the material form taken by the means to life that is common to capitalist societies. Accordingly, the significance of the commodity lies in the fact that it has the capacity to satisfy some human want or need. Perceived in this way the commodity is thus a *use-value*. The commodity, however, can also be viewed from the perspective of its *exchangeability*; that is, from the standpoint of its capacity to command other commodities in exchange. Unlike use-value, which is primarily representative of a *qualitative relation* between objects and human needs, the value that is expressed through the exchange of commodities is based primarily upon a *quantitative relation* between individual commodities. Hence the significance of a commodity when regarded in terms of its exchangeability is essentially the ratio at which it will exchange with other commodities. As such the commodity is said to possess a *value*. Laid out in the first chapter of *Capital*, the concept of value is used quite precisely by Marx to describe the manner in which commodities are designated a status in which they are effectively treated as qualitatively equal, and different only in the respective quantities at which they achieve equivalences with each other. Moreover, Marx immediately stresses the significance of the difference between use-value and the value-form itself, and in doing so draws our attention to what appears to be the natural basis of value:

> What initially concerns producers in practice when they make an exchange is how much of some other product they get for their own: in what proportions can products be exchanged? As soon as these proportions have

attained a certain customary stability, they appear to result from the nature of the products, so that, for instance, one ton of iron and two ounces of gold appear to be equal in value, in the same way as a pound of gold and a pound of iron are equal in weight, despite their different physical and chemical properties.

<div align="right">(Marx 1976:167)</div>

The common misrecognition that value has its basis in some natural or physical law would at first glance appear to be of trivial significance. But Marx demonstrates throughout the pages of *Capital* how this misleading appearance of value lies at the very heart of capitalist production and exploitation and is a necessary condition for its reproduction.

If commodities are simultaneously use-values and values, each term merely representing different perceptions of the commodity's significance, then it may be tempting to regard value, as it materialises in exchange, simply as an objective valuation or measurement of use-value. Indeed, this was a notion which at the time of Marx's writing had assumed the status of the common sense of classical political economy. At the core of Marx's political economy, however, lay the systematic rebuttal of the idea that value expressed through the commodity-form was merely a product of a logic of supply and demand, and that the values seen when commodities exchanged with one another were in effect nothing but the objectification of the relative demand of a given proportion of use-values. For Marx, value bore no intrinsic relation to use-value at all. Value was not the simple and objective measure of the qualitative attributes of a given use-value; on the contrary, value had its basis in the concrete social relations of capitalist production and expressed the expenditure of a certain amount of *social labour* in that production.

Here we can regard the character of social labour from two distinctive perspectives. First, social labour can be conceptualised in terms of its specific quality; that is, as *concrete labour* under which material nature is transformed by the application of specific productive activities in order to produce use-values of a particular kind. Second, social labour can be considered independently of its qualitative characteristics as *abstract labour*. Since, under the value-form, any qualitative difference existing between commodities is effectively marginalised at the expense of those commodities' quantitative relationship, it follows logically that the labour which is embodied in the production of those commodities is also rendered qualitatively equal. Therefore, since exchange-value represents a measure of the *magnitude* of the value of a commodity when compared with other commodities, then by extension so is exchange-value a measure of the magnitude of the abstract labour that is embodied in a commodity in comparison to the abstract labour that is embodied in other commodities. The measure of abstract labour itself is *time*:

The labour-time materialised in the use-values of commodities is both the substance that turns them into exchange-values and therefore into com-

modities, and the standard by which the precise magnitude of their value is measured. The corresponding quantities of different use-values containing the same amount of labour-time are equivalents; that is, all use-values are equivalents when taken in proportions which contain the same amount of expended, materialised labour-time. Regarded as exchange-values all commodities are merely definite quantities of *congealed labour-time*.

(Marx 1970:30)

Additionally, the criterion against which this abstract labour-time gains its capacity to determine value is simply:

the form of average labour, in a given society, the average person can perform, productive expenditure of a certain amount of human muscles, nerves, brain, etc. ... The characteristics of this average labour are different in different countries and different historical epochs, but in any particular society it appears as something given.

(Marx 1970:31)

Value, then, expresses a quantitative relation between amounts of abstract labour; its source is thus homogenous labour assessed purely in terms of its temporal quantity as determined by an historically and geographically contingent, social average capacity. Value is therefore the objectification, or the material embodiment, of abstract labour which manifests itself under the form of exchange-value.

SURPLUS-VALUE REVEALED AS THE EXPLOITATION OF LIVING LABOUR IN PRODUCTION

Initially, the general formula for the circulation of capital would seem to present us with a paradox: namely that if all commodities are exchanged only for their value equivalents in other commodities then how is it possible for a surplus-value or profit to be generated in production? Logically the value that is consumed during production would be recreated precisely as the exchange-value of the produced commodity, leaving neither a net surplus nor a net deficit value. The very existence of a surplus-value or profit from production inevitably prompts the question of its origin.

Classical political economy assumed the genesis of profit to lie in an unequal exchange of commodities within the labour market. The economist Ricardo in particular had suggested that profit was produced when labour was sold for a value which was less than its true market value. For Marx, however, the idea of an unequal exchange between wages and labour could not explain the origin of surpluses, which resulted, as in any economic system, from the act of material production itself. To be sure, individual producers can achieve profits from buying cheap and selling dear. But profit in such instances is only achieved via the redistribution of the value of the surplus product, not by the production of surpluses themselves. Yet under capitalism, a healthy economy

is defined as a state where all capitalists are producing positive profits from production, a phenomenon which can only ever result from the generation of a surplus product from within that production.

In order to explain the origin of surplus-value Marx outlines the critical distinction between *labour-power*, which is defined as the *capacity* to do socially useful work, and *labour* itself, which is defined as the actual execution of labour-power for the purposes of producing use-values. The distinction between the concepts of labour-power and labour is the funda-mental distinction upon which Marx's labour theory of value rests, for this distinction recognises that these two concepts are, in value terms at least, to be treated as entirely different entities, and in which terms the former has a lower value than the value that is created by the latter. Let us then consider the specific functions that labour-power and labour play in the production of surpluses in more depth.

Capital existing in the form of money is initially invested into the productive process. This money capital is used to purchase two basic commodities. First, there is that investment of money capital into the means of production. This Marx calls *constant capital* and it takes the form of that proportion of value needed to secure raw materials, machinery and other productive inputs. Second, there is the investment of that proportion of money capital needed to secure the appropriate supply of labour-power. This investment is termed *variable capital*. Constant capital is so called because its value remains unchanged throughout the process of capital circulation and as such is incapable of creating any new value. Because the means of production are merely the objectification, or embodiment, of *dead labour* which has been performed at another time and place they are capable of transferring on to the product only a value which is not in excess of their own value. In this respect Marx argues that:

> However useful a given raw material, or a machine, or other means of production may be, even if it cost £150 or, say, 500 days of labour, it cannot under any circumstances add more than £150 to the value of the product. Its value is determined not by the labour process into which it enters as a means of production, but that out of which it has issued as a product. In the labour process it serves only as a use-value, a thing with useful properties, and cannot therefore transfer any value to the product unless it possessed value before its entry into the process.

> (Marx 1976:314)

The recognition that the means of production are never responsible for the production of surplus-value directs our attention to the sale of labour-power for wages; that it, the sphere of variable capital. Variable capital is so called because its value varies during the circulation process. Here labour-power is unique amongst all forms of commodity by the fact that it alone retains the capacity to create value. This can be explained in that the commodity

purchased by the initial money capital is labour-power, or the *capacity* to perform socially useful labour, and not *living labour* itself. Labour-power is sold for its value. But living labour in production, which is the use-value of labour-power, can create a product which, when objectified and realised in the commodity market proper as an exchange-value, is of a value greater than the value of labour-power. The origin of this surplus-value, then, lies not in an unequal exchange of wages for labour, for there is nothing unequal about the buying and selling of labour-power, but rather in the application of labour-power as living labour in production.

The generation of a certain surplus from living labour derives from the difference between the amount of *socially necessary labour-time* contained in a given working day and the total length of the working day itself. The term socially necessary labour-time is used by Marx in what appears to be two senses (Marx 1976:325n). First, socially necessary labour-time is a term used to designate: 'the labour-time required to produce any use-value under the conditions of production normal for a given society and with the average degree of skill and intensity of labour prevalent in that society (Marx 1976:129). Second, since labour-power is itself a commodity which is treated no differently by the market from any other form of commodity, it will necessarily follow that the use-value of labour-power, which is living labour, requires a certain amount of time for its own production. Of course the production of living labour rests upon the *reproduction* of labour-power; that is, the value of the labour, which is measured in wages, and that is needed to reproduce for each worker an historically specific, social average standard of living as determined independently by the labour market (Marx 1976:324–5). Since the true measure of value is abstract labour which expresses, not individual acts of labour but rather the social average time and intensity taken by labour to produce a given proportion of use-values, then any instance of production which manages to produce use-values at a more efficient rate than that of this social average will not only be able to reproduce the initial value of the variable capital invested and consumed in production, but also be able to produce a surplus-value:

> If the *labour-time* of the worker is to create value in proportion to its duration, it must be *socially necessary labour-time*. That is to say, the worker must perform the *normal social* quantity of useful labour in a given time. The capitalist therefore compels him to work at the normal social *average* rate of intensity. He will strive as hard as possible to raise his output above this *minimum* and to extract as much work from him as possible in a given time. For every intensification of work above the *average rate* creates surplus-value for him. Furthermore, he will attempt to extend the labour process as far as possible beyond the limits which must be worked to make good the value of the variable capital invested, i.e. the wages of labour.
>
> (Marx 1976:987)

In summary, then, the time spent during the working day that is worked above and beyond the socially necessary labour-time needed to reproduce the value of labour-power is deemed to be *surplus labour-time*. Here the worker spends a proportion of the working day working, not for wages, but only for capital (Marx 1976:324–39). The product that is yielded by this surplus-labour is thus held to be a surplus product which can be disposed of in the commodity market proper to generate surplus-value. Hence surplus labour-time effectively represents the theft of a proportion of the working day and its product from living labour. Accordingly, surplus-value similarly represents a value that is *expropriated* by capital from the total value of labour. The very existence of surplus-value when realised as private profit for the capitalist thus bears testimony to a certain degree of *unpaid labour* in production and is therefore the objectification of a proportion of expropriated value from living labour. Hence:

> the actual function specific to capital as such is the *production of surplus-value* which ... is nothing but the production of *surplus-labour, the appropriation of unpaid labour* in the course of the actual process of production. This labour manifests itself, objectifies itself, as *surplus-value*.
>
> (Marx 1976:978)

This is simply what is meant by the phrase 'the exploitation of labour' and as such forms the essential foundation for the class-based contradiction and antagonism which exists between the social constituencies of capital and labour. Hence, when stripped of some of its more emotive connotations, exploitation can be said to have a very precise and functional meaning in Marxist political economy, namely as a term which is descriptive of the material existence of unpaid labour in the production process for the appropriation by capital as private profit.

SURPLUS-VALUE CONCEALED AS THE FETISHISM OF COMMODITIES

If the exploitation of living labour by capital exists as the generalised condition necessary for the production of surplus-value, and therefore for the reproduction of the capitalist mode of production as a whole, then how is it possible that such systematic exploitation goes generally unrecognised by those who are exploited? Central to our understanding of this issue lies the concept of *fetishism*.

In a general sense the concept of fetishism in Marx's work refers to the way in which material objects whose characteristics are essentially the product of prevailing social relations appear to derive those characteristics from nature. Although not restricted as a term to activities pertaining directly to political economy, fetishism none the less finds perhaps its clearest and most basic manifestation in *the fetishism of commodities*. Here what is seen as essentially a social relation between individual producers assumes the

form of a relation between the objects of their production. In short, there occurs an 'objective appearance of the social characteristics of labour' (Marx 1976:176). Because commodities come to assume the value-form, and the social labour that is embedded in their production surfaces to common perception as an exchange-value, then the social relationship between producers manifests itself simply as the ratio at which the objects produced by labour exchange with one another under given market conditions. Hence value, which is in essence expressive of the social character of labour, becomes *naturalised* in the way that commodities seem to relate to one another objectively in the market. In a famous passage from *Capital*, Marx lays bare the dichotomy that exists here between the appearance of the commodity and its social essence:

> The commodity-form . . . [has] absolutely no connection with the physical nature of the commodity and the material relations arising out of this. It is nothing but the definite social relation between men which assumes here, for them, the fantastic form of a relation between things . . . I call this the fetishism which attaches itself to the products of labour as soon as they are produced as commodities, and therefore inseparable from the production of commodities.

(Marx 1976:165)

Commodity relations appear to us in reified forms: as a complex of object relations determined by an apparently autonomous and self-regulating logic. This logic seems to result from the nature of the commodities themselves rather than from the social relations involved in their production. Such is the nature of this fetishism of commodities that the value of the commodity assumes the guise of a value independent of human determination and thus appears to reside as an intrinsic property of the commodity itself. This value is then objectified, or made visible, at the moment the commodity becomes an exchange-value with another commodity in the market. Typically, one dimension of this exchange takes the form of money. The money-form provides an abstract or standardised criterion against which all commodities may be assessed 'objectively' and from which every commodity may have its price. The highly abstracted form taken by this 'absolute commodity' money further succeeds in masking value's true source in social labour, and as such pushes commodity fetishism to its extreme form. It is precisely because the value that is realised by living labour in production is objectified in the exchange-values of the products of this labour that it is extremely difficult to see the disparity which exists between this value and the lower wage-value of labour-power. Similarly in the sphere of consumption, commodity fetishism disguises the essential social reality of the production of commodities and makes it generally impossible to penetrate down beneath this appearance and to identify the real conditions and social relations from which the commodity emerges.

The ways in which commodities converge and collect in the market, their untarnished appearance as they emerge butterfly-like from the grubby chrysalis of production, the fact that they appear to speak only about themselves as objects and not about the social labour of their production is ultimately what constitutes the fetishism of commodities. The sphere of production is thus the night-time of the commodity: the mysterious economic dark side of social exploitation which is so effectively concealed in the dazzling glare of the market-place. It is the total and necessary effacement of the concrete social relations of their production from the surface of commodities that represents, for Marx, the significance of this mysterious process. Beautiful South African fruit, or the latest Ford automobile, each appear to derive their values only from a comparison with other commodities and their use-values; each claims to represent merely a 'fair price' in contrast to English or French fruit, or with the products of Toyota or General Motors. It is therefore impossible to see that behind these apparently natural object relations, behind the way that these commodities seem to conduct their business only with each other on the shelves of shops and supermarkets or within the car showroom, that there lie the universal social relations of capitalist exploitation existing between South African, English, French, American or Japanese workers, who, although divided by geography, history, culture, race and language, and in many other ways, are essentially united by their class position within the system of capitalist production.

Marx did not experience the birth of the consumer society. Neither did he address directly those topics of consumption and culture which are of chief concern to us here. There can be no dispute however, that Marx's writings leave us with a rich legacy of ideas from which we may be able to begin to make intelligible the complex forces at play in today's consumer society. Whilst the social and material environments encountered by people today may appear, on the surface at least, to be virtually unrecognisable from those Marx encountered, it is possible to argue that such changed appearances belie a clear consistency in the essential social conditions that underpin both, as well as intervening, historical periods. Consequently, although capitalism may have undergone massive change over the 100 years since Marx wrote *Capital*, there can be no doubt that as a system of socio-economic organisation capitalism still retains at its heart one undeniable characteristic: the appropriation of surplus-value by one class from another. This should in no way imply that it is legitimate analysis to dispense with a certain sensitivity to the investigation of historical change and specificities. Marx himself would have been the first to recognise the impact of new and unique social conditions upon the manner in which capital was accumulated and social relations configured. To this extent the concept of *appearance* in Marx does not imply falsity. On the contrary, the concept of appearance refers to the particular manifestations that the underlying or essential social relations assume at specific historical moments. Consequently, this does not ask us to

trade away the appearances of contemporary social and economic forms and relations solely to the analysis of capitalism's 'universal' logic. Rather, it points to the *significance* embodied within the appearance of those social and economic forms and relations. This is why contemporary social analysis, when viewed from the prism of historical materialism and Marxist theory, can never be content with Marx's original writings alone, but must engage in a constant and ever unfolding analysis of the manner in which productive forces, themselves in a state of perpetual transformation, function as a mediating power on the social world generally. Having said this, let us begin to consider some of the established Marxist perspectives on the nature of contemporary consumer society and culture.

THE FALL OF USE-VALUE

In the modern consumer society we are, in our daily lives, confronted with an unprecedented cornucopia of commodities and exchange-values. The commodity has become our standard means to life; our means of reproduction, both as a flesh-and-blood species and as a social species-being. If we follow the central principle revealed in Marx's analysis, then resulting from the conditions which produce the commodity-form we should expect to see the emergence of a definite mode of life: distinctive social relations and particular ways of experiencing and expressing those social relations in and through cultural activity. Moreover, the thorough permeation of the commodity-form throughout everyday life also bears witness to an equally thorough fetishism of commodities. As more of our needs and their satisfactions are inevitably drawn into the market mechanism, and as more and more areas of our lives are touched by the market, then the more autonomous, self-governing and suprahuman appears to be the dynamic movement of commodities and their exchange-values. As we daily confront these commodities and their imagery, in our shops, homes and streets, on our television screens, and in our magazines and newspapers, then the more magical their transubstantiation into values and meanings appears to be. Under such conditions of saturated exposure, the commodity truly seems to deny any basis in social labour, and the values and meanings which are attached to it have, it would seem, been decided upon by mysterious laws decreed by unseen gods. This forces us to address an aspect of the commodity that Marx did not himself directly consider, namely the processes by which commodities attain their *social meanings* as objects of everyday life and culture.

Since a primary consequence of the logic governing the commodity-form is the necessary obfuscation of the social relations of production from the appearance of the commodity, then it should follow that the commodity, as it surfaces as a consumer good, is an object *without* any overt social meaning. Of course in the modern consumer marketplace the social meanings that attach themselves to commodities are, in the first instance, supplied by such

institutions as advertising, marketing and similar promotional organisations. Without such institutions, commodities would be likely to confront consumers as alien objects devoid of cultural significance. Therefore, one of the primary functions of advertising is, as Judith Williamson (1978:12) has suggested, to create 'structures of meaning'. It is this function of defining the meanings of commodities that Sut Jhally has referred to as the 'theft and reappropriation of meaning':

> in non-market societies there is a unity between people and goods, but in capitalism there is a separation between object and producer. The world of goods in industrial society offers no meaning, its meaning having been 'emptied' out of them. The function of advertising is to refill the emptied commodity with meaning. Indeed the meaning of advertising would make no sense if objects already had an established meaning. The power of advertising *depends* upon the initial emptying out. Only then can advertising refill this empty void with its own meaning. Its power comes from the fact that it works its magic on a blank slate.
>
> (Jhally 1989:221)

Jhally's point is important because it reminds us that the commodity is always consumed symbolically, as a social meaning or as a cultural good, as well as in its material substance as a functional utility. One may even go so far as to suggest that the success of today's consumer economy actually depends upon the regulation of the symbolic and cultural dimensions of commodities; that is, the exercise of control over the *economy of symbolic or cultural goods*. Seen in this light, Ernest Dichter's notion of the 'soul of things' may represent much more than a fanciful piece of marketing hyperbole. The idea represents, in fact, an important recognition that the material and the symbolic dimensions of goods, their economic values and their cultural meanings, share an inseparable and insoluble relationship.

Marx, it would appear, had clearly recognised this point. In arguing that through its material production, humanity not only reproduces itself physically, but also intellectually as a conscious species-being through the cultivation of a 'definite mode of life', Marx was also effectively acknowledging that the cultural sphere of social life represented much more than a relatively superficial adjunct of human existence. In culture there is embodied the vital and spontaneous correlate of species reproduction. In a well-used passage from the preface of *A Contribution to the Critique of Political Economy* Marx was to write:

> In the social production of their existence, men inevitably enter into definite relations which are independent of their will, namely relations of production appropriate to a given stage in the development of their material forces of production. The totality of these relations of production constitutes the economic structure of society, the real foundation, on which

arises a legal and political superstructure and to which correspond definite forms of social consciousness. The mode of production of material life conditions the general process of social, political and intellectual life. It is not the consciousness of men that determines their existence, but their social existence that determines their consciousness.

(Marx 1970:20–1)

Given this, one of the major roles for organisations such as advertising, marketing, commercial design and indeed the totality of the so-called 'cultural industries' can be seen as follows: to attempt to construct an economy of symbolic or cultural goods that is aligned sympathetically with capitalism's fundamental objective, namely its own successful reproduction. Moreover, given that capitalism represents a system of material production founded upon the repression of human potentialities, one may even go so far as to argue that the function of advertising is in fact to disguise the impoverished nature of modern forms of objectification.

Unfortunately, when these issues have been addressed directly by many Marxist writers they have been done so in a manner which is insensitive to the uneven and highly complex nature of the power of capitalism to regulate the cultural sphere. Such a position can be found in some of the work of the Frankfurt School. In Herbert Marcuse's *One-Dimensional Man* (1986) (see also Adorno and Horkheimer 1972), Marcuse suggests that the common claim that the rise of consumer society has seen the birth of a radical and liberating social democracy and embourgeoisement is little other than the emergence of a new ideology of capital. In their recently acquired affluence, by assimilating the new needs that have been supplied by the cultural industries, and in accepting the dominant ideology to 'relax, to have fun, to behave and consume in accordance with the advertisements' (Marcuse 1986:5), Marcuse argues that the working classes have become, not the living evidence of a new social utopia at all, but rather clear proof of capitalism's strengthened control over greater areas of working-class life. The emergence of the new and affluent middle classes of today's consumer society has only succeeded in making the essential social relations of exploitation that are hidden beneath the illusions of this new social democracy and the 'classless society' increasingly difficult to decipher:

If the worker and his boss enjoy the same television program and visit the same resort places, if the typist is as attractively made up as the daughter of her employer, if the negro owns a cadillac, if they all read the same newspaper, then this assimilation indicates not the disappearance of classes, but the extent to which the needs and satisfactions that serve the preservation of the establishment are shared by the underlying population.

(Marcuse 1986:8)

Similarly, the product of human labour, where it was once (and could yet become again) a healthy extension of the self, the objectification of essential

species-being and the embodiment of the dynamic transformation of nature into a positively energising social form, has, under the all-pervasive logic of the modern commodity-form, become a didactic and seemingly autonomous agent of social control. In a direct inversion of Marx's ideal formulation of the relationship between production and consumption, people are themselves now mere extensions of the products they consume:

> The people recognise themselves in their commodities; they find their soul in their automobile, hi-fi set, split-level home, kitchen equipment. The very mechanism which ties the individual to his society has changed, and social control is anchored in the new needs which it has produced.
>
> (Marcuse 1986:9)

In fact Marcuse's general concern about the consumer society was not the usual criticism that had been levelled against it by such cultural critics as Leavis (1930) or Hoggart (1958): consumer society was, for Marcuse, not a hedonistic society of unbridled and permissive pleasure, but an ascetic, over-rationalised and bureaucratic society offering very little opportunity for creative cultural expression or for radical forms of political action and thought.

In Marcuse's work it is possible to begin to identify the source of the substantial disquiet registered by many critics of consumer culture. What has been lost in modern forms of consumption is the idea that goods embody real use-values. In becoming an exchange-value, the cultural meanings of goods, which would otherwise find a firm anchorage in their material composition as utilities for the satisfaction of corporeal needs, have in fact become malleable, free-floating and symbolic illusions based upon little other than non-material desires and ideological fantasies. Such fantasies are conjured up in the highly aestheticised and seductive imagery and packaging of advertising and commercial product design. John Berger (1972), for example, specifies the powerful and often overwhelming imagery and language of sexuality, power, guilt, envy and, above all, glamour as the key discursive fields for such contextualisation. Advertising, argues Berger, has created an enormous fissure between the reality of the product's production (and the social relations embodied therein) and the fantastic ideology which surrounds the product in its publicity. Publicity, he suggests, 'remains credible because the truthfulness of publicity is judged, not by the real fulfilment of its promises, but by the relevance of its fantasies to those of the spectator-buyer. Its essential application is not to reality but to day-dreams' (Berger 1972:146). He concludes that:

> Capitalism survives by forcing the majority, whom it exploits, to define their own interests as narrowly as possible. This was once achieved by extensive deprivation. Today in the developed countries it is being achieved by imposing a false standard of what is and what is not desirable.
>
> (Berger 1972:154)

Raymond Williams (1962) would seem to agree with this view. Williams provides us with an ironic twist to the common cliché that modern society is too materialistic. Advertising, he suggests, has tended to dissolve culture's basis in material utility:

> If we were sensibly materialist, in that part of our living in which we use things, we should find most advertising to be of insane irrelevance. Beer would be enough for us, without the additional promise that in drinking it we show ourselves to be manly, young at heart, or neighbourly . . . But if these associations sell beer, . . . as some evidence suggests, it is clear that we have a cultural pattern in which the objects are not enough but must be validated, if only in fantasy, by association with personal and social meanings which in a different cultural pattern might be more directly available.
>
> (Williams 1962:185)

For Williams it would appear that the symbolic and cultural dimensions that are supplied to consumer goods by advertising have triumphed over the ability of goods to function as material use-values. This is a position taken to its extreme by W. F. Haug in *Critique of Commodity Aesthetics* (1986). Here the organic relation between needs and material use-value is shattered as consumption becomes increasingly defined in terms of desire and fantasy. This desire and fantasy is initially founded upon the aestheticised appearance of the modern commodity-form. Under such conditions the product itself effectively undergoes a complete physical metamorphosis:

> The beautifully designed surface of the commodity becomes its package: not the simple wrapping for protection during transportation, but its real countenance, which the potential buyer is shown first instead of the body of the commodity and through which the commodity develops and changes its countenance . . . As an example of this, a US bank, in order to facilitate the exchange of money, recently changed even the design of its cheques to make use of new psychedelic colours.
>
> (Haug 1986:50)

The function of commodity aesthetics is, then, to accelerate the rate of commodity exchanges and value turnovers. This involves an ever rapid turnover of aesthetic fashions and styling changes, and the implementation of shorter product lifespans (material and aesthetic 'product senility'). It is a process that necessarily entails the real ideal of commodity aesthetics to be 'to deliver the absolute minimum of use-value, disguised and staged by a maximum of seductive illusion, a highly effective strategy because it is attuned to the yearnings, and desires, of the people' (Haug 1986:54).

Haug's argument represents a common thematic thread woven throughout much Marxist theory. Here there is held to be a natural and unequivocal

relationship between need and use-value. Many Marxist commentators have used this central assumption as the basis from which to argue for a new form of society in which production and consumption are reunited and a non-alienated humanity is thus allowed to re-emerge from the repression of capitalist modes of production and consumption. It has been the pioneering work of the French sociologist Jean Baudrillard (1975, 1981, 1988a) that has perhaps done most to overturn this notion. For Baudrillard the idea that use-value embodies a natural relation to need, and therefore manages to evade the realm of political economy, has allowed the concepts use-value, utility and materialism to be unduly privileged over the symbolic and the cultural dimensions of consumption. But, suggests Baudrillard, this fails to recognise that both needs and use-values are historically specific and are only ever the product of processes of social determination. Indeed, Baudrillard focuses this critique of 'orthodox' Marxist theories of consumption upon a 'blindspot' that can, he claims, be traced back to the pages of Marx's own writings. Baudrillard alleges that in centring his analysis of the commodity-form exclusively on the sites of production, labour and exchange-value as the true determinants of social relations under capitalism, Marx was forced to misrepresent the roles that consumption and use-value play in this process. Since Baudrillard raises several important issues about the nature of contemporary consumption that pertain to this study, it is well worth considering his critique of Marx a little further.

Marx presents use-value as the 'unmysterious' dimension of the commodity. In use-value there is to be found the objective relation between the sphere of needs and the sphere of production, which exists here as an isolated relationship between people and their goods. Because use-value is posited as the unmysterious dimension of the commodity, Baudrillard assumes that for Marx use-value represents nothing but the expression of a natural relationship between an object and a person, so that to each object corresponds a predetermined or unique use based upon a natural and a stable need. In Marx's schema, it is because use-value has been subordinated to exchange-value that the organic relation between humanity and nature is ruptured and use-value diminished in its function of releasing the life-energies of humanity. For Baudrillard this conceptualisation of use-value represented Marx's greatest theoretical error, for in seeing use-value only as an objective relation between objects and people, he had effectively (and ironically) fetishised use-value. Presented as a category that is somehow immune from processes of social determination, use-value is allowed to pass unnoticed beyond the scrutiny of historical analysis and go unrecognised as a repressive aspect of the commodity-form. Consequently, while Marx had so rigorously unveiled the logic of exchange-value as the naturalisation of the social relations of production, he had failed to identify the fact that in use-value there was expressed the social relations that were constituted within the sphere of *consumption*:

> Use-value in this restrictive analysis of fetishism appears neither as a social relation nor hence as the locus of fetishisation. Utility as such escapes the historical determination of class. It represents an objective, final relation of intrinsic purpose which does not mask itself and whose transparency, as form, defies history.
>
> (Baudrillard 1988a:64)

This bias towards production and the 'naturalisation' of use-value in Marx was not at all surprising, Baudrillard continues. The concepts of production and use-value were of course the very concepts that had formed the major social and economic ideals of the period in which Marx was writing. As such, Baudrillard claims that Marx had fallen victim to the dominant ideology of the nineteenth century, namely that obsession formed in the wake of the Industrial Revolution in which the ideals of work, rationality and utility were seen as the fundamental sources of a moral and spiritual enlightenment.

It is important, argues Baudrillard, that this naturalisation of use-value is not treated merely as an unexplored oversight in the work of Marx. Whilst the analysis of exchange-value has revealed the commodity to be the efficient screen of exploitation and repression existing within the sphere of production, use-value is unproblematically established in Marxist theory as the 'crown and sceptre of political economy' (Baudrillard 1988a:72); it is effectively granted such a status of epistemological privilege and refuge that it blinds us to the oppressive manner in which commodities circulate within the sphere of consumption. In short, for orthodox Marxism, use-value is established as the material basis of humanity's potential for self-advancement. But in perceiving the concepts of need, utility and use-value as the objective and stable foundations upon which some utopian system of production could be established, Marx had dissolved and neglected that aspect of the 'ideological and historical labour process that leads subjects in the first place to think of themselves as individuals, defined by their needs and satisfaction, and so ideally to integrate themselves into the structure of the commodity' (Baudrillard 1988a:71–2).

For Baudrillard, then, it is within the realm of *consumption* that there is inscribed the whole network of social and class relations of modern capitalist society. Use, utility and need are each socially determined at a cultural level and their intelligibility becomes contingent upon their historical definition and placement as individual elements within a *structured system* of uses, utilities and needs. That the various meanings attaching to these elements have been subjected to the most rigorous forms of naturalisation has tended to bestow upon them the function of the most pervasive and powerful agents of social control. For it is with the inability to recognise the social construction of our needs and their satisfactions in the use-values of commodities, that those needs can position us within the ideological system of consumption 'to each according to his needs':

use-value fetishism is indeed more profound, more 'mysterious' than the fetishism of exchange-value. The mystery of the commodity and exchange-value can be unmasked . . . and raised to consciousness as a social relation. But value in the case of use-value is enveloped in total *mystery*, for it is grounded anthropologically in the (self-) 'evidence' of a naturalness, an unsurpassable original reference . . . Here mystery and cunning are at their most profound and tenacious.

(Baudrillard 1988a:72)

When seen in this light the commodity not only appears as the objectification of the misrepresentation through exchange-value of the social relations embedded within the processes of production, but more importantly, perhaps, that agent which, in its form as a use-value, is responsible for the regulation and reproduction of the prevailing social and economic order at the level of consumption. The commodity-form, then, more than masking the true source of value in production and human labour, becomes of critical significance in the valorisation of social relations as they manifest themselves through the commodity as a cultural and symbolic form.

Baudrillard's critique of Marx has been severely censured for a gross misrepresentation of Marx's original formulation of use-value (see for example Kellner 1989a; Jhally 1987; Preteceille and Terrail 1985). However, I believe that many of the concerns raised by Baudrillard in this respect do indeed lend themselves as valid arguments in the critique of the theories of consumption that have been outlined above and that have emerged from the broad Marxist perspective. Certainly Baudrillard's ideas draw our attention to the complex manner in which commodities function as signs and symbols in the sphere of consumption, as well as their potential as regulating agents in the domain of culture. This represents the logic of 'sign-value', where, through advertising and marketing especially, commodities acquire certain cultural meanings. Hence:

In [the] field of connotations the object takes on the value of a sign. In this way a washing machine *serves* as an equipment and *plays* as an element of comfort, or, of prestige, etc. It is the field of play that is specifically the field of consumption. Here all sorts of objects can be substituted for the washing machine as a signifying element. In the logic of signs, as in the logic of symbols, objects are no longer tied to a function or to a *defined* need. This is precisely because objects respond to something different, either to a social logic, or to a logic of desire, where they serve as a fluid and unconscious field of signification.

(Baudrillard 1988a:44)

For Baudrillard the logic of sign-value represents the final triumph of capitalism in its attempt to impose a cultural order compatible with the demands of large-scale commodity production. Individuals have here been

reduced to the status of mere consumers, and consumers have become nothing but the vehicles for the transmission of controlled and predetermined differences between consumer objects which function to classify the social world according to the demands of advertising and the mass media. This logic of the 'form-sign' may be likened to a set of traffic lights, for just as traffic lights are able to effect changes in the behaviour of drivers by changing their colour, then so too, in changing their sign-values, are consumer objects able to effect changes in consumer needs and behaviours. The manipulation of needs and behaviours in this manner has made the consumer little other than a hollow shell into which the system of commodity production may deposit whichever needs are required for a given moment:

> Objects are *categories of objects* which quite tyrannically induce *categories of persons*. They undertake the policing of social meanings, and the significations they engender are controlled. Their proliferation, simultaneously arbitrary and coherent, is the best vehicle for a social order, equally arbitrary and coherent, to materialize itself effectively under the sign of affluence.
>
> (Baudrillard 1988a:16–17)

What we consume, therefore, is not the object of consumption itself, but its meaning and its sign-value.

Baudrillard's ideas open up the thorny question of the role that commodities play as the materials of lived, everyday culture. Unfortunately Baudrillard's assertion that needs in the modern consumer society are only ever the product of the manipulation of commodity sign-values by institutions such as advertising and the mass media, and that needs are, in this respect, always 'immanent', is clearly premature. As Douglas Kellner has correctly argued in his recent assessment of Baudrillard's ideas, Baudrillard:

> is theorising use-values and needs strictly from the standpoint of how they are perceived by capital and how capitalists might fantasise how they are actually producing use-values and needs. From a two-class, or multi perspectival standpoint, however, one can see that commodities have various uses, some defined by the system of political economy and some created by consumers or users.
>
> (Kellner 1989a:37)

This forces us to address more precisely some of the ways in which commodities function symbolically at the moment they have passed through the market and have entered into the realm of everyday life; that is, at the moment they are transformed from *commodities for consumption* to *objects of consumption*. This is the subject of Chapters 2 and 3.

Chapter 2

Exploring the economy of symbolic goods

OBJECTS IN EVERYDAY LIFE

Given the arguments so far expressed, it would seem that today's consumer society represents a greatly impoverished way of life. This sense of impoverishment appears to stem from the commodity-form. Whether we consider it in its guise as an artificial accelerator or manipulator of consumer needs, the mask hiding the expropriation of value by one class at the expense of another, as an object that denies humanity's spiritual life-energies, or as that ideological agent contributing towards a pacific and depoliticised populous, the commodity is seen to be no less than a *tyrannous object*.

Yet in the clamour to describe the repressive and denigrating effects of the commodity as it emerges from the sphere of production, it may be easy to forget that once it achieves its primary purpose of exchange it passes over into another domain: the realm of everyday life. In its passage through the market and its transformation from a commodity *for* consumption to an object *of* consumption, the commodity is itself transformed from an ideal use-value and imagined meaning into the material and symbolic object of lived experience. This is not to say, however, that the process of commodification leaves this object untouched; the meanings and symbolic values that cluster around the commodity during its initial contextualisation in design, advertising and marketing do not disappear in the moments of its use. On the contrary, the investment of a substantial sum of capital into the market positioning of the commodity has surely stamped itself onto its surface as something not easily ignored.

But the marks of production are not indelible, are not an insoluble power that completely regulates the meanings and symbolic values that commodities are permitted to acquire throughout their life as cultural objects. Although, in its guise as an object of lived culture, the commodity is by no means symbolically fluid, it is certainly symbolically malleable and thus able to assume a variety of meanings and significations according to the contexts of its use and the cultural competences of its users. This chapter will continue to explore some of those themes concerning the cultural and symbolic

dimensions of consumption that were raised in Chapter 1. Through a study of the theories outlined in the work of the French social anthropologist Pierre Bourdieu, this chapter describes some of the ways in which goods are used symbolically as a means of reproducing the existing social order and established class relations in and through culture. To begin, however, let us briefly consider some of the general positions regarding the role that goods play as communicators of culture and cultural identity.

A variety of anthropological and psychological studies have sought to explore the ways in which objects often function symbolically, through ritual and custom, as forms of expressing kinship, community and other social relations. Often drawing upon the empirically observed, real-life experiences of ordinary people, many of these studies provide us with a rich source of preliminary information regarding the importance of the psychological relationships formed between people and their goods.

A major topic explored in this body of research considers the idea that material objects constitute a vital element in the cultivation of and reflection upon human identity; who we are, our perception of self, and the valuation of our self-esteem would all appear to be influenced by what we own and possess (see Belk 1988). In short, material objects often function as dynamic elements of an extended self. Indeed, in some exceptional circumstances the mere presence of, or close proximity to, certain material objects would seem able to transform completely the perception of self and identity. Take, for example, the following passage describing the close relationship between a 40-year-old male and his expensive Porsche:

> Sometimes I test myself. We have an ancient, battered Peugeot, and I drive in it for a week. It rarely breaks, and it gets great mileage. But when I pull up next to a beautiful woman, I am still the geek with the glasses. Then I get back into my Porsche. It roars and tugs to get moving. It accelerates even going uphill at 80. It leadeth trashy women . . . to make pouting looks at me at stoplights. It makes me feel like a tomcat on the prowl . . . Nothing else in my life compares – except driving along Sunset at night in the 928, with the sodium vapor lamps reflecting off the wine-red finish, with the air inside reeking of tan glove-leather upholstery and the . . . Blaupunkt playing the Shirelles so loud it makes my hair vibrate. And with the girls I will never see again pulling up next to me, giving the car a once-over and looking at me as if I was a cool guy, not worried, instead of a 40-year-old schnook writer.

> (Quoted in Belk 1988:145)

This example illustrates well the general tendency for people to invest a certain amount of their self into material objects as a way of managing their sense of place, social position and identity. The attachments formed with and the memories stirred by personal belongings may serve in some way as an important reminder of our histories and biographies. In a study of object

attachments in a number of Chicago homes, Mihali Csikszentmihalyi and Eugene Rochberg-Halton (1981) discovered that the older people become, then the stronger becomes the attachment to particular objects. For the authors, the objects deemed to be the most important for old people were not especially those symbolising social prestige or pecuniary status, but those in some way reminiscent of other individuals. Personal momentos, gifts and presents that symbolised close relations between loved ones have, the authors continue, been invested with a certain proportion of 'psychic energy' which here serves as a symbolic commitment to the relationship in question. This is a phenomenon very similar to that described by Marcel Mauss (1990) in his now classic work on gift-giving and exchange in archaic societies. Indeed, such a phenomenon would appear to be an almost universal activity, both in terms of its cross-cultural similarities and in its consistency over time. Hence from an urban, industrial and modern Chicago environment to the ancient and highly structured rituals and customs of Maori society, material objects and artefacts function as a means of establishing a symbolic and metaphysical bond between various social-group members, and are used to objectify personal and social relationships:

> A person who owns a nice home, a new car, good furniture, the latest appliances, is recognised by others as having passed the test of personhood in our society . . . the objects we possess and consume . . . tell us things about ourselves . . . This information includes the social recognition that follows upon the display of status symbols, but it includes also the much more private feedback provided by special household objects that objectify a person's past, present and future as well as his or her close relationships.
>
> (Csikszentmihalyi, quoted in Belk 1988:148)

> What imposes obligation in the present received and exchanged, is the fact that the thing received is not inactive. Even when it has been abandoned by the giver, it still possesses something of him. Through it the giver has a hold over the beneficiary.
>
> (Mauss 1990:11–12)

The depth to which the subject–object bond may possibly extend has been revealed in the various psychological data describing the effects of the severing of this bond. The psychological impact following from the loss of material possessions, by either accident, theft or natural disaster, have been well documented (for example, Goffman 1961; Rosenblatt et al. 1976). Such reports indicate that the loss of a valued object will often be accompanied by a period of grieving which is not dissimilar in its form to that which accompanies the death of a close friend or relation. Consider, for example, the highly emotional account of the theft of a cherished bicycle:

It hurts to think that someone else is selling something that for me is more precious than money . . . Everyone who owns a bike has their own story that makes their bike more than just machinery to them. And you ripped it off. You stole a piece of my life. You didn't just steal a chunk of metal to sell . . . You walked off with my memories.

(quoted in Belk 1988:142)

However useful such evidences may be in illuminating the role that objects may play in managing and constructing a sense of identity, they may only reveal a partial picture of the significances people place upon objects. One potential problem of overstressing the personalised nature of some subject–object bondings is a tendency to isolate the particular relationship under study from its wider social and cultural context. Such a bias is particularly evident in many of the psychological accounts of the subject–object bonding. Indeed, many such studies are often prone to reduce the object to a status that is little other than some neutral receptacle into which the various emotions and personal feelings may be voluntarily deposited. Yet objects normally embody a much wider sense of a social framework, and as such carry the ability to provoke perceptions that derive from beyond the immediate and isolated subject–object relation. An anthropological approach which appears sensitive to this fact can be found in the various investigations undertaken by Mary Douglas (for example, Douglas 1984), and in particular her collaboration with the economist Baron Isherwood (Douglas and Isherwood 1978).

In *The World of Goods*, Douglas and Isherwood argue that goods function symbolically as a code or language, and as a means of making social behaviour intelligible. The symbolic purpose of goods, they suggest, is 'to make visible and stable the categories of culture' (Douglas and Isherwood 1978:61). This function is seen to include but also to extend well beyond the type of competitive and conspicuous display when goods are used as markers of social prestige and status, a theme so famously explored nearly 100 years ago in Thorstein Veblen's *The Theory of the Leisure Class* (1953).

In common with structuralist writers such as Baudrillard, Douglas and Isherwood regard the consumption of material goods as inseparable from the 'consumption' of their social meaning. In this respect, goods are simultaneously material and symbolic objects, useful not only for their functional and physical properties, but also as important instruments of cultural taxonomy and classification. Again, in common with Baudrillard, there is posited a 'system of objects', or a structured categorisation of consumer goods corresponding to a similar system of needs and social divisions. Consumer goods therefore always carry with them meanings of various social relationships, and they are an articulation of existing social divisions and structures. Specific object choices are seen to index an individual's membership of a particular cultural formation and can be used symbolically to express cultural relationships. Goods also serve to materialise

the often abstract social rules governing cultural behaviour, such as, for example, when it is and when it is not culturally acceptable to give cash as a gift:

> It is all right to send flowers to your aunt in the hospital, but never right to send the cash they are worth with a message to 'get yourself some flowers'; all right to offer lunch or drinks, but not to offer the price of lunch or a drink.
>
> (Douglas and Isherwood 1978:58)

The major difference between the type of cultural analysis offered by Douglas and Isherwood and that considered in Baudrillard's structuralist approach to consumption centres around the source of power for the determination of the social meaning of goods. In Baudrillard's schema, the delineation of structures of social meaning is seen to originate from external agencies such as advertising and the media. For Douglas and Isherwood, however, the production of social meaning is seen as a result of a relatively autonomous mode of cultural action. Whilst this action is never voluntary, in the sense that all members of society are required to choose and use goods according to certain established social conventions and from within existing social divisions and cultural differences, the consumption patterns and preferences of social groups is here seen to derive from a conscious and purposeful management of symbolic goods, as though all social members utilised those goods in full cognisance of existing cultural rules, codes and conventions.

Whilst this type of approach may represent a refreshing counter to the manipulationism predominant in many other theories of consumption, it is none the less not without its problems. Seeing in consumer goods merely the functional vehicles for the transportation to consciousness of latent cultural categories, Douglas and Isherwood have reduced the significance of goods to a status where they simply indicate existing and pre-established social divisions and categories. It is, therefore, only through the operation of a deeper social structure that material goods are organised into structured patterns of difference at a cultural and symbolic level. Hence 'partitioning amongst goods appears clearly as the expression of social partitioning' (Douglas and Isherwood 1978:148). In this way the social structure is itself presented as both pre-defined and senior to its symbolic expression in material culture. As such, categories of people and groups are seen to pre-exist categories of things or objects. This would suggest that use-value has once again been naturalised. In this instance however, use-value is conceptualised in terms of the utilitarian capacity of the symbolic structure, and in which its basic unit – the sign – has been reduced to the unmediated and perfectly natural symbolic channel for expressing social categories and classifications. There are, however, limitations with such an approach. As Marshal Sahlins has commented, this form of analysis:

aims to collapse the conceptual structure of an object code into a functional message, as though cultural things were merely substantialized versions of social solidarities, the latter here both assumed as privileged and as practical. So in the end, the true logic of the social-cultural whole is utilitarian.

(Sahlins 1976:73)

From this perspective we can see the importance of the pioneering work of structuralist commentators such as Baudrillard and Barthes. In structuralism the symbolic order is not seen to function simply as some neutral medium of expression for latent meanings already formed and merely waiting to be materialised in speech and culture by a rational and conscious human agent. The processes of signification are themselves regarded as the originators of social meaning and not mere channels for its transportation or simple utilities facilitating its unaffected emergence into culture.

Unfortunately, however, the important recognition that there can exist no form of social meaning from outside of the structuring principles of language, and that language itself cannot be reduced to the status of a simple mirror of reality, has had the effect, in certain moments of 'high structuralism', of unduly privileging the medium of expression over the subject. To this extent, the subject of social discourse may be marginalised as the mere 'product' of language, and be totally hidebound by the rules and principles inscribed within that language. Clearly what is needed here is an intervention into the study of the consumption of objects which avoids both extremes of theoretical formation: the objectivist bias towards the autonomy of the object and the subjectivist bias towards the autonomy of the subject. Perhaps the most sophisticated attempt to negotiate such a theoretical route between these two extremes can be found in Pierre Bourdieu's sociology of culture.

THE ART OF MAKING DIFFERENCE

In Bourdieu's *Distinction* (1984) there is to be found the culmination of many years of empirical research into contemporary French society and culture. One of the epistemological themes guiding the lines of argument in *Distinction* is an attempt to break with the overly formalist mode of analysis commonly found within many of the dominant methodologies of postwar social theory. Here Bourdieu is at pains to stress that social action can not be defined merely as the predetermined product of a series of external rules of socialisation. In a recent interview, Bourdieu summarises his position in the following way:

My intention was to bring real-life actors back in who had vanished at the hands of Lévi-Strauss and other structuralists, especially Althusser, through being considered as epiphenomena of structures. I do mean 'actors', and

not 'subjects'. An action is not just the mere carrying-out of a rule. Neither in archaic nor in our society are social actors regulated automatons who, like clockwork, follow mechanical laws existing outside of their consciousness.

(Bourdieu 1986:41)

But while Bourdieu is keen to avoid the fetishism of social structures that have been so prevalent within the disciplines of structuralism and functional sociology, he is also alive to the highly problematic nature of many ethnomethodological or social-psychological descriptions of the individual in which social action effectively becomes the product of the voluntary endeavours of a freely calculating subject operating in full cognisance of the social conditions and structures within which she or he is located. Consequently, Bourdieu's methodology aims to reposition social action as a concept located between the two extremes of theoretical formation: the actor either as the fully conscious maker of social meaning, or merely as the slave to various external forces and the object of socialisation processes.

The concept that Bourdieu brings to the task of tracing this delicate line between the poles objectivism (determinism) and subjectivism (voluntarism) is that of the *habitus*. A complex concept, the habitus provides Bourdieu with a firm basis upon which to develop an intricate model of culture and cultural relations.

Instigated in early childhood through interaction with family members and other social agents, the habitus is defined as *the* characteristic feature of the cultural group. In essence, the habitus provides a group-distinctive framework of social cognition and interpretation; it is the embodiment of the various dispositions, temperaments and cultural sensibilities that structure group behaviour whilst simultaneously providing for individual group members a mechanism for the structuring of social experience. Neither a functional product of socialisation and external social rules, nor simply a random configuration of natural dispositions, the habitus represents the structuring of cultivated dispositions into a matrix formation providing for a certain consistency or logic to everyday practices and actions. But more than this, the habitus assumes a role of an interpretive intermediary structure which regulates the principles of social action that have already been internalised by the actor, as well as that of the cognitive mechanism able to assimilate and incorporate into this existing schema all of the contemporary, future or unforeseen social experiences which may possibly be encountered. To this extent the habitus represents a conceptual framework describing a 'perception-enabling prism' which houses the various social dispositions that, according to its particular logic, allow for the cultural classification of the social world. Hence:

The habitus is necessity internalised and converted into a disposition that generates meaningful practices and meaning-giving perception; it is a

general, transposible disposition which carries out a systematic, universal application – beyond the limits of what has been directly learnt – of necessity inherent in the learning conditions.

(Bourdieu 1984:170)

Or alternatively:

The structure constitutive of a particular environment . . . produce *habitus*, systems of durable, transposible *dispositions*, as structured structures predisposed to function as structuring structures, that is, as principles of the generation of practices and representations which can be objectively 'regulated' and 'regular' without in any way being the product of obedience to rules, objectively adapted to their goals without presupposing a con- scious aiming at ends or an express mastery of the operations necessary to attain them, and, being all this, collectively orchestrated without being the product of the orchestrating action of a conductor.

(Bourdieu 1977:72)

This definition makes the habitus much more than merely an elaborate description of a particular cultural locale; the habitus is granted a dynamic and enabling role in the determination of social action. It is both the classifier of social groups as well as being a classifying apparatus belonging to groups: a relatively flexible cognitive framework for making sense of social experi- ences, and a stable, although never static, set of classifying principles, conditional and variable in relation to time and space, and upon which a series of generative dispositions may produce a complex repertoire of adaptable methods of cultural taxonomy. Just as the child in Piaget's theory of cognitive development is able to multiply the number of mental schemata to accommodate new learning experiences, then so too is the cultural actor of Bourdieu's habitus able to build upon and modify the existing schema of cultural perception in order to manœuvre between direct experiences of the objective world and the established mechanisms of classification.

These systems of classification and cultural ordering are manifest in the distinctive cultural practices and particular object preferences displayed by groups; that is, in class taste. They are revealed in what at first sight appears to be a series of disparate and unrelated cultural fields. These fields may include those most normally associated with culture, such as dress-sense, house layout, and preferences in cinema, painting, music, sport and archi- tecture, but are also seen in the more abstract and less obvious cultural fields of moral and ethical disposition, political preference, humour, psychological sensibility and even those most 'natural' of human characteristics: taste in food, table manners and bodily deportment.

Using the concept of habitus, Bourdieu is able to develop a model of social action in which culture and cultural relations are given a relative, but real,

autonomy from the relations of economic production. Arguing that cultural practices cannot be reduced merely to the symbolic reflection of economic conditions, the concept of habitus allows Bourdieu the theoretical space necessary to account for the diverse patterns of cultural classification which exist not only between different social classes, but also in those instances of cultural difference occurring between social groupings who share exactly the same economic class position. This means that just as economic relations express networks of power, which can be quantified in economic capital, then so too do cultural relations express the differential levels of learned and empowering competences, or *cultural capital*, as these are relatively distributed throughout the social field. Cultural capital is here defined as the possession of certain cultural competences, or bodies of cultural knowledge, that provide for particularly distinguished modes of cultural consumption and for the relatively sophisticated classification of cultural and symbolic goods. However, unlike economic capital, which may be acquired instantaneously, the receipt of cultural capital is entirely conditional upon a long-term investment of time spent, chiefly, in education. Through education, cultural capital may be accumulated and its possession may enable the reproduction and monopolisation of the existing stock of symbolic capital; that is, the metaphorical quantities of status and prestige, as recognised by others, that may be derived from the skilful management of social symbols. Therefore, the greater the possession of and investments in educational and cultural capital, the more articulate and distinguished becomes the mode of cultural consumption that is adopted, and hence the greater the yield of symbolic capital that may be granted. In this respect, taste, or cultural preference, is shown by Bourdieu to be the product of social systems of taxonomy derived from specifically learned cultural competences, and not, as is sometimes argued, the product of a natural or an innate disposition.

With the innovative metaphors of cultural and symbolic capital, and by retaining the core Marxist premise that the determination of social relations in capitalist society always depends upon relations of social power, Bourdieu is able to extend the understanding of the logic of social relations to account for their operation in those social domains where economic position would appear to be less directly relevant in the determination of social position generally. According to Bourdieu, the origin of power lies in the production of social differences which may be either real or symbolic, economic or cultural. The effective operation of social power is always conditional upon the establishment and conventionalisation of social hierarchies. For in order to be reproduced successfully, the social hierarchies within which power is inscribed must be made visible and the values that attach to these differences naturalised and recognised by the majority of groups as the legitimate property of such differences. In *Distinction*, Bourdieu both describes and theorises the manner in which cultural difference between social groups is often used as a means of generating symbolic power for those groups with the greatest accumulation of

cultural capital. Given that in most advanced industrial societies there has been, since the time of the Second World War, a genuine effacement of many of the economic differences by which class distinctions have traditionally been signalled, then questions of culture and cultural difference become paramount to our understanding of the manner in which hegemony and social order are both maintained and reproduced. If mere ownership and possession of material goods alone begins to lose its potency as a marker of social prestige and distinction, then the cultural differences generated by the symbolic competences that are brought to bear upon the cultural consumption of those goods becomes the critical point of leverage at which power may be exercised effectively and relations of social plutocracy established.

Against this background Bourdieu is able to interpose the concept of habitus as that theoretical concept which may account for the various class dispositions which structure and naturalise symbolic and cultural differences. For what is produced by each habitus formation is effectively a stable and group-specific way of seeing or making sense of the social world; in other words, a *distinctive mode of cultural consumption*. Seen in the broader social context, these modes of consumption represent comparatively valued, cultural taxonomies which constitute an important dimension of the social hierarchy itself. The chief index of classification in this respect is the amount of cultural capital needed to gain access to a given mode of cultural consumption: the greater the cultural capital required to operationalise a particular mode of cultural consumption, the more exclusive that mode of consumption becomes and hence the greater the symbolic power it may generate for the group in question. The habitus, then, produces systems of cultural classification which, when made visible in class tastes, function to classify those systems of classification themselves. To this extent, mode of consumption or class taste 'classifies the classifier'.

For Bourdieu the overarching condition which guides a given mode of consumption is the relationship of each social group to the realm of basic economic necessity. In itself this observation is not new: class proximity to the domain of economic necessity has been most famously explored by Veblen in *The Theory of the Leisure Class* (1953) (see also Galbraith's discussion of the New Class (Galbraith 1985:260–7)). In Veblen's theory, the leisure classes urgently sought to objectify their newly acquired *nouveau riche* status by the consumption of those goods displaying no obvious utilitarian or functional value; goods became the symbolic index of a leisured or non-working lifestyle. But Bourdieu is able to move well beyond such a uni-dimensional model of cultural consumption as the conscious and conspicuous management of status symbols. Processed via the habitus, each group's relationship to the realm of economic necessity effectively resurfaces as an objectively perceived cultural 'world-view'. It appears here as the apparently spontaneous and innate sequence of preferences and practices that constitute class taste and that 'naturally' appear to inform class-specific

cultural judgements. This process of mediation between the objective con-
ditions that produce the class habitus and the modes of cultural consumption
that the habitus is allowed to generate cuts across all of the cultural fields;
it is not only to be seen in a group's attitude to those aspects of culture
most closely associated with the realms of material subsistence and physical
comfort (such as preferences in food, clothing, furniture and other ostensibly
utilitarian goods), but is also the determining factor governing the judgement
of solely cultural and symbolic products, but especially those of music,
drama, literature, painting, cinema, photography and other such aesthetic
preferences.

In concrete terms, this means that working-class taste is the product of a
particular world-view transformed via a habitus that has been forged from the
'lifestyle of necessity'. For those whose social origins are closest to the realm
of economic necessity, and by virtue of this fact who have also been denied
access to cultural and educational capital, the ability of goods to perform a
clear material and symbolic *function* becomes the determining criterion of
cultural judgement. Working-class taste in food, for example, is generally
governed by the capacity of individual foodstuffs and meals to satisfy hunger
and provide plentiful protein. This is transformed unconsciously by the
habitus to a symbolic level where the typical working-class meal objectifies a
deep-seated struggle to escape the yoke of economic scarcity. This is why,
wherever possible, the meal, and more importantly perhaps, its mode of
cultural consumption within the working-class lifestyle so often embodies a
sense of material substance, abundance and elasticity: 'soups or sauces,
pastas or potatoes . . . served with a ladle or spoon to avoid too much
measuring or counting' (Bourdieu 1984:194). In the sphere of aesthetic
judgement too the same criterion of selection, based above all else upon the
subordination of a symbolic form to its function, is seen to persist. Here the
need to determine easily and unambiguously an 'objective meaning' of
aesthetic goods becomes paramount. The legitimacy of such goods is thus
assessed principally according to the adequacy of the medium in question in
expressing a stated content. Typically, the aesthetic form of such goods
should be easily 'accessible', display a clear correspondence to its subject
matter, or deliver an immediate, sensory and direct (physical) experience.
For this reason working-class tastes in aesthetic goods lean towards the
obviously melodic or rhythmic in music, and images that accurately and
fulsomely render their subject matter according to the long-established
conventions of 'common sense' aesthetic practices and the traditional means
of transcribing aesthetic content (e.g., naturalistic images of colourful and
spectacular sunsets or mountain landscapes). Such choices are often validated
in the eyes of the working classes when contrasted with the opaque and
'difficult' character of highbrow artistic forms (e.g., abstract and non-
figurative paintings or the various experiments in the avante-garde), and they
are compounded by the 'convoluted' and seemingly perverse approach to art

and culture normally exhibited by some fractions of the middle classes who are richest in cultural capital, but especially those intellectuals and aesthetes trained in the scholarly and the 'legitimate' treatments of the arts:

> The value of a photograph is measured by the interest of the information it conveys, and by the clarity by which it fulfils this informative function, in short its legibility, which itself varies with the legibility of its intention or function, the judgement it provokes being more or less favourable depending upon the expressive adequacy of the signifier to the signified. It therefore contains the expectation of the title or caption which, by declaring the signifying intention, makes it possible to judge whether the realisation signifies or realises it adequately. If formal explorations in the avante-garde theatre or non-figurative painting, or simply classical music, are disconcerting to working-class people, this is partly because they feel incapable of understanding what things must signify, insofar as they are signs.
>
> (Bourdieu 1984:43)

Lacking the cultural and educational capital to classify symbolic goods by any means other than a pragmatic and purely functional schema of classification, popular taste is firmly located within the relatively narrow confines of a habitus capable only of a uni-dimensional logic of perception. The cultural category of the popular thus becomes that category of classification defined chiefly by those goods whose symbolic form is intelligible by all social classes but is consumed only by those unable to appreciate the more 'cultivated' of symbolic forms. Popular taste and its functional logic is therefore set as the primary benchmark against which the remainder of all other taste formations, which have at their heart a systematic exclusion of popular forms and the denial of popular modes of consumption, may be fixed and confirmed.

Nowhere is the attempt to transcend the logic of popular taste and the struggles to monopolise symbolic capital more clearly demonstrated than in those class fractions of the petit bourgeoisie where economic capital is perhaps most evenly distributed. If evidence was ever needed that culture constitutes an important and relatively autonomous domain in which social and class relations are constituted, then one need only consider the very different modes of cultural classification and consumption exhibited by those class fractions whose access to economic capital is broadly the same. Whilst the occupations of shopkeeping, clerical work, positions of junior management, technical work, teaching and the various roles of the media professionals may well occupy the same socio-economic terrain, Bourdieu's analysis of the relative distribution of cultural capital within this terrain reveals it to be characterised by a variety of extremely diverse modes of cultural consumption. For those lacking significant amounts of cultural capital, such as shopkeepers or craftspeople, the habitus produces systems of cultural taxonomy that are inclined towards the function-centred logic of

working-class or popular taste. Photographic preferences, for example, tend towards the 'common sense' function of the photograph as a pragmatic document of social ceremonies, family occasions, and national or traditional events. Alternatively, for those middle-class groupings such as primary teachers, technicians, or those working directly in the occupations of cultural production (advertising, journalism, fashion design, cinema and publishing) who possess significant amounts of cultural capital photography is consumed very differently. Here photographic preference becomes the occasion for a display of cultural competence which is based in the first instance upon a formal appreciation of the field in question. This has the effect of inclining preferences towards more 'trivial' or abstract photographic contents (as seen in the typical choices of photographs of tree bark, rope, pebbles, cabbages, and an old woman's hands). What is significant about these choices is not the particular photographic content, but the formal composition of the photograph and the extra-textual knowledges which underpin and inform the aesthetic judgement of the photographs.

What produces these different consumption patterns within the middle-class strata is chiefly the time spent in, and qualifications gained from, education. But it is important to note that education in this respect is not simply a vehicle for the transference of discrete and isolated epistemic 'facts' (of 'simply knowing about something'). On the contrary, educational capital is valued for its capacity to code and contextualise social experience in a way that grants a sense of distinction to those who possess it. In short, educational capital produces a privileged linguistic form. But this highly attuned mode of language is not conditional for its effectiveness upon an association with the discrete educational subject disciplines from which it has emerged. As such, it may be turned outwards from the confines of its isolated disciplines and used as a means to describe a wide variety of everyday objects, forms and practices. For those with the greatest access to such an exclusive mode of cultural consumption, films, for example, may represent one arena where the opportunity exists to objectify cultural competences and to confirm that objectification in the eyes of the less educationally privileged:

This transposible disposition, armed with a set of perceptual and evaluative schemes that are available for general application, inclines its owner towards other cultural experiences and enables him to perceive, classify and memorise them differently. Where some only see 'a Western starring Burt Lancaster', others discover 'an early John Sturgess' or the 'latest Sam Peckinpah'. In identifying what is worthy of being seen *and the right way to see it*, they are aided by their whole social group . . . and by the whole corporation of critics mandated by the group to produce legitimate classifications and the discourse necessarily accompanying any artistic enjoyment worthy of the name.

(Bourdieu 1984:28, my emphasis)

This statement seems to indicate that cultural practices, and not the objects associated with specific practices, are the key determinants in the construction of cultural hierarchies. It is, therefore, the degree of exclusivity of the cultural codes that is brought to bear in the act of interpreting objects which ultimately grants individuals cultural distinction:

> When the message can only be deciphered by the possessors of a code which has to be acquired by way of a long, institutionally organised process of learning, reception depends upon the receiver's mastery of the code. In other terms, reception is directly related to the disparity between the level of the information offered and the level of the receiver's competence.
>
> (Bourdieu 1972:26)

In some ways this makes cultural goods little other than *symbolic utilities*, valuable not for their inherent properties, but as objective vehicles for the demonstration of the interpretive skills of particular consumers.

While there is much to recommend Bourdieu's approach here, it is important to note at this stage that this position does not benefit from the complete marginalisation of the issues of commodification and the aesthetic/symbolic contextualisation of goods by commercial agencies such as advertising and marketing. In many instances cultural goods have already been given a potential meaning and symbolic value prior to their introduction as the symbolic goods of lived culture. As indicated earlier, while advertising and marketing do not have the ability to achieve a total symbolic closure around the goods that they promote, the power of such agencies cannot be ignored: consumers may not passively absorb the meanings that are provided by advertising, as is suggested by Baudrillard, but neither are those meanings insignificant.

Bourdieu is far from unique in neglecting to address the powers of commercial organisations and their attempts to set an agenda over what meanings and cultural values should attach to everyday objects. In this respect *Distinction* is situated firmly within that anthropological and ethnographic critical tradition in which the structures and routines of everyday life, social relations, and their objectification in material culture, are often seen to fall beyond the influences of a broader political and ideological determination. If, as was indicated at the beginning of this chapter, Baudrillard has suggested that cultural action is subsumed under the totalising frame of the commodity, capitalism and systems of signification, then Bourdieu's approach suggests the opposite: there is almost a complete failure to consider the impact of the object of consumption in its guise as a commodity and inscribed with meanings and preferred use-values at a production level. While it is certainly true that commodities become the objects *of* consumption, and are used by people as symbolic co-ordinates for the mapping and construction of social relations, this should not lead us to assume that the powers of the

advertisers, designers, marketers, or point-of-sale strategists in general are negligible in the discursive framing of those co-ordinates. For Bourdieu, cultural action would seem to be undiminished by the fact that commodities have already been positioned into domestic life and lived culture as the bearers of particular ideologies and as representative of certain social relations.

This, then, opens up the way for a consideration of those various approaches to consumption that display a certain sensitivity to the *dual nature* of goods; that is, as the bearers of commercial ideologies, and as instruments for the use in a relatively autonomous form of cultural expression.

Chapter 3

Culture, consumption and commodities

CULTURE, IDEOLOGY AND HEGEMONY

Bourdieu's neglect of the commodity leads us to consider the relationship between commercial artefacts, their aesthetic and ideological contextualisation, and the roles and uses they may serve in everyday life and culture. This issue will be addressed from the perspective of cultural studies, particularly as it has developed as a critical tradition in Britain, initially through the research of Stuart Hall and others at the Centre for Contemporary Cultural Studies at Birmingham.

Cultural studies emerged as a distinctive interdisciplinary corpus of social research during the 1970s. For those engaged in its development at that time, cultural studies came to be seen in terms of a necessary epistemological reorientation of sociological research and theory needed to examine the fundamentally new character of post-war British society (see Clarke 1991). As Stuart Hall (1990) has recently commented:

> For me, cultural studies really begins with the debate about the nature of social and cultural change in postwar Britain. An attempt to address the manifest break-up of traditional culture, especially traditional class cultures, it set about registering the impact of new forms of affluence and consumer society on the very hierarchical and pyramidal structure of British society. Trying to come to terms with the fluidity and the undermining impact of the mass media and of an emerging mass society on this old European class society, it registered the cultural impact of the long-delayed entry of the United Kingdom into the modern world.
>
> (Hall 1990:12)

Moreover, as a discrete subject discipline the importance of cultural studies lay in the fact that its concerns were never solely those of the mere documentation of the changing social character of Britain during this period; rather its aim was to explore the possibilities of new critical paradigms that would be able to theorise such changes adequately. In this light the primary aim of cultural studies was the establishment of a critical perspective in

which the concept of culture could be seen as both the product of, and the response to, the social conditions of a period. Culture was therefore to be defined as 'that level at which social groups develop distinctive patterns of life, and give *expressive form* to their social and material life-experience' (Hall *et al.* 1976:10).

This definition was derived in no small part from the radical work of Raymond Williams who argued that the term culture came to describe 'a particular way of life, which expresses certain meanings and values not only in art and learning but also in institutions and ordinary behaviour' (1965:57). This made culture a group-characteristic response to, and the internalised effects of, a certain social locale; it was neither the product of an unambiguously rational or calculating behaviour by social groups in expressing their ways of life, nor was it merely the result of imposed or prescribed values, beliefs and systems of meaning that were passed down from particular societal interests. Culture was that dimension of social activity providing for what Williams called a 'structure of feeling': those often intangible but very real processes of social understanding and cognition which unified a community sharing the same life experiences. The concept of structure of feeling therefore represented a mechanism that cemented, made recognisable and allowed a reflection upon a group's cultural identity and its collective consciousness. Williams continues:

> We find here a particular sense of life, a particular community of experience hardly needing expression, through which the characteristics of our way of life that an external analyst could describe are in some way passed, giving them a particular and characteristic colour. We are usually most aware of this when we notice the contrasts between generations, who never quite talk 'the same language', or when we read an account of our lives by someone outside the community, or watch the small differences in style, of speech or behaviour, of someone who has learned our ways yet was not bred in them.
>
> (Williams 1965:57)

Such a conception of culture clearly underwrites that outlined by Stuart Hall in his general description of the cultural studies project. For Hall culture is 'not *a* practice; nor is it simply the descriptive sum of the "mores and folkways" of societies . . . It is threaded through *all* social practices, and is the sum of their interrelationship' (Hall 1980:22). From this stance, the task that cultural studies was to pursue involved a tracing of the relationships between certain historical social conditions, the formation of particular social collectivities arising from within those conditions, and the meaningful articulation of the experiences of those collectivities in response to such conditions. Cultural studies therefore:

stands opposed to the residual and merely reflective role assigned to the

'cultural'. In its different ways it conceptualises culture as inter-woven with all social practices; and those practices, in turn as a common form of human activity; sensuous human praxis, the activity through which men and women make history. It is opposed to the base superstructure way of formulating the relationship between ideal and material forces, especially, where the base is defined by the determination by the 'economic' in any simple sense. It prefers the wider formulation – the dialectic between social being and social consciousness ... It defines culture as both the means and values which arise amongst distinctive social groups and classes, on the basis of their given historical conditions and relationships, through which they 'handle' and respond to the conditions of existence: *and* as the lived traditions and practices through which those 'understand-ings' are expressed and in which they are embodied.

(Hall 1980:63)

There is a striking similarity here between the definitions of culture that are offered by both Hall and Williams, and Bourdieu's concept of habitus: both conceptual terms share the same sense of the creative and trans-formative possibilities embodied in cultural expression. However, neither lapses into the sort of quasi-romantic idealism in which culture is treated as merely the symbolic expression of some sort of 'honest solidarity' between members of an organic community who appear as abstracted from any wider network of social structures and relations. In fact the cultural-studies project was initially politically situated within the critical tradition of western Marxism, and as such tended to see the overarching social force that shaped all of contemporary culture as the fundamental class relation embodied in the capital–labour contradiction. Culture was that group experience and articu-lation of the social world that was inscribed within the social relations of production and not an autonomous domain exclusive of them. Consequently, whilst not directly reflective of economic relations, cultural relations were none the less clearly aligned to them and manifested themselves as 'relations of domination and subordination, along the scale of "cultural power" (Hall *et al.* 1976:11).

For this reason, the sphere of popular culture was soon recognised to be the central focus of analysis. For within the domain of the popular there was embodied that key ideological terrain upon which the inherent antagonisms existing between capitalism's two primary classes were 'worked-through' and, in most cases, resolved. Given this broad position, cultural studies initially saw its role within Marxist cultural theory as twofold. First, it aimed to re-examine many of the gloomy prognostications of pessimistic theories of mass society in which the various manifestations of contemporary popular (commercialised) culture were held up as irrefutable evidence of the total pacification of 'the masses' by the cultural industries. Second, cultural studies represented something of a bold, critical challenge to the then highly

fashionable discipline of structuralism, which, in its 'purest' form at least, had tended to reduce the notion of social action to the functional product of unconscious rules and social structures. As the previous discussion on Bourdieu's work has already noted, the development of the concepts of habitus and cultural and symbolic capital was strongly motivated by the need to construct a model of culture in which social action came to represent more than the functional response to predetermined social structures. In a similar vein, a central theme which initially informs cultural studies was the attempt to reframe the difficult issue of ideology, particularly as the concept had been developed by Althusser (1971) and Poulantzas (1975). From this perspective, much of the literature that emerges from the cultural-studies research of the late 1970s and early 1980s can be seen as the attempt to problematise the notion of a 'dominant ideology'. This was seen to be thoroughly interwoven within social practices and discourse, and appeared to be functionally transmitted via the various state apparatuses of the family, the education system, the church, the communication industries and, by extension, advertising and other forms of commodity promotion.

In 'Ideology and the State', Althusser argues vigorously for a radical reinterpretation of the concept of ideology. Indeed it is surely one of the central contributions of Althusser's work to the corpus of Marxist theory that he manages to realign the issue of social reproduction through ideology away from the rather deterministic and uni-dimensional 'base–superstructure' metaphor of class relations and their ideological forms. This was a model which, when taken to its extreme, 'vulgar' Marxist interpretation, had tended to regard ideology as little other than the production of illusions and which generated in subjects a false consciousness. For Althusser, what is embodied in ideology is a system of representations about the real relations under which people live. But this system of representations 'is not the system of the real relations which govern the existence of individuals, but the imaginary relation of those individuals to the real relations in which they live' (Althusser 1971:155). In short, the system of ideology describes the real social relations of existence in a way which conceals from subjects certain important truths and knowledges about those relations. Far from being simply a calculating conspiracy of false ideas manipulated by a dominant class, Althusser's formulation of ideology posits the concept, as Belsey succinctly puts it, as functioning by obscuring:

> the real conditions of existence by presenting partial truths. It is a set of omissions, gaps rather than lies, smoothing over contradictions, appearing to provide answers to questions which in reality it evades, and masquerading as coherence in the interests of the social relations generated by and necessary to the reproduction of the existing mode of production.
>
> (Belsey 1980:57–8)

Such a definition moves the concept of ideology away from the sense that it

functions as a conscious and deliberate process of manipulation towards the idea that its operation is 'profoundly unconscious':

> Ideology is indeed a system of representations, but in the majority of cases these representations have nothing to do with 'consciousness': they are usually images and occasionally concepts, but it is above all as *structures* that they impose on the vast majority of men, not via their 'consciousness'. They are perceived-accepted-suffered cultural objects and they act functionally on men via a process that escapes them.
>
> (Althusser 1971:155)

Ideology seen from this perspective represented certain socialised systems of thinking about and perceiving the social reality which whilst never merely pure inventions of a dominant class were none the less always seen to favour their interests.

In her highly influential book *Decoding Advertisements* (1978), Judith Williamson draws directly upon Althusser's conceptualisation of ideology to explain the manner in which advertising becomes a key ideological ground upon which subjectivity is reproduced. She argues that ideology in advertising should not be seen as mere propaganda for commodities; that is, the injection into passive subjects of false beliefs and erroneous ideas about the social reality. Ideology is, she suggests:

> always precisely that of which we are not aware. It is only ideology in as far as we do not perceive it as such. And how does it become 'invisible', what keeps it hidden from us? – the fact that we are *active* in it, that we do not *receive* it from above. It works *through* us, not at us. We are not deceived by someone else 'putting over' false ideas: ideology works far more subtly than that. It is based on false *assumptions* . . . In ideology, assumptions are made about us which we do not question, because we see them as 'already' true: time itself has been appropriated as part of ideology in so far as it involves giving superior status, always, to anteriority . . . Ads create an 'alreadyness' of 'facts' about ourselves as individuals: that we are consumers, that we have certain values, that we will freely buy things, and so on. We are trapped in the illusion of choice.
>
> (Williamson 1978:41–2)

Such a formulation had quite properly diverted the focus of cultural analysis away from the manifest contents of popular cultural forms and towards the manner in which such contents were framed and contextualised discursively to signify particular meanings that were held to be commensurate with the interests of dominant social groups. But the legitimate recognition by Marxist structuralism that the reproduction of ideology necessarily entailed the active reproduction of systems of social meaning had also tended to foreclose prematurely a number of important questions concerning the actual realisation of this process in everyday, lived situations. Althusser's

work in particular describes for us the *ideal* scenario for ideological repro-
duction; it is the 'blueprint' of dominant ideology which is, at once, held to
be co-terminous with the concrete expressions of social discourse as they
occur in lived culture. Importantly, there is no sense here that the repro-
duction of certain dominant meanings is ever achieved in anything other than
a purely functional manner. As Stuart Hall comments, Althusser's theory of
ideology presents us with a process of social control which is 'too uni-
accentual, too functionally adapted to the reproduction of the dominant
ideology . . . it was difficult, from the base-line of this theory, to discern how
anything but the dominant ideology could ever be reproduced in discourse'
(Hall 1982:78). Similarly, as Paul Willis argues, 'structuralist theories of
[social] reproduction present the dominant ideology as . . . impenetrable.
Everything fits too neatly. There are no cracks in the billiard-ball smoothness
of process' (Willis 1978:175).

It was, then, from such a position that cultural studies began to explore
ways of reconceptualising the problematic of the relationship between
culture, ideology and social reproduction. It was from this perspective that
the work of Vološinov and Gramsci in particular, while remaining firmly
within the Marxist paradigm of social analysis, seemed to offer important
ideas which appeared to be sensitive to the vexed and problematic question of
the relationship between social class and everyday culture.

In *Marxism and the Philosophy of Language* (1973), Vološinov identifies
the sign as the prime arena of class struggle. Vološinov's views in this
respect may be summarised as the efforts of a dominant or 'superclass' to
establish and stabilise the meaning of signs within social discourse according
to its own interests. The nature of this struggle is, therefore, one that centres
around the attempt to produce a language system within which individual
signs are framed so as to appear completely homologous to both the social
reality and to the dominant societal interests of a particular time. This makes
the struggle to map the character of language overtly political; it is regulated
by the quest to give signs the appearance of a certain universality, a
seemingly immutable bonding to their referents and in which the signification
of those referents – of reality – is seen to embody an almost 'transcendental'
equivalence, or a 'true and eternal' value of reality, rather than merely an
arbitrary and conventionalised representation of it. In essence, it is the
struggle to establish a mode of signification which all social groupings come
to accept as natural, a mode of signification in which reality is (re)presented
from the social perspective of the superclass whilst that perspective is
simultaneously naturalised.

However, where Vološinov's ideas broke with the more orthodox struc-
turalist model of the ideological function of language was with the recogni-
tion that social reproduction in language could never be assumed to be
routinely accomplished. For in every instance, insists Vološinov, signs
remain *multi-accentual*; that is, capable of provoking multiple meanings and

significations according to their users and to the variety of unique social contexts into which they are inserted. This fact makes the struggle to stabilise social meaning around a series of dominant definitions of reality a *real* struggle: it is one that is made problematic through its concrete realisation in culture. From this perspective we can see that the superclass is engaged in a ceaseless battle to control the multi-accentual nature of the sign and the *polysemic* properties of signifying chains. The superclass is forever attempting to foreclose the potentialities of the sign to invoke numerous meanings, to make the sign uni-accentual and restrict it to one fixed equivalence of reality. Obversely, the superclass attempts to delimit the possibilities of signs being used subversively as a means of marking out radical cultural difference and as a method of destabilising the existing social order. For example, the sign 'woman' has commonly been used as a means of upholding a certain male-centred social authority deemed necessary to legitimise the division of social labour in capitalism by gender: woman = second or fairer sex; woman = domestic labourer (e.g., 'woman's work'); woman = practical incompetence (e.g., 'women drivers'). However, through definite acts of political struggle, feminism has, to some extent, been able to reclaim the sign 'woman' as a more positive and anti-patriarchal meaning that, in many instances, has proved disruptive of the prevailing social order, for example 'women are angry'. In certain uses, and at certain moments, this struggle over the ownership of the sign can clearly be seen in process; that is, as belonging exclusively to neither interest, but caught in the flux of meaning which exists between both poles of linguistic determination. This can be seen, for example, in the phrase 'the career woman', a phrase which sits somewhat uneasily as a meaning between both interests: as neither wholly representative of patriarchal interests, although accommodating some aspects of them, nor directly reflective of a feminist ideology, although by no means absolutely antithetical to it.

Vološinov's central argument – the inherent multi-accentuality of the sign – is clearly important, for it nominates the category of the cultural as precisely that arena where ideology and language operate, and, as such, the site where the exact, historically contingent, configuration of social relations are 'worked-through' or 'handled'. It is for this reason that Vološinov has argued for the study of language and its ideological effects to be carried out, not merely in the analysis of the nature of the systems of signification that formally structure linguistic content (*langue*), but within the social contexts within which it functions (*parole*). As Henriques and Sinha (1977) have argued: the study of ideology can only be approached successfully when analysis considers 'the living socially embedded utterance in context' (Henriques and Sinha 1977:95). This implies that the attention of the analyst of ideology is required to turn away from the formal analysis of certain ideological texts in their isolation – such as popular films, television programmes, political discourses and, of course, consumer goods – and

towards the analysis of the actual moments of reading and the uses given to these forms as they become situated within the lived routines and patterns of everyday life.

Having gone this far to free language from the conceptual strait-jacket of structuralist analysis, we must avoid what is surely the obvious temptation to view the multi-accentual nature of the sign in terms which define its uses and function as pluralistic and socially unregulated. We must resist the perspective which sees in language only a sort of malleable, or even fluid, linguistic utility, available equally to all social groups for the representation of their own discrete versions of social experience. As Bourdieu, amongst others (see Bernstein 1977), has forcefully demonstrated, the distribution of cultural, symbolic and linguistic competences, and access to certain cultural codes and signifying systems, is far from evenly allocated in society but weighted heavily in favour of the dominant social classes and groups.

If Vološinov's ideas provided the means for a vital departure from structuralist theories of social reproduction, then it was surely the rediscovery of the work and ideas of Gramsci, the leader of the Italian communist party of the 1930s, that gave the cultural-studies project a powerful impetus to consider contemporary cultural formations from within the frame of social domination and resistance.

For Gramsci the important question of how a bourgeois ideology functions to reproduce the prevailing social order within the capitalist state should be conceptualised in terms of a struggle to maintain *hegemony*. Hegemony in this sense is understood as the quest to establish a 'moral, cultural, intellectual and, thereby, political leadership over the whole of society' (Bennett, in Bennett, Mercer and Woollacott 1986:xiv). Hence:

> A social group can, and indeed must, already exercise 'leadership' before winning governmental power (this is indeed one of the principal conditions for the winning of such power); it subsequently becomes dominant when it exercises power, but even if it holds it firmly in its grasp, it must continue to lead as well.
>
> (Gramsci 1971:57–8)

The hegemonic process typically involves the coming together of various social groupings into a 'hegemonic bloc', an alliance of interest groups working together for the overall benefit of each group in order to achieve an intellectual authority over the majority of subordinate groupings. In this sense hegemony is here conceived, not in terms of the mere passage of dominant values and beliefs from some homogenous dominant class to a homogenous subordinate class, nor is culture considered to be, in any a priori sense, the immanent product of ideological systems that have articulated and positioned subjects beyond their direct control; rather, hegemony is seen as a social process which, whilst never fully assured of its efficacy, attempts to define and negotiate a certain 'legitimate ideological terrain' encapsulating

and accommodating the perceived interests of subordinate groupings whilst simultaneously upholding the interests of dominant groupings. As such, the social power embodied in the hegemonic process is typically achieved through the act of mobilising a political and cultural consensus, which, whilst never fully stable, none the less attains a substantial measure of consensual equilibrium between the majority of social groups. As Alan O'Shea (1989) has pointed out:

> In Gramsci a 'hegemonic bloc' is a different order of concept from 'the ruling class'; it can include an alliance of quite diverse social strata (including sections of the working class) and constitutes an 'unstable equilibrium' – a temporary and fragile stabilisation of contending forces, and demands involving compromise at economic, political and cultural levels of the social formation. Thus a society is not seen as held in the grip of a 'dominant ideology' reflecting 'the dominant interests', whether capitalist or patriarchal, but as the site of the constantly changing balance of forces. In the sphere of ideology too we have a 'field' of discourses each struggling to become the 'obvious', 'common-sense' way of thinking and acting.
>
> (O'Shea 1989:376)

It is a sense of the striking of a resonant chord within the popular consciousness, of winning the hearts and minds of ordinary people, which makes culture articulated through the hegemonic process far more than the mere passive 'living-out' of a series of prescribed dominant ideologies. This point is important, for it suggests that consent and consensus must be actively fought for, legitimised and constantly reproduced by the dominant social groups. But this fact implies that consent and consensus may also be questioned, challenged or lost. Such a recognition builds into cultural-studies methodology the notion of cultural resistance and opposition to dominant ideas and ways of thinking about and describing the social reality. It allows for the very real possibility of genuine diversity and radical difference in cultural practices, at least in those instances where groups may feel themselves marginalised and neglected in the way in which they are addressed ideologically or feel their interests to be inadequately represented. The following section considers some of the ways in which the theoretical issues that have been outlined above may be used to think productively around the questions concerning the relationship between consumption, culture and capital.

CONSUMPTION: THE REDISCOVERY OF PLEASURE IN CULTURAL STUDIES

Cultural studies posits cultural forms as the critical sites of struggle upon which various social groups attempt to define the boundaries of social meaning. When applied to the topic of consumption, this observation

suggests that consumer goods lead a double life: as both agents of social control and as the objects used by ordinary people in constructing their own culture. Ideologically and aesthetically contextualised by advertising, design, marketing and other promotional forms, commodities are to be considered as 'texts' inviting certain preferred forms of reading and decoding which aim to reproduce dominant social relations. But in their role as cultural artefacts, consumer goods become important material and symbolic resources with which ordinary people reproduce their life and their patterns of life. The recognition of the dual nature of consumer goods undoubtedly complicates any theory in which consumption is treated from only one of these per-spectives. For if consumption is simultaneously the touchstone of the political economy, underwritten by a commercial logic which places the realisation of surplus-value at its core, as well as the site upon which popular pleasures are produced, often as a result of the unforeseen uses and meanings given to goods by consumers in their everyday domestic life, then it is clear that we need to construct a theoretical model of consumption which is sensitive to both its economic and cultural dimensions.

In theory, the advantage of employing a cultural-studies methodology to the analysis of consumption is considerable. In recognising that cultural relations are inseparable from the social relations of production, but at the same time granting culture a certain degree of autonomy from those relations, such a methodology avoids the idea that the concepts of the market and culture are ultimately one and the same category. In essence, the culture of consumption is never simply a mere symbolic echo or the purely functional realisation of product positioning by advertising and marketing strategies. Similarly, the market is never a simple reflection of consumer tastes and needs, or for that matter an institution which slavishly follows autonomous or sovereign cultural practices. This suggests that consumers have clear limits placed upon the range of meanings and uses which they may assign to commodities by the fact that those commodities are already adapted, both functionally and symbolically, by advertising and their design to meet the imagined needs of an ideal market. Likewise, the design and symbolic contextualisation of commodities by producers and advertisers are structured by the lived meanings and uses of commodities as they have passed over into the status of cultural objects in everyday life.

Given the central space occupied by consumption in contemporary life, it is indeed surprising that the rich potential of the sort of methodology provided by cultural studies has not, at least to date, been applied to the topic of consumption in any systematic or sustained manner. For anyone wishing to understand better the complex and reciprocal relationship between every-day cultures and consumer goods this point is made all the more frustrating by the fact that those few studies which have addressed this relationship have provided us with fascinating and important insights into the cultural dimen-sions of contemporary consumption. Alison James's (1979) study of sweets

and children's culture, for example, or Dick Hebdige's *tour de force* essays 'The object as image: the Italian scooter cycle' (in Hebdige 1988) and 'The impossible object: towards a sociology of the sublime' (1987), as well as Elizabeth Wilson's (1985) studies in fashion and culture, each present us with powerful evidences revealing the complex forces at play in the processes by which people use, communicate and construct their collective identities with mass-produced and mass-mediated commodities. Amongst other things, these studies demonstrate that commodities can be symbolically recontextualised and materially adapted to provide important and sometimes liberating spaces for self-expression and cultural resistance to dominant or established definitions of the social reality – a phenomenon perhaps most forcefully demonstrated in the Punk culture of the late 1970s, the Acid House culture of the late 1980s, or in youth culture in general (see Hebdige 1979).

Perhaps the most closely argued attempt to theorise consumption from this sort of perspective comes from the French social anthropologist Michel de Certeau. In *The Practice of Everyday Life* (1984) de Certeau stresses the creative and empowering possibilities of everyday cultural action. In the act of reading, for example, de Certeau sees, not the mere reproduction of social meanings, already mapped out by a bureaucratic and technological system which has been able to foreclose the possibilities of texts being used subversively to produce radical social meanings, but an act of 'enunciation': a positive and energising social process which readers may use to hew from the materials and structures which confront them and in which they are forced to live, a certain 'tactical space' of cultural resistance. Hence the analogy de Certeau chooses to use in describing everyday cultural action is that of the 'guerilla war' in which culture becomes the field of combat upon which ordinary people, through their familiar daily routines, confront the substantial edifice and powers of the economic and political system. The dichotomy existing here between production and consumption is characterised by de Certeau in the following terms:

> In reality a rationalised, expansionist, centralised, spectacular and clamorous production is confronted by an entirely different kind of production, called 'consumption' and characterised by its ruses, its fragmentation (the result of circumstances), its poaching, its clandestine nature, its tireless but quiet activity, in short by its quasi-invisibility, since it shows itself not in its own products, but in an art of using those imposed on it.
>
> (de Certeau 1984:31)

De Certeau's remarks stress the dynamic and culturally enabling nature of consumption. For consumption is never a passive or unmediated social process of assimilating that which is offered for consumption by producers, but is always a process through which social meanings are constructed and contested. This fact invites us to foreground the critical areas of textual polysemy, the multi-accentual character of the sign in social discourse, and

the ever-shifting historical conditions and forces which underwrite the exact formation of social relations at any given moment.

Much of the research stemming from a cultural-studies methodology throughout the 1980s has tended to concentrate upon the above issues in relation to the reception (consumption) of television texts, as well as examining the role that television plays as a cultural form within domestic life (see Morley 1980). Specifically, many of these studies have sought to explore the relationship between the discursive framing of television contents by programme makers and the subsequent 'management' of those contents by the various, socially situated audience groupings. Here audience members are said to offer 'negotiated readings' of media texts according to their precise position within the social structure. As David Morley puts it in *The Nationwide Audience*:

> The audience must be conceived of as composed of clusters of socially situated individual readers, whose individual readings will be framed by shared cultural formations and practices pre-existent to the individual: shared 'orientations' which will in turn be determined by factors derived from the objective position of the individual in the class structure. These objective factors must be seen as setting parameters to individual experience, although not 'determining' consciousness in any mechanistic way; people understand their situation and react to it through the level of subcultures and meaning systems.
>
> (Morley 1980:15)

But in addressing both the questions of how television texts are framed discursively and the cultural contexts and competences which underpin any given act of viewing, recent cultural-studies work has moved significantly towards the development of an ethnography of reading. From this perspective the importance of television is seen to be as much about its function in giving meaning and structure to domestic relationships and familial situations as it is about specific instances of textual decoding (see Hobson 1982; Ang 1985; Radaway 1984).

Such work has greatly illuminated our understanding of the processes of television consumption and usage, and it may indeed provide us with important information and knowledge about the cultural dimensions of consumption in general. But there is an inherent danger in an approach which stresses the relative autonomy of the audience from the text and, in some cases, the audience's empowerment in constructing negotiated and oppositional readings from texts. In this respect, Meaghan Morris warns us against any unfounded celebration of what she has termed 'the ideal knowing subject of cultural studies' (Morris 1988:20); that is, a fully calculating subject who is freely able to produce meanings and pleasures from what are effectively little other than 'raw materials' of cultural expression provided by television and other mass-mediated cultural forms. This warning comes as a response to

what are in themselves the quite valid findings of many recent studies emphasising the complexity of media consumption. While such studies are rightly resistant to reducing the act of reading or viewing to the mere functional product of the text, it may be tempting from this perspective to marginalise any effects which may result from the meanings and ideologies already inscribed within the text prior to its consumption. This is a position that has been most vocally articulated in much of the recent work of John Fiske. As Fiske does not simply restrict his analyses to the consumption of television and other media forms, but extends them to include studies of consumer goods and consumption in general, it well worth considering his position in some depth.

At the core of much of Fiske's recent work on consumption lies the attempt to rescue the concept of popular pleasure from the wholly negative definitions it is often accorded in critical cultural theory. Whether denigrated as the manifestation of a false consciousness, as in some of the writings of the Frankfurt School, or, in its most closely argued formulation, seen as the socio-psychological mechanism by which dominant ideologies are materialised in subjectivity (see in particular Barthes 1975; Mulvey 1975), the concept of popular pleasure has occupied a central space in modern Marxist theories of social and cultural reproduction. Laura Mulvey, for example, regards the popular pleasures of looking which are invited by the standard Hollywood film as a key cinematic device for the reproduction of established gender relations. Arguing that the moment at which viewers experience textual pleasure is simultaneously the moment at which the ideologies of patriarchy become effective, Mulvey calls for the 'destruction of pleasure as a radical weapon' of feminist film-making.

Fiske, however, approaches the issue of popular pleasure from a somewhat different perspective, not only suggesting that the experience of pleasure taken from mass-mediated cultural forms cannot be reduced merely to the materialisation of a dominant ideology, but that pleasure actually constitutes the occasion for subversive reworkings of and resistances to dominant ideology. In the field of television, for example, Fiske illustrates this assertion by pointing to the inability of the television text to secure automatically an ideological closure around its preferred meanings, its constant failures to make its messages uni-accentual, and the fact that television often unintentionally provokes a plurality of meanings and pleasures by the fact that it is forced to address a broad range of audience constituencies who are widely dispersed across the social and cultural space. Contrary to the common Marxist wisdom that in watching popular television programmes, audiences are also engaged beyond their consciousness in reproducing dominant ideologies and hence 'working hard' for consumer capitalism in the cultural sphere, Fiske puts forward the notion that television represents the site of a 'semiotic democracy' (Fiske 1987:239). By this, Fiske means 'the delegation of the production of meanings and pleasures to its viewers'. The

semiotic democracy of television is, he continues, the 'opening up of the discursive practice to the viewer . . . the work of the institutional producers of its programmes requires the producerly work of its viewers and has only limited control over that work'. Against the view that television is a ruthlessly efficient ideological apparatus, Fiske redefines its status to that of a mere 'menu' of semiotic contents. Viewers therefore produce 'their own meanings and pleasures from what is available'.

This position then allows Fiske (1989a, 1989b) to recast the cultural status of consumer goods and consumption generally as liberating and empowering cultural resources. Drawing upon numerous examples of the cultural subversion of consumer commodities and consumption – the tearing of jeans, shoplifting, and the 'misuse' of shopping malls by teenagers, Fiske is able to cite these as evidence of capitalism's failures to produce and impose a popular culture which is coherent with the ideology lying behind the production of its commodities and the ideal forms that consumption should take:

> A homogeneous, externally produced culture cannot be sold ready-made: culture simply does not work like that. Nor do the people behave or live like the masses, an aggregation of alienated, one-dimensional persons whose only consciousness is false, whose only relationship to the system that enslaves them is one of unwitting (if not willing) dupes. Popular culture is made by the people, not by the culture industry. All the cultural industries can do is to produce a repertoire of texts or cultural resources for the various formations of the people to use or reject in the ongoing process of producing their popular culture.
>
> (Fiske 1989a:23–4)

With such a bold declaration, popular culture is transformed into a marvellously subversive space in which its forms and artefacts are seen, not as the reason for a melancholic denigration as objects of ontological alienation and exploitation, but precisely the reverse: a cause for celebration. So although produced by consumer capitalism for the appropriation of surplus-value and as agents of social control, commodities, once they are transformed into the objects of popular culture, become pure symbolic utilities as well as material resources effectively unmediated by the market. These, consumers may use, modify and customise in order to satisfy their diverse subcultural needs, which, because of the inherent complexities involved in their formation, can never be addressed adequately or rendered accurately by the advertisers, market researchers or media professionals.

It may be extremely tempting to regard mass consumption chiefly as a liberating and subversive cultural practice, and indeed aspects of the position outlined by Fiske surely form a welcome and refreshing corrective to the sort of totalising and wholly negative definitions of the term that have been offered by such figures as Marcuse and Baudrillard. But I believe that Fiske's

approach, which seems to be galvanised by quasi-romantic notions of 'the people', and which suggests that there is a distinction to be made between an authentic popular or people's culture and a purely manipulative commercial or corporate culture, is to miss the point about what is actually at stake in the many forms of cultural practice that are objectified in mass-produced consumer goods. In my view, there are two extremely tenuous and unsustainable assumptions that are made here. First, although Fiske is correct to suggest that meaning and pleasure are not the inherent properties of a text which are to be functionally materialised in the act of reading, but are indeed the product of the reader's active engagement with the text, this should not lead us to assume that, as Ien Ang (1990:247) correctly warns, we may 'cheerfully equate "active" with "powerful"'. Fiske's assertion that the production of meaning and pleasure is delegated to the viewer/reader/consumer should not imply that consumers approach the mass-mediated text, be it a consumer object, an advertisement, a soap opera or a pop video, ideologically detached from it or with a complete autonomy from the narrative and aesthetic devices inscribed within that text. This would be to lapse into that position which mistakes the multi-accentual character of the sign for a pure, malleable utility, freely open to any user for the articulation of oppositional meanings or as a means of facilitating subversive and scandalous pleasures. In the field of consumption, consumer goods should not be seen as the mere objects of a semiotic democracy, but rather as the objects through which social struggles are conducted and social relationships between groups articulated in everyday life. Whilst it is important therefore to counter the view that the concepts of the market and culture are co-terminous, it is equally important not to present these concepts as mutually autonomous or isolated spheres of influence.

The second problematic feature of Fiske's position on culture and consumption concerns the tendency to overemphasise the role that consumer goods play as materials for undermining dominant definitions of the social reality. To overstress this aspect of cultural consumption is to reduce the realm of everyday social experience merely to the social experience of subordination, and it is to present the logic which underwrites cultural practice as little other than a logic of cultural resistance. This runs counter to the initial conceptualisation of culture that was outlined earlier where perceptive writers such as Hall and Williams, for example, had refused to condense the totality of modern social relations into the bipolar oppositional categories of capital and labour, base and superstructure, production and consumption, or dominant and subordinate classes. This means that in the cultural sphere the capital–labour contradiction becomes, not the determining condition of cultural practice, but the *overarching* condition under which a plurality of cultural relations, which most notably also include relations which are articulated by gender and ethnicity, are configured and accommodated. This recognition provides the theoretical space necessary

when considering the highly complex network of modern cultural relations which can not be accounted for simply in terms of a straightforward ratio of domination and subordination. The use of Gramsci's concept of hegemony, for example, becomes a means of moving beyond the highly problematic notion of a unified dominant class who speak a single ideological language. Hegemony stresses the relative incommensurability of many social practices and discourses across the entire social field and it highlights the often tenuous nature of power in modern capitalist society, power which is often founded upon shifting and unstable social alliances and which is always contingent upon the exact historical conditions where that power is to be found. Consequently, any theory of popular culture which attempts to shoehorn all cultural practice into a simple distinction between 'the dominant' and 'the subordinate' will be forced inevitably to neglect the uneven distribution of cultural competences, power and capital as these are dispersed amongst 'the subordinate' classes themselves. As Celeste Michelle Condit has suggested: Fiske's 'totalised concept of resistance from a system is at odds with a theory that posits a wide range of groups with a wide range of investments in the system they share' (Condit 1989:118).

The thumb-nail sketches of the various ideas and theories that have been described thus far do not in themselves provide us with the 'answer' to the question of why the relationships between capital, consumption and culture assume distinctive appearances at particular historical moments. Rather, these ideas will hopefully provide us with important points of reference – theoretical utilities – in a study of the major social transformations of capital during the twentieth century. This is undertaken in Part II.

The social transformations of capital

Chapter 4

Accumulation, regulation and growth

As we have seen, the procurement of surplus-value, the striving for profits, represents a fundamental feature of capitalism. However, it would be wrong to assume that the profit motive alone constitutes the essence of capitalism. The pursuit of profit has, as Max Weber once remarked, existed 'amongst all sort and conditions of men, in all ages and in all countries of the world'. For Weber what distinguishes the pursuit of profit in capitalism from profit-making activities in non-capitalistic economic systems is that capitalism seeks 'the pursuit of profit by means of continuing rational capitalistic enterprise: that is ... the constant *renewal* of profit, or "profitability"' (Weber 1978:333). However, Weber's remarks here seem to imply that the goal of capitalist enterprise is only to seek a perpetual reproduction of a given rate of profit. This suggests that once attained across a particular economy these stable profits would ensure a certain measure of economic, and presumably social, homoeostasis. But the clear historical evidence of regular economic crises in capitalist societies, often following on from periods of relatively stable profitability, should alert us to the fact that the mere reproduction of profit is in itself not the end goal of capitalism. The essential logic of capitalism manifests itself as a compulsion for the *constant accumulation of capital* and, even more accurately perhaps, as an insatiable appetite for *accelerating* the rate at which this accumulation occurs. This demands that profits are not only reproduced through the repeated circulation of capital, but also expanded regularly. The full implications which follow from this are legion, their consequences restricted not only to the economic sphere, but often impinging dramatically upon all areas of human activity. In this chapter I discuss the logic of accumulation and its social consequences. This discussion will provide a conceptual basis for a more concrete examination of twentieth-century capitalism which will be undertaken in the following chapters.

CAPITAL: VALUE IN MOTION

Towards the end of volume III of *Capital* Marx stresses the social character of capital: 'capital is not a thing, but rather a definite social production

relation, belonging to a definite historical formation of society, which is manifested in a thing and lends this thing a specific social character' (Marx 1956:814). Consequently capital for Marx assumes a very precise definition. Hence whilst money and commodities may represent the primary manifestations of capital neither money nor commodities are intrinsically constituted as capital, for only within a very definite relationship do they take this form. In Marx's schema, capital is defined simply as the material process under which *value valorises itself* (Marx 1976:252, 1060). Capital is therefore the objective form taken by *self-expanding* or *self-creating value*.

In order to explain how capital can be conceptualised as self-expanding value Marx first distinguishes between two fundamental transactions involving exchanges between money (M) and commodities (C). In the transaction C–M–C, commodities of one type are exchanged for commodities of another. Here money simply functions to facilitate an act of exchange between two qualitatively different use-values. Accordingly, neither money nor commodities are in this instance representative of capital. However, in the inverted transaction M–C–M, money is now exchanged via the medium of the commodity for money. The only logical rationale for such a transaction is to secure a quantitative increase in the initial money outlay; that is, to secure an increase in value. It is therefore under this circumstance alone that both money and commodities come to function as capital.

The basic transaction M–C–M can be elaborated to show how value that is objectified as capital is set in motion as *industrial capital* in order to produce more value. In its essential manifestation, industrial capital in circulation assumes three distinct and objective forms: *money capital*, *commodity capital* and *productive capital*. An initial sum of money capital (M) is advanced to purchase two basic forms of commodity. These commodities are *labour-power* (LP) and *means of production* (MP) (i.e., raw materials, machinery and other inputs). Labour-power and means of production combine to form productive capital (P) which represents production in process. This produces a new commodity (C') which is of a greater value than commodities C initially employed to produce it. However, in order that the value contained in commodity C' may be realised it must first be returned back to the money-form through a market exchange. The money M' which is realised through this market exchange is therefore of a greater value than the initial money M advanced. Since C–C' and M–M' represent quantitative expansions in commodity values and money values respectively, we can say that there has been a net expansion of value during the various processes of exchange and production. The final value M' therefore includes a proportion of *surplus-value*, which is typically realised as *profit* for the capitalist, and that has been added at some stage during the circulation process. This means that capital can be defined essentially as *value that has been set in motion solely for the purposes of creating greater value*. The whole process of the

circulation of industrial capital can be summarised by the general formula for capital:

$$M \longrightarrow C \Big\langle \begin{matrix} \{LP \\ \\ \{MP \end{matrix} \quad \ldots P \ldots C' \longrightarrow M' \, (M + \Delta M), M \longrightarrow C, \text{etc.}$$

GROWTH: THE RATE OF CAPITAL EXPANSION

The necessary acceleration of the rate at which capital is accumulated is simply the product of *free-market competition* between independent producers. As we have seen, the accumulation of capital derives from the capitalist's ability to procure surplus-values from the application of living labour in production. The magnitude of surplus-value procured is assessed as that labour-time and its product that is contained within the working day which exists in excess of the socially necessary labour-time of that same working day. The value benchmark against which all labour-time is itself assessed is abstract labour: the average labour taken in any society to produce a given quantity of use-values. This means that, in order to remain competitive in a free-market situation, individual producers are compelled to procure surpluses and accumulate capital at a rate which is at least equal to that of the social average rate of accumulation. The fear of falling behind the average rate of accumulation and the quest to remain competitive therefore forces producers to explore ways in which production may be made more efficient. The goal of efficiency in production is therefore simply to obtain a greater surplus-value from commodity production relative to a standard investment of money capital into circulation. Since living labour is the only productive source capable of creating surpluses, it follows that any new productive technique that is employed by a given producer to increase the rate of accumulation and stay ahead of the social average rate of accumulation can only ever result in a greater level of exploitation of living labour.

The procurement of greater surpluses from production assumes two principle forms: the extraction of *absolute* and of *relative* surplus-value (Marx 1976:643ff.; Marx 1973b:407–10). The procurement of absolute surplus-value rests upon an extension of the length of the working day without any commensurate increase in the wage-value of the socially necessary labour-time contained therein. The procurement of relative surplus-value involves a reorganisation of the various elements which comprise the productive forces of a given historical period (be they elements of the means of production or of the deployment of labour-power). Such a reorganisation of productive forces aims to achieve an increased productive capacity within a unit of production without any lengthening of the working day. This may

involve new or redefined divisions of labour, rationalised and reorganised working routines, or the introduction of technological innovations into the means of production. In essence, because the length of the working day remains unchanged the net result of the procurement of relative surplus-value entails an increase in the productivity of labour-power which is achieved via a reduction of the socially necessary labour-time that is needed to reproduce that labour-power. Accordingly, any such reduction of socially necessary labour-time will involve an increase in the surplus labour-time within the working day. However, the logic of competition ensures that any gains in the rates of relative surplus-value that have been achieved by individual producers are ultimately short-lived as the greater mass of competitors are forced to adopt similar innovations to their production. This inevitably results in the devaluation of abstract labour.

The procurement of absolute and relative surplus-values are critical to our understanding of economic and social transformation under capitalism. The quest to procure relative surplus-value in particular lies at the very heart of the revolutionary, disruptive and ultimately violent impulse of capital. The logic of capital accumulation continually forces producers to alter and amend their working practices and to implement new productive technologies into the means of production. In a much quoted passage from *The Communist Manifesto* Marx and Engels write:

> Constant revolutionising of production, uninterrupted disturbance of all social conditions, everlasting uncertainty and agitation distinguish the bourgeois epoch from all earlier ones. All fixed, fast-frozen relations, with their train of ancient and venerable prejudices and opinions, are swept away, all new-formed ones become antiquated before they can ossify. All that is solid melts into air, all that is holy is profaned.
>
> (Marx and Engels 1983:17)

Such constant revolutionising of production also forms the mainstay of the fundamental antagonism between capital and labour, compelling both capitalists and workers to consolidate as classes in order that they may protect and preserve their interests. Typically this antagonism manifests itself as the struggle to establish the duration of the working day, or in the often bitter disputes arising from the attempt to introduce new technologies into the productive process. Although the concept of class, even when viewed from a strictly Marxist perspective, cannot simply be reduced to the clear-cut constituencies of capital and labour, these constituencies none the less form both the material and the conceptual foundation upon which this highly complex category is composed. Consequently, a proper understanding of the capital–labour contradiction becomes a prerequisite factor for any analysis of the political, social and, particularly in respect of this study, the cultural dimensions of class composition and inter-class struggles within modern capitalist societies.

The full social implications which arise from the pursuit of both absolute and relative surplus-values, particularly those affecting the sphere of consumption and the regulation of patterns of everyday cultural life, will be discussed in some detail below (pp. 120–37). For now, however, it is sufficient simply to stress the critical role that these methods of surplus generation play in the acceleration of the rate of capital accumulation.

In itself fulfilling no socially useful function, and least of all initiated by the quest to satisfy consumer needs, the obsessive competition to accumulate at a greater rate than a given social average surfaces to common perception as the term *economic growth*. Growth may be here defined as the rate at which capital in circulation is expanding through the increased exploitation of living labour. Given its absolute centrality to the logic of accumulation it is unsurprising that the ideology of growth finds itself so deeply embedded within the consciousness of capitalist societies. Its social appearance as the edifying and sacrosanct principle overseeing all forms of economic and social progress succeeds in masking the fact that the unremitting pressure of the fear of failure in the pursuit of growth is the prime motivating factor permeating every dimension of the capitalist economy. Indeed, it is the perpetual quest to secure and sustain economic growth which makes capitalism a most unstable economic system. For essentially capital is driven by an imperative which forces it to undertake the continual search for those economic conditions which may be the most immediately propitious for growth. However, this tends to blind capitalist enterprise to the detrimental long-term social, environmental and, eventually, economic consequences that are often the logical outcome of such conditions. In more concrete terms, capitalist innovations to the whole circuit of production, distribution, exchange and consumption tend to perceive nothing other than opportunities for immediate and short-term gains in productivity and accumulation while paying scant regard to the need for establishing relatively enduring socioeconomic foundations upon which the greater magnitude of newly accumulated capital may be put to work usefully in generating further accumulation.

OVERACCUMULATION

It has long been held to be part of the common sense of Marx's analysis that capitalism is an inherently crisis-prone system of socio-economic organisation. This tendency towards crisis in capitalism is ultimately rooted within a deep structural contradiction existing within the logic which drives the accumulation process. On this point Andrew Gamble (1981) has commented:

> As an economic system capitalism has always been marked by instability, which arises principally from its own internal compulsion to expand . . . In its quest for profits capital seeks to overcome all obstacles in the path of its accumulation. That is why competitive capital accumulation between

individual enterprises has no resting place short of the complete auto-
mation of the productive process and the industrialisation of the whole
world. But its progress towards these limits has been interrupted by great
crises of overproduction, because the accumulation of capital constantly
tends to race ahead of the conditions which can sustain it. Capitalism as a
world system has suffered twenty such general crises of overproduction
since 1825.

(Gamble 1981:8)

For Marx, the essence of capitalism's tendency towards crisis can be traced
to the *changing composition of capital over time*.

In value terms all capital can be said to be composed of a certain ratio of
constant capital (the value of the means of production) to variable capital (the
value of labour-power as quantified in the sum total of wages). This ratio of
constant to variable capital constitutes *the organic composition of capital*
(Marx 1976:762), and the greater this ratio of constant to variable capital,
then the higher the organic composition is said to be. Since it is within the
sphere of variable capital that there is expressed the production of surplus-
value from living labour it necessarily follows that a rising organic composi-
tion of capital within the economy as a whole will always result in some
reduction of surplus-value within that economy.

What Marx was able to demonstrate in *Capital* was that the powerful
motivations towards growth and technological innovation within the accum-
ulation process would inevitably result in a rising organic composition of
capital and hence the tendency for the rate of profit to fall. In short, growth
and technological innovation, themselves intrinsic elements within the accum-
ulation process, are held to be mutually antagonistic features when seen from
the perspective of the long-term reproduction of the accumulation process.
Since growth is defined as the rate at which capital in circulation is expanding
through the application and increasing exploitation of living labour in
production, then, when seen in terms of growth at least, the preservation of
labour-power becomes a fundamental component of the continued repro-
duction of the accumulation process. But we have seen that the logic of
competition between independent producers, itself a fundamental mainstay
of the accumulation process, forces producers to explore ways in which new
technologies may be introduced into the means of production for the sole
purposes of appropriating relative surplus-values and reducing socially
necessary labour-time. Therefore, the overriding function of the introduction
into production of new technologies is always to replace labour-power for
those technologies; that is, to increase the ratio of the mass of the means of
production relative to the mass of the labour that is needed to employ it
(Marx 1976:762). In value terms, then, technological innovation in capital-
ism, the substitution of living labour for dead labour, is, by definition,
always expressive of a rising organic composition of capital; that is, a rising

ratio of constant to variable capital. The inevitable pull towards the de-
velopment of new technologies introduced at the expense of labour-power
consequently undermines directly the necessity for growth which is based
upon the preservation of labour-power.

We shall see presently (pp.66–72) how this tendency towards a reduction in
surplus-value, a declining rate of accumulation and the drift towards major
economic crises may be tempered and postponed by direct intervention into
the accumulation process by the capitalist class. First, however, it is important
to describe the manner in which crises, when they do inevitably occur,
manifest themselves. Here I focus upon the concept of *overaccumulation*, and
draw particularly on the work of Harvey (1982, 1985, 1989).

In a technical sense, the notion of overaccumulation describes a logical
tendency for there to emerge over time an imbalance between the various
forms of capital in circulation. Such an imbalance between money, pro-
ductive and commodity capital in circulation essentially constitutes the
production of 'a surplus of capital relative to opportunities to employ that
capital' (Harvey, 1982:192). Expressed in a more general sense, a state of
overaccumulation can be defined as the tendency for persistent increases to
the rates of profit and accumulation to outstrip the available opportunities and
conditions upon which this acquired capital can be deployed into socially
useful production. This inevitably leads to a slowdown in the rates of profit
and accumulation. Typically, the consequence of this unrealised potential
will be that at some point within the circuit of accumulation capital will
appear in the form of an idle capacity: as capital effectively frozen at a
particular point. Harvey (1982:195) identifies the primary manifestations of
overaccumulation as follows:

1 an overproduction of commodities – a glut of material commodities on the
 market expressed as an excess of inventories over and beyond that
 normally required to accomplish the smooth circulation of capital;
2 surplus inventories of constant capital inputs and partially finished com-
 modities over and beyond those required for the normal circulation of
 capital;
3 idle capital within the production process – particularly fixed capital which
 is not being used to its full capacity;
4 surplus money capital and idle cash balances over and beyond the normal
 monetary reserves required;
5 surpluses of labour-power – underemployment in production, an expansion
 of the industrial reserve army over and beyond that normally required for
 accumulation, a rising rate of exploitation which creates at least a temporary
 devaluation of labour-power;
6 falling rates of return on capital advanced expressed as falling real rates of
 interest, rates of profit on industrial and merchant's capital, declining
 rents, etc.

In order that the various forms of capital in circulation can remain in balance with each other and that a major crisis of overaccumulation is to be avoided, then any large-scale quantities of surplus capital must be eliminated. It it this fact alone which forces capitalists to consolidate as a class interest in order that they may coordinate workable responses to the threat of overaccumulation, a fact which itself violates the fundamental principles of individualism and unfettered free-market enterprise (see O'Connor 1984). Here it is possible to argue that the forms of the responses to overaccumulation that are taken collectively by the capitalist class represent perhaps the most significant actions that occur within the economic sphere which impact upon the entirety of social life in advanced capitalist societies. As Harvey (1989:181) puts it, 'we here encounter the heroic side of bourgeois life and politics, in which real choices have to be made if the social order is not to dissolve into chaos'. For Harvey (1982:196ff., 1985:132, 1989:181–4), the responses to the overaccumulation problem can be characterised under three broad headings: the devaluation of capital; absorption of overaccumulation; macro-economic control and regulation.

Devaluation of capital

The devaluation of capital represent perhaps the most immediate opportunity to erase potentially harmful surpluses of capital and to restore the overall balance of capital in circulation. Devaluation, or the 'writing down' or 'writing off' of the value of capital, may take several forms: money capital can be devalued by inflation or by debt default; labour-power may be devalued through unemployment and falling real wages to the labourer (a rising rate of exploitation); finished or partially finished commodities may be sold off at a loss; commodities may be physically destroyed; and the value embodied in fixed capital (plant and machinery) may be lost as it lies idle.

Absorption of overaccumulation through temporal and spatial displacement

Clearly devaluation represents an extremely negative response to the problem of overaccumulation. The destructive and often brutal nature of devaluation ensures that as a political-economic strategy in the preservation of the reproduction of the process of accumulation, devaluation constitutes only a temporary and short-term solution to the problem of eradicating unwanted surpluses. For Harvey, a far more enduring and potentially positive response to overaccumulation is to be achieved by the absorption of overaccumulation through the temporal and spatial displacement of capital.

The temporal displacement of capital is defined by Harvey (1985:135–41, 1989:198) as, first, 'a switch of resources from meeting current needs to exploring future uses'. Here surpluses of capital and labour existing in the present can be sunk into the building of long-term public and private

enterprises (in plant, social and welfare infrastructures, the built environment, etc.) where their values can be reclaimed at some future point. The feasibility of such long-term investments, however, rests upon the availability of credit and the establishment of 'fictitious capital formations', the later being defined as speculative money capital, the value of which is wholly contingent on the execution of some future production. Second, the temporal displacement of capital may involve 'an acceleration of socially necessary turnover time (the speed with which money outlays return profit to the investor)'. Here surpluses created in the past can be absorbed by the more efficient production, distribution and consumption processes of the present.

The spatial displacement of capital involves the absorption of surpluses through geographical expansion: 'This "spatial fix" . . . to the overaccumulation problem entails the production of new spaces within which capitalist production may proceed . . . the growth of trade and direct investments, and the exploration of new possibilities for the exploitation of labour-power' (Harvey 1989:183).

Macro-economic control

Orchestrated through some institutionalised agency such as the state, the strategic coordination of economic activity (which may itself involve the organisation of capital devaluations or the absorption of overaccumulation through the temporal and spatial displacement of capital) has historically proved to be the most effective means of stabilising the capital imbalances caused by overaccumulation.

REGULATION THEORY

Ultimately however, the long-term reproduction of the accumulation process rests upon far more than the technical management of capital by its political and economic agencies. Within the spheres of both production and exchange, the smooth circulation of capital relies upon the cooperation of those human agents whose interests are by no means identical (and often deeply antagonistic) to those of capital. The preservation of such wage and commodity relations which are sympathetic to the successful circulation of capital rests upon the agencies of capital being able to exert a sufficient measure of socio-ideological control over labour-power in the sphere of production, and similar control upon consumers within the sphere of exchange. It is of course at this point that the concerns of capital within the modern world inevitably become firmly implicated in the composition of those social structures which fall outside the direct flows of capital. The agencies of capital are thus compelled to turn their attention towards the prevailing familial, kinship, gender and ethnic relations, the built environment of daily life, mass-mediated systems of communication, and the

complex weave of everyday cultural norms if they are to ensure that both workers and consumers think and behave in a manner which is at best supportive and at worst not antagonistic to the long-tem reproduction of the accumulation process. In order to begin to conceptualise how capital might exert an influence over the entirety of social life I will draw upon the work of a number of French political economists, collectively referred to as the *Regulation School* (in particular Aglietta 1987; Lipietz 1985, 1987; Billaudot and Gauron 1985).

For the members of the Regulation School, the broad project under investigation is to 'develop the potential of Marx's concepts by deploying them in a critical study of the major social transformations of the present century' (Aglietta 1987:17). If we take Marx and Engels's original observation that from their material life and the production of their means to life, humans develop 'a definite form of expressing their life, a definite mode of life' (Marx and Engels 1974:42), then the work of the Regulation School can be seen in terms of an historico-theoretical study of the development of productive forces and the associated social relations of that production within late nineteenth- and twentieth-century capitalism. For the Regulationists, an adequate understanding of the internal logic of capitalism cannot be fully grasped without a proper appreciation of its historical development. Historical evidence is used in Regulationist theory, therefore, not to provide mere empirical exemplars as a means of illustrating the unchanging essence of the laws of capital accumulation, but as a way of conceptualising those laws in terms of their historical contingency upon the exact trajectories of the development of productive forces, the precise composition of social relations and the outcomes of specific class struggles. Hence, for the Regulationists the fact that the history of capitalist development can be conceptualised in terms of a number of distinctively structured phases suggests that there is nothing pre-determined about the development of capitalism, but that each phase effectively represents a 'workable response' to the material conditions within which it is situated.

The importance of this historically embedded theoretical scrutiny is captured in two important terms: the *regime of accumulation, the mode of regulation*. Since these terms will form the conceptual 'spine' of much of the subsequent material of this book, it is important at this stage to explain their meaning and significance within Regulation School thinking.

Regime of accumulation

The notion of a regime of accumulation is used as an 'intermediary concept' useful in articulating the connection between many of the essential components of the logic of capital accumulation, as outlined originally by Marx, and the historical forms and relations that these essential principles assume during a given social epoch or period. Accordingly, the concept of regime of

accumulation may enable us to formulate a number of criteria which may begin to make intelligible the precise nature of the relationships between Marx's concepts of social *essence* and social *appearance* in modern capitalism. Similarly, its grounding in concrete historical specificity also makes the regime of accumulation an ideal concept for the proper and sensitive exploration of the classical Marxist formulation of base and superstructure, without being compelled to reduce the latter concept to a mere predetermined function or self-evident product of the former concept. For Lipietz, a regime of accumulation:

> refers to a systematic and long-term allocation of the product in such a way as to ensure a certain adequation between transformations of conditions of production and transformations of conditions of consumption. A regime of accumulation can be defined as a *schema of reproduction* which describes how social labour is allocated over a period of time and how products are distributed between different departments of production over the same period.
>
> (Lipietz 1987:32)

A regime of accumulation may therefore be said to refer to the unique composition and organisation of the productive forces (the forms and status of technologies, the qualitative composition and deployment of labour-power, etc.) in a given historical period which enable the relatively long-term reproduction of the social relations which accompany those productive forces. However, it is important to stress that the concept of a regime of accumulation not only refers to those directly observable or immediately visible phenomena within the sphere of production, but also to the social conditions which are left in the wake of the organisation of the mode of production and from which labour-power must be reproduced in all its material and non-material dimensions. This makes the concept of a regime of accumulation both a description of the particular patterns of organisation governing the production process as well as the associated social conditions that govern the reproduction of labour-power. For Aglietta, when there is seen to exist a certain long-term stability between the various elements of production and consumption which combine to form the primary circuit of capital, when there is a stable 'articulation between process of production and mode of consumption' (Aglietta 1987:117), then there can be said to exist a distinctive or recognisable regime of accumulation.

Mode of regulation

In order that any long-term stability may exist between production and consumption, a regime of accumulation must find its materialisation in specific 'institutional forms, procedures and habits which either coerce or persuade private agents to conform to its schemas. These forms are

collectively known as a *mode of regulation*' (Lipietz 1987:33). The mode of regulation is therefore:

> the regime of accumulation materialised in the shape of norms, habits, laws and regulating networks which ensure the unity of the process and which guarantee that its agents conform more or less to the schema of reproduction in their day-to-day behaviour and struggles.
>
> (Lipietz 1987:14)

With the emergence of a mode of regulation there is effectively accomplished the construction of an elaborate social infrastructure built to accommodate the stable reproduction of the regime of accumulation. This social infrastructure not only incorporates those domains of social life which most overtly touch the spheres of production and consumption, as in the various strategies of macro-economic policy and direct state intervention into the affairs of private accumulation, but is also seen to house the 'non-directly economic' aspects of social life. These may include such areas as social planning and welfare provision, the dominance of certain political attitudes and ideologies as well as those far less tangible features which are characteristic of particular eras and are collectively referred to by the term *culture*. This latter dimension of the mode of regulation may also be comprised of the regulation of the collective symbolic codes, linguistic structures and aesthetic practices through which culture is itself articulated. In short, the mode of regulation finds its function in the management and mobilisation of a number of institutionalised ideas, values and beliefs which are shaped into distinctive cultural practices. The mode of regulation thus provides an 'architecture of socialisation' (Billaudot and Gauron 1985:22) which may house a relatively enduring social, political and cultural consensus existing over a given social period or socio-economic epoch. As Lipietz suggests:

> The stabilization of a regime of accumulation or a mode of regulation obviously cannot be analysed in terms of its economic logic alone. Such 'discoveries' are the outcome of social and political struggles which stabilize to form *a hegemonic system* in Gramsci's sense of the term: in other words class alliances based upon a consensus (and a varying degree of coercion) which shape the interests of the ruling classes, and sometimes of the interests of the dominated classes, into the framework of the regime of accumulation.
>
> (Lipietz 1987:20)

Aglietta, in his seminal work *A Theory of Capitalist Regulation: The US Experience*, identifies two basic configurations of the regime of accumulation and, similarly, two basic configurations of the mode of regulation. These have been summarised as follows (see Barbrook 1990; Brenner and Glick 1991:49):

1 *The extensive regime of accumulation* in which growth is secured primarily, although not exclusively, through the adoption of artisanal methods of production and takes the form of the appropriation of absolute surplus-value (primarily by an extension of the working day and an increase in the magnitude of the total labour force).
2 *The intensive regime of accumulation* in which growth takes place largely via an investment into fixed capital. Growth within an intensive regime of accumulation tends to be characterised by the appropriation of relative surplus-value (the introduction of new, more efficient technologies into production coupled with the adoption of new labour practices which are designed to increase productivity per productive unit).
3 *The competitive mode of regulation*. Here the regulation of the regime of accumulation is achieved directly via the competitive determination of prices by the market mechanism. This applies both to the determination of the price of labour and to the commodity market proper.
4 *The monopolistic mode of regulation*, where regulation takes place primarily through an oligopolistic system of pricing and the fixing of wages via a 'complex system of capital–labour and government institutions' (Brenner and Glick 1991:49).

Broadly speaking, Aglietta suggests that an extensive regime of accumulation is most appropriately regulated by a competitive mode of regulation, while an intensive regime of accumulation is regulated by a monopoly mode of regulation.

By tracing the relationships between regimes of accumulation and their modes of regulation as they at first stabilise and eventually give way under the overbearing weight of crises of overaccumulation, we ought to be able to highlight several important aspects of the economic logic which has dictated many of the major social transformations within the capital–consumption–culture nexus during the twentieth century. From this standpoint, the general argument advanced by several members of the Regulation School has been as follows.

Emerging during the early years of the present century, and reaching its maturity in the immediate post-war years, the dominant regime of accumulation characteristic of advanced capitalism has been that of *Fordism*. Taking its name from the revolutionising of the productive processes by the American automobile manufacturer Henry Ford, Fordism represented the emergence of an intensive regime of accumulation based upon a general system of mass production using semi-automatic assembly lines, 'Taylorist' forms of job fragmentation and demarcation, and the implementation of single-purpose or dedicated machinery. This regime of accumulation, when appropriately wedded to a developed monopolistic mode of regulation, opened up the possibility of the first high-wage, mass production – mass-consumption economy. This regime of accumulation and its corresponding

mode of regulation is generally regarded to have held firm until the early 1970s, when it could no longer be reproduced adequately and broke under the pressure of a massive crisis of overaccumulation. Since that time, it is said, capitalism has begun to develop a number of radical alternatives to the mass-production schema in order to re-energise the processes of accumulation. Although the precise impact, extent and indeed existence of a new regime of accumulation and mode of regulation have been hotly contested over recent years, there appears none the less to have emerged a general consensus as to the arrival of a new *post-* or *neo-Fordist* schema of production. This is commonly said to embody the use of computerised flexible technologies in the processes of production, distribution and exchange, as well as the implementation of flexible working practices and a reconstituted labour pool. This results in a highly specialised schema of production capable of swift responses to changes in the composition of both the labour and goods markets.

Although this model may have been infused with a different set of terminologies, political consequences and conclusions from those outlined by the Regulation School, the idea of an historical transition from Fordism to some new form of capital accumulation has become the broadly orthodox model describing recent socio-economic changes. Using the concepts of Fordism and post-Fordism as useful labels to conceptualise recent socio-economic transformations, I shall explore some of the ways in which the domains of consumption and culture have been reformed in the wake of these transformations. The following chapter begins by discussing some of the important issues surrounding the emergence of Fordism as an historical socio-economic force.

Chapter 5

The political economy of Fordism

In this chapter I will outline some of the significant features of Fordism as it is said to have existed as a distinctive and mature regime of accumulation within advanced capitalist societies from the end of the Second World War until the major economic crisis of the early 1970s. Unfortunately the sheer scale of Fordist social organisation coupled with the wide diversity of its influences necessarily makes any attempt at summary appear to be more schematic than is perhaps ideally desirable. Therefore, this chapter should be read as being deliberately synoptic. Rather than claiming to render any exhaustive account of the various nuances and inflections taken by Fordism over the period in question and across different geographical spaces, the broad character of Fordism is described.

For Aglietta, Fordism was characterised as an *intensive regime of accumulation*, and as such attained unprecedented levels of sustained growth throughout the post-war years by means of substantial increases in *relative surplus-value*. This, as I shall argue below, is not to deny the vital contribution that the appropriation of absolute surplus-value played in the successful emergence of Fordism. Nor is it to suggest, as perhaps Aglietta does, that the appropriation of relative surplus-value played only a relatively small part in American industrial development prior to the 1920s and the beginnings of Fordism (see Clarke 1988; Brenner and Glick 1991). The significance of the point that is made by Aglietta and other Regulationists that Fordism represented an intensive rather than an extensive regime of accumulation, rests upon their claim that Fordism engendered a complete structural transformation of *the whole way of life* of the wage-earning classes (rather than merely bringing about changes to the organisation of labour and to the means of production). Fordism therefore suggests the birth of mass consumption, the emergence of the modern consumer society and a whole raft of corresponding social and cultural changes. In short, by the time that Fordism had achieved its status as a fully fledged regime of accumulation in the 1950s and 1960s, it had brought about a wholesale transformation of both the conditions of production and of the conditions of consumption; that is, a transformation of the social relations of production and a transformation of the whole way of

social life from which those production relations emerge and are ultimately sustained.

Such change was made possible only by the development of a distinctive mode of monopolistic regulation. This was most obviously founded upon an extraordinary hegemony which imposed itself on the majority of social life, and which found its prime focus in the remarkable alliances within the capital–labour–state triplet. It could be seen, for example, in an unprecedented social contract between capital and labour, in the many mutually beneficial coalitions between corporations, and in the rise and rise of the nation state as the supreme centre of social authority. It was also visible in the unquestioned belief in and application of welfarism, in the sphere of politics and political ideology, and in the huge transfigurations of public and private space which resulted from the consistency of belief and practice that was found within urban and regional planning, architecture, design and in all of the concrete and abstract structures which housed the activities of both work and leisure. Just as importantly perhaps, the mode of regulation stamped its hallmark upon the contemporary mode of aesthetics as well as the numerous other practices and forms of expression which best articulated the major cultural formations and sensibilities of the era in question. However, before considering these and other features of developed Fordism, as well as appreciating Fordism's significance and impact as a social force upon everyday life, it is first necessary to trace its origins.

The heartland of Fordism has, of course, always been the USA. For much of the nineteenth century, however, the US economy could be described as an extensive regime of accumulation which was regulated by a competitive mode of regulation where the market, acting virtually autonomously, had tended to stabilise prices. Under these conditions, what mattered most to US production was the 'frontier spirit'; the constant quest to extend the scale of production, either through a lengthening of the working day, an expansion of the size of productive capacity, or by extending production into new geographical territories. In short, growth during this period of American production was secured for the most part through the appropriation of absolute surplus-value.

Of course, science and technology, particularly towards the end of the nineteenth century, had begun to play their part in the inevitable requirement to modernise production. However, while a gradual process of mechanisation and the implementation of certain technological innovations had begun to transform American industry's production norm and to provide a new stimulus for growth, it was clear to some industrialists that a significant proportion of productive capacity lay untapped. New machinery and technology, when its aim *was* to alter production methods, had only begun to do so within the *means of production*. Critically, the organisation of labour remained largely unchanged and centred upon artisanal and craft methods of working. By the turn of the century these methods began to yield increasingly

diminished proportions of surplus labour-time and hence led to falling rates of profit. Essentially, American labour was becoming relatively inefficient in comparison with the new modernised plant and machinery.

It was against the background of what, with hindsight, we can see as an increasingly exhausted nineteenth-century regime of accumulation that figures such as Frederick W.Taylor and Frank Gilbreth began to develop a series of schemas for production which sought to rationalise the organisation of labour and establish working practices that would greatly facilitate an increase in industrial efficiency and productivity. The publication in 1911 of Taylor's *Principles of Scientific Management* can be seen here as something of a watershed in modern industrial and economic history. In it, the remedies espoused by Taylorism (as it later became known) to the ills of industrial inefficiency were relatively simple in conception but far-reaching indeed in their subsequent consequences. They consisted of the following features: first, a wholesale rationalisation of the total labour process by the fragmentation of jobs into routine and repetitive tasks that required relatively unskilled labour; second, the standardisation of the duration of the working day; third, the constant supervision and surveillance of the workforce to ensure an optimum labour-time ratio; fourth, the introduction of time and motion studies to achieve a *continual* process of work-practice rationalisation; fifth, and most important, the utilisation of these principles as a means of making more efficient use of the existing industrial technologies, so that, for example, machines had an absolute minimum shut-down period. The net impact of these principles upon American industry was a wholesale rationalisation of the organisation of labour. Furthermore, the simplification of individual work tasks also threw into relief those aspects of the labour process that were, because of their simplicity, now possible to be performed by specialised machinery. This meant an inevitable stimulation of the processes of technological renewal throughout the advanced industrial sector. As a result, continued mechanisation of the means of production and the constant rationalisation of the labour process began to form a 'virtuous circle' which enabled individual producers to achieve ever-increasing profit margins and to accelerate the rate at which capital was accumulated. The apogee of this combination of Taylorist forms of labour management and the continual reinvestment into the means of production was reached in 1913 with the establishment of Henry Ford's first automated car assembly line.

The historical importance of Ford to capitalist methods of production lay in the manner by which he successfully combined the principles of Taylorism with new forms of mechanisation. This resulted in the first fully operational economy of scale, producing low cost, high volume standardised commodities. More specifically, mass production was characterised by the rational deployment of a largely semi-skilled or unskilled workforce operating special purpose or product-specific machinery designed to handle standardised product components. All of these features came together in the new

practice of flowline assembly which replaced the older, relatively inefficient, method of nodal assembly. The successful combination of these factors in Ford's Detroit factories marked an important historical break from the far more labour-intensive forms of small-scale craft production which had previously dominated American industrial life. The key to the success of mass production lay in the fact that although the fixed costs involved in setting up a production run were initially high, these costs could be more than offset by the extremely low variable costs of maintenance and administration once the system was up and running. The result was a product that arrived in the marketplace at a substantially lower price than those of all of Ford's competitors. Evidence of the economic viability of Ford's system at this time can be glimpsed by the unprecedented speed by which he managed to secure 50 per cent of the American automobile market within three years of establishing his first factory (Murray 1987).

The true significance of Ford's achievements was, however, to impact far beyond the immediate economic imperatives of individual producers: mass production set in motion a train of events that were to have profound consequences throughout modern society and transform not only the economic sector itself, but also the entire way of social and cultural life over the following decades. But such a transformation of everyday life by no means followed automatically or unproblematically from the new mode of production. The massive transformation of social life was, in the first instance, the result of a number of potentially serious problems which mass production had stored up during its early years, and which, so long as profit shares remained high, had gone largely unattended over this time. In order to fully appreciate the factors that enabled Fordism to emerge after the Second World War as a truly radical socio-economic force, it is first vital to understand the nature of the severe problems that it faced as a seminal regime of accumulation. These problems were to erupt violently in the form of the great financial crash of 1929 and the ensuing economic crisis of the 1930s.

For Aglietta and other Regulationists, the overwhelming cause of the Great Depression of the 1930s was to be found in a deep structural incommensurability between the new, and by then, dominant regime of intensive accumulation and an outdated mode of competitive regulation. In its broadest terms a regime of accumulation, if it is to endure for any reasonable length of time, must ensure that a certain measure of stability exists within two fundamental spheres of the primary circuit of capital accumulation. First, a regime of accumulation should be able to secure the long-term quantitative and qualitative supply of labour-power commensurate with the scale and form of the prevailing mode of production. It should be able to guarantee a labour market of a sufficient size and possessing the appropriate skills that are needed for a given mode of production. In other words, it must be able to stabilise *wage or labour relations*. Second, a regime of accumulation must also be able to guarantee the appropriate market capacity needed to match

both the quantitative and qualitative nature of the commodities being produced. It must ensure a large degree of compatibility between the spheres of production and consumption, between the production of use-values and the scale and composition of needs. This is the requirement to stabilise *commodity or exchange relations*. Any systematic failure to guarantee either of these relations over a period of time will always lead to some form of economic crisis. We may therefore call a failure to stabilise wage/labour relations a *crisis of production*, and a failure to stabilise commodity/exchange relations a *crisis of consumption*.

During the 1920s, mass production in the US was drifting rapidly towards both a crisis of production and a crisis of consumption. The new productive regime pioneered by Henry Ford had succeeded in changing dramatically the quantitative and qualitative output of commodities, but it had not significantly altered the established wage/labour relation. At this time the prevailing mode of competitive regulation had ensured that the unrestricted market mechanism had kept to a minimum the labour costs that were incurred by individual producers. From the perspective of capital at least, this mode of regulation had suited well the earlier extensive regime of accumulation in which the stability of the commodity/exchange relation was not, by and large, directly dependent upon the spending capacity of wage-earners. But the arrival of mass production, of course, required mass consumption: a sufficiently sized mass market composed of the wage-earning classes that would be able to absorb the full influx of mass-produced commodities. In the absence of a nationwide, economically enfranchised working-class consumer market, producers had generally tended to concentrate their activities on the 'quick fix' of geographical, or horizontal, market expansion. This had been greatly facilitated by the dramatic improvements in transportation and the longer shelf life of certain perishable goods made possible by new canning and refrigeration techniques. It was clear, however, that geographical expansion alone could not sustain indefinitely the current rates of productivity. In order to remain viable, the productive apparatus would soon need to consider a radical form of vertical expansion within its market potential if the dynamic nature of the new productive system was not to outstrip the limits of demand.

However, US industry at this time was facing far more immediate problems than those of the vagaries of unforeseen future market demand. Again within the sphere of wage-labour there was also emerging the very real threat to the maintenance of high productivity levels which resulted from a growing number of costly labour disputes. These had been brought about by the psycho-physical consequences of the new working practices upon the workforce. While there can be no doubt that Taylorist principles of 'Scientific Management' greatly improved the organisational efficiency of labour and increased substantially levels of productivity, they also succeeded in producing barbaric working conditions. Writing in the 1930s, Gramsci, in his seminal essay 'Americanism and Fordism', spoke of Taylorism as:

developing the worker to the highest degree of automatic and mechanical attitudes, breaking up the old psycho-physical nexus of qualified professional work, which demands a certain active participation of intelligence, fantasy and initiative on the part of the worker, and reducing productive operations exclusively to the mechanical, physical aspect.

(Gramsci 1971:302)

Taylor himself did not seek to conceal the fact that the new principles of Scientific Management that he was fervently advocating necessarily rested upon a conception of the workforce as little other than a 'human machine'. Such insensitivity to the 'human content' of the production process was generally shared by most industrialists during the early phase of mass production. It was tellingly revealed by Taylor himself when, writing of the work of pig-iron handling, he suggested the work to be 'so crude and elementary in its nature that the writer firmly believes that it would be possible to train an intelligent gorilla so as to become a more efficient pig-iron handler than any man could be' (Taylor 1911:40). It should come as no surprise that the principles of Taylorism, when coupled with the assembly-line techniques adopted in Ford's factories, succeeded in producing the sort of industrial and working environments that were in many respects as brutal, alienating and dehumanising as any in the history of capitalism. It should also come as no surprise, therefore, that the new productive processes that were pioneered in Ford's factories were to be met initially by a growing tide of industrial unrest. Absenteeism, 'blue Mondays', wildcat strikes and other disruptive industrial practices all became as much of a feature of early mass production as the unprecedented volume of goods that the factories were then producing, and a growing politicisation of the workforce, together with an emergent Socialist Party of the USA, began to pose a significant threat to the embryonic economic regime.

It would be quite wrong of course to suggest that the degrading working conditions that were foisted upon the workforce went entirely unnoticed by all of the captains of industry. Many, including Ford himself, had well understood the priority of developing a social infrastructure that would lead to the formation of a new type of worker. This was not only to be achieved by his integration into the new factory system itself, but also by developing patterns of social life generally that would accommodate the successful reproduction of labour-power. As early as 1914, barely one year after the establishment of his first factory, Ford had introduced his famous innovation of a five-dollar–eight-hour day for each worker as some recompense for having to endure the new working environments. Moreover, Ford had anticipated the need to educate the workforce into certain core American values, and he even went so far as to employ a 'sociology' team, whose task it was to instruct employees into the morally correct (i.e., rational) way of life that was demanded by a modern industrial society. This was to be a way of

life which, amongst other things, would include an abstinence from the 'evils' of alcohol. Indeed, the introduction of Prohibition can be traced directly to the requirements of American industry at this time. Such experiments in social control were, during this period, certainly embryonic, and they had little enduring impact upon the consciousness of the workforce in general (the repeal of Prohibition is perhaps the clearest evidence of this fact). However, Ford's initial attempts at regulating the everyday patterns of life of the workforce and their families did provide a powerful historical marker from which far more intensive and systematic economic and ideological agencies were later to draw precedent. These would include the very different, but by no means incompatible, practices and ideologies adopted by advertising and the welfare state of the post-war years.

It is at this point that we can see that the threats that were posed by industrial unrest and an impending underconsumption were by no means unconnected problems. Indeed the potential solutions to these problems were, broadly speaking, very similar: a wholesale resocialisation of the labourforce and their familial and community structures in favour of a mass-consumption norm. But, as we shall see in Chapter 6, the transformation of a generally impoverished working class, whose culture bore more than the residual hallmark of traditional ways of life, into the affluent workforce of the consumer society of the 1950s and 1960s was not to be routinely accomplished. The process of 'producing consumers' would involve the slow and by no means straightforward implementation of a wide range of initiatives which fell initially under the auspices of both corporate capital and the nation state. These were to evolve an economic and cultural environment in which a widespread access to the means of commodity consumption could be wedded to a new social consciousness of consumption. Such an environment would genuinely support an economic system based upon the mass production of standardised commodities, not only by providing the wage-earning classes with both the means and the will to consume, but, just as importantly perhaps, implicating labour irreversibly with the interests of capital and thereby compromising much of its radical political consciousness.

Early attempts to institute a mass-consumption norm, as exemplified in Ford's early efforts, tended to founder upon a working-class lifestyle which all too often would display, at best, an ambivalence or, at worst, an outright resistance to what were essentially the alien ways of life promoted by the new productive regime and the advertising imagery surrounding the consumer goods it produced. It was partly this failure to mobilise a popular cultural consensus in favour of mass consumption, and partly the failure to provide an adequate wage and welfare infrastructure, which contributed to the inability of early Fordism to galvanise a sufficient reservoir of sustainable consumer demand that was drawn from a large-scale working-class base. In these failures the seeds of the first great crisis of overaccumulation of the modern

era were sown. This was a crisis which, in part, culminated in the sudden and devastating financial crash of 1929 and the economic depression which remained throughout the 1930s.

If the early years of the new productive regime had been marked by the attempts of private capital to forge a social and economic environment supportive of mass production, then the severity of the Depression ensured that this initiative would now be seized by the state. In the US, where an orthodoxy of anti-interventionism had long been established, certain progressive industrialists (and here Ford was again in the vanguard) attempted to raise wages as a means of generating economic recovery. However, initially in the form of Roosevelt's New Deal, the state soon assumed the mantle of establishing some genuine semblance of national economic stability. Roosevelt introduced a package of economic measures, the basic aim of which was to use state spending on the infrastructures of production and consumption as a means of providing enough employment to generate sufficient consumer demand so as to absorb the very worst excesses of overproduction. While the material impact of the New Deal may well have been much overstated during its passage into twentieth-century social and economic mythology, there can indeed be no doubt as to its symbolic importance: Roosevelt's vision of a national economic stability which was backed by a new democratic welfarism provided a powerful and often irresistible precedence, both in its concrete social actions and its ideological persuasiveness, upon which future Fordist policies could be modelled.

It was, however, in many post-war European countries that the imprint of the state on economic and social policy was eventually to leave its most marked impression. The publication in 1936 of John Maynard Keynes's *The General Theory of Employment, Interest and Money* seemed for many to provide a blueprint for economic stability and growth. Given the economic background of sudden and devastating financial crisis against which the book was written, Keynes's central premise – that modern capitalism was an inherently unstable economic system if left without any form of systematic external regulation or control – found much favour in many quarters of European government. The much vaunted concept of absolute market sovereignty which had been so keenly advocated by such figures as Adam Smith and Stanley Jevons in the eighteenth and nineteenth centuries was, it seemed, in need of a massive reappraisal in an era where the sudden collapse of mass markets could lead to the terrible privations that had been witnessed during the 1930s. Mass markets, it was argued, were too unpredictable and the effects wrought by their collapse too unimaginable to be left to the mere whim of the self-regulation, or 'hidden hand', of the 'market mechanism'. If capitalism was to be made to function for the common good, then this could only be achieved via a substantial and unprecedented intervention into private economic affairs by the apparatuses of the public state; as Franco Modigliani puts it: 'the fundamental practical message of the *General Theory*

[is] that a private enterprise economy using an intangible money *needs* to be stabilized, *can* be stabilized, and therefore *should* be stabilized by appropriate monetary and fiscal policies' (Modigliani 1977:1).

Essentially, what each variant of subsequent post-war Keynesian economic policy sought to achieve was the manipulation of the sum total of national consumer demand as a means of counteracting the fluctuating and destabilising tendencies of markets when left to their own devices. At the core of this macro-economic theory lay the attempt to stabilise the highly volatile relation between wages, productivity and inflation. If the costs of labour rise at a greater rate than the rate of productivity then profit shares will be squeezed, investments will be curtailed and there will be a general fall in the rate of accumulation. Alternatively, if productivity rises at a greater rate than the rate of increase of real wages (i.e., as measured against the cost of living), then, over time, there will follow demand failure and overproduction, once again resulting in drop in the rate of accumulation. Consequently, in order to avoid either a crisis in wage relations or a crisis in commodity relations it becomes critical that a mass-production/mass-consumption economy manages to maintain a relatively constant, and certainly a stable, differential between, on the one hand, the rate of labour costs and, on the other, the rate of productivity. When taken together, all advanced capitalist countries between the years 1955 and 1968 witnessed a remarkably stable relationship between these two rates, a differential which fluctuated little from an average of 3½ per cent a year (Armstrong, Glyn and Harrison 1991:121).

To a large extent, this stability between wage and production rates was to be achieved through an unprecedented alliance between the various agencies of capital and labour. As Armstrong, Glyn and Harrison (1991) have suggested:

> Broadly speaking, workers obtained certain rights and material benefits. The most important rights were those to free trade unions and certain forms of representation. The most important benefits were adequate job provision, regular pay rises and state welfare services. In return, they did not question capitalist ownership or control. Employers were prepared to tolerate these rights and provisions in return for a profitable economic environment.
>
> (Armstrong, Glyn and Harrison 1991:136)

From such a fundamental coalition did the affluent societies of the post-war years take shape. Capital was persuaded by the state to trade away its most overt forms of exploitation (an erosion in the value of real wages) in return for the guarantee of sustainable and steady rates of profit, whilst labour forsook its natural inclination towards militancy in return for significant increases to the rates of real wages. Importantly, this now meant that high levels of productivity could at last be met by correspondingly high levels of consumption. Such a strategy, it seemed, had finally delivered into the hands

of the modern capitalist economy the means to abolish the threats of demand failure and overproduction. The net result was an unprecedented period of stable growth which existed throughout most of the advanced industrial world and which was to last until the early 1970s.

But the economic miracle was not to be achieved solely by the direct social contract signed upon the factory floor between capital and labour. This contract was of course to be hugely underwritten by the creation of the welfare state. For if the sphere of direct wealth creation was thought to be too important to be left to the unpredictable logic of the free market, then so too was the reproduction of labour-power thought to be too important to be left to the abstract laws of the same economic principles. Building upon clear precedents established in Germany as far back as the 1880s, governments of both the left and the right throughout most western countries began to recognise and act upon the imperative of establishing a general system of social insurance which would guarantee for every worker 'the minimum income needed for subsistence'. From this principle, the widespread introduction of state-sponsored systems of education, housing, income maintenance and health-care would soon become the stabilising force *par excellence* of the new social structure; they would be seen to be the ultimate guarantor of a popular consensus, an effective mandate for the new regime of accumulation.

At this point we can summarise the main features that brought to fruition Fordism as a mature regime of accumulation during the period 1945–73: first, the culmination of a series of transformations to the means of production and labour practices; second, the effective emasculation of the revolutionary powers of labour which was compensated for by real gains in wages and hence provided the necessary consumption capacity for the full realisation of productivity; third, the establishment of macro-economic controls and the increased interconnection between the apparatuses of the nation state and private enterprise who were now united under the general principle of the 'national economic interest'; fourth, the formation of a new type of working-class society cast by the full application of welfare rights and the principles of social and consumer democracy.

Driven on by the massive rebuilding programmes and investment opportunities that were left in the wake of the Second World War, Fordism took its chance to remake the world anew. The touchstone of this system soon became the American productive base, and this materialised when the dollar became the international reserve currency following the Bretton Woods agreement of 1944. Under this US leadership which was backed by an enormous military might, Fordism crystallised as a complex network of agreements, coalitions and alliances bringing together an often diverse range of industrial, financial, labour and state partners. This was, above all else, a time of enormous social, economic and political consensus which, as we shall see presently, also had its correlate in a certain hegemony in cultural affairs.

This has led some commentators to see this period as the culmination of a longer-term sweep of transformations to capitalism, the origins of which can be traced to the late nineteenth century. Claus Offe (1985), for example, and more recently Lash and Urry (1987) have spoken of the rise of *organised capitalism*. Organised capitalism is here understood to describe the steady evolution of capitalism as it has changed from a liberal or *laissez-faire* model of enterprise which dominated the eighteenth and much of the nineteenth centuries, to a twentieth-century, state-managed capitalism. The former type of capitalism was based upon an ideology of individualism, a private-enterprise system governed by the central principle of a completely unfettered commodity exchange within a sovereign market and regulated only by its own 'inherently stabilising' mechanisms. Organised capitalism however, saw that such principles were slowly eroded and replaced by the political ideologies of corporate control, state planning and government intervention into most domains of socio-economic activity. Throughout the advanced industrial world during the first two thirds of the twentieth century the rise of organised capitalism not only touched those directly economic aspects of society, but also any sphere within social life that may possibly have had a bearing upon the operation of the market. In this context, Fordism represented the full flowering of a number of developments in the long-term evolution of modern capitalism. Using as a basis for analysis some of the key points provided in Lash and Urry's account, we can identify the following features as central to the development of an organised capitalism:

1 The concentration and centralisation of industrial, banking and commercial capital; the growth of cartels and the implementation of many price-fixing markets to assure a general measure of agreement between producers over levels of productivity and prices.
2 The separation of ownership from control and the development of new forms of rigid, hierarchical, authoritarian and bureaucratic systems of management in order to guarantee the most efficient deployment of capital and resources.
3 The rise of a bureaucratic, administrative and professional middle class employed largely in the new managerial, scientific and technological occupations. This paralleled the rise of a new ideology of social embourgeoisement, or the 'classless society', tangible evidence of which was held to be the phenomenon of the so-called affluent worker.
4 The growing importance and bureaucratisation of collective-bargaining organisations within labour markets and the implementation of various formal and legislative mechanisms between labour and capital. These were implemented in order to pacify radical working-class and labour movements through the exchange of real gains in income and working conditions for the assurance of politically passive and undisruptive labour.
5 The 'inter-articulation' and the tacit and formal coalitions between the

state and large monopolies in order to ensure a certain coordination between key socio-economic initiatives and objectives. The adoption of specifically Keynesian fiscal and monetary policies such as transfer payments as a means of manipulating or managing consumer demand to stabilise the market. The implementation of highly protected national markets to safeguard against the destabilising consequences of unregulated international trade and competition.

6 The rise of welfare statism in the attempt to provide a stable social environment for the reproduction of labour-power.

7 A greater bureaucratisation and centralisation of the state.

8 The increasing expansion of markets and production globally within the broad framework of Empire.

9 The concentration of industrial activity into a few key sectors, most notably those of automobile manufacture, building and construction, shipping and other transportation equipment, petro-chemicals, steel, rubber, and the production of 'white goods'.

10 The establishment of a mass-core workforce employed in the above industrial sectors and consisting of a largely male, blue-collar workforce.

11 The association of specific industries with certain national and regional centres.

12 The growing importance of large-scale industrial cities which came to dominate particular geographical regions and provide the prime source of employment for those regions.

13 The cultural-ideological configuration of 'modernism'.

Additionally, it is worth noting the following developments which, although not necessarily unique features of organised capitalism, were none the less critical to its stabilisation:

1 The systematic transformation of the geographical spaces of daily life, most notably in housing and transportation networks, to accommodate the redispersed configuration of the public and private spheres.

2 The reorganisation of familial relations; the demise of the extended family unit and the birth of the small family household as the modern 'unit' of consumption.

3 A socialisation of finance; mainly the provision of extensive consumer credit, hire-purchase facilities and mortgages.

4 The rapid development of mass media and other electronic communication networks to correspond to the extensive reorganisation of geographical relations and the dispersal of localised communities.

5 The growth of a number of critical cultural-economic intermediary agencies in order to regulate the appropriate cultural dimensions of a mass-consumption norm. Such agencies would include those of advertising, marketing, mass design, commodity aesthetics and the new 'science' of motivational research.

Of course not all of these developments applied equally to every country. For Lash and Urry the sum of such developments represented an 'ideal-type' organised capitalism. The extent to which this ideal-type was allowed to penetrate the socio-economic structure of a given country was always dependent upon the precise economic, social and cultural history of the country in question. Consequently, the period when a country first became industrialised, the degree to which certain pre-capitalist organisations, such as the church, universities, guilds and aristocratic bodies, may be resistant to change and persist into the capitalist era, the strength of traditional cultural norms in resisting change, and the geographical size of each country, was to each play a determining role in the extent and impact of organised capitalism. For example, not every sector of the manufacturing sphere in some countries fully embraced an ideal-type Fordism and the true principles of mass production. A curious feature of the indigenous car industry in Britain, represented by manufacturers such as Austin and Morris, was that it tended to adopt a mixture of new mechanised production techniques whilst at the same time retaining, and in some cases positively espousing, the virtues of some older craft methods of assembly and labour organisation.

In spite of the uneven development of organised capitalism throughout the advanced industrial world, what is surely not in question was the considerable impact upon everyday life that such socio-economic transformations had engendered. In basic terms, the structure of everyday life had undergone a radical change: people lived differently, worked differently and satisfied their needs differently. The rise in the value of real wages established a new standard of living, whilst new consumer goods, such as white goods and other domestic appliances, became available for the first time to a majority and not merely restricted to a privileged middle-class market. As Jonathan Gershuny (1986) has argued, many 'households could be warmer, better fed and clothed and get more entertainment' (Gershuny 1986:336). Less time was needed to be spent on routine domestic chores and more time was available to spend on new forms of consumption, and especially new forms of leisure such as eating and drinking out-of-home, the participation in and spectatorship of sporting activities, visits to the cinema, clubs and more time available to watch television, listen to the radio, etc.

The substantial changes wrought by the economic reorganisation on the conditions in which and from which ordinary people established their daily living routines thus begs the inevitable and far more problematic question of the impact of Fordism/organised capitalism upon everyday *culture*. This is considered in the following chapter.

Chapter 6

Easing the passage of modernity

While the previous chapter has attempted to summarise the relatively concrete components which comprised Fordist political economy, the purpose of this chapter is to consider the far more abstract structures within which the major cultural formations of the Fordist period were housed. My intention here is not to provide a comprehensive account of Fordist culture as such (if such a thing could ever have been said to have existed), but merely to identify those institutions of the Fordist era which can reasonably be said to have functioned as agencies of 'cultural regulation'. The premise I work from, therefore, is essentially straightforward: in a mass-consumption economy, in order for value to remain in motion and for the accumulation process to proceed relatively smoothly, the agencies of capital require that the mass of ordinary people (whether taken from the standpoint of labour-power or as consumers) both think and behave in a manner which is broadly supportive of the prevailing economic and political interest. Of course, even during the most stable periods of economic prosperity the realities of everyday cultural action can by no means be reduced to a mere function of the various institutions of regulation. As we have seen, there is an overwhelming body of subcultural, feminist and other evidence to suggest the extremely tenuous hold that the cultural or 'consciousness' industries have over the hearts and minds of ordinary people. However, while it is important to recognise the 'relative autonomy' of culture, it is equally important to resist the super-ficially seductive idea that everyday culture represents an isolated sphere of human activity somehow emerging from within an ideological vacuum: the formation of any group's cultural sensibility is always limited by the material and symbolic structures of the social reality within which it is located. It is also constrained by the diet of material and symbolic resources which are available to it and which effectively constitute the 'raw materials' of cultural expression. It is therefore proper that we pay close attention to those institutions that help define the nature of those structures and provide the available range of cultural goods.

What follows, then, is more or less a 'snapshot' of what I have called, somewhat rhetorically perhaps, 'official Fordist culture'. By this I refer to the

complex and sometimes contradictory network of value and belief systems suggested by the various social agencies whose implicit, and sometimes explicit, functions have involved, either formally or informally, a regulation of the routines, practices and ways of thinking that could be found within the daily lives of ordinary people living in Fordist society. My use of the term *agencies of cultural regulation* in this context, however, is not meant to signal anything as totalising or repressive as the notion of the consciousness industries; rather it is intended to depict a number of commercial and state institutions and organisations that have had a vested interest in promoting a sort of 'ideal Fordist cultural formation', an ideal cultural formation as viewed, perhaps, from the perspective of capital and the state.

When seen from such a perspective, the relationship between economy and culture appears to be crystal clear and can be summarised as follows. The key to successful economic enterprise not only depends upon the acquisition of appropriate labour-power for production, but also upon the establishment of such social conditions as are appropriate for the *reproduction* of that labour-power. Simply put, the expenditure of a given sum of labour-power must always embody a certain proportion of *socially necessary labour* – that proportion of daily labour which is objectified in quantities of time and is necessary to secure a value equivalent to the means of subsistence. The value of socially necessary labour is materialised in the wage which can then be exchanged for those objects of consumption that will enable labour-power to be reproduced according to a given social average standard of living.

Of course, we would be in error if we reduced the value of socially necessary labour to a value equivalent only to the means of basic physio-logical subsistence (what it takes to purchase basic shelter, food, clothing, etc.). Human needs are, in every form of society, always socially relative and valued according to an historically specific standard of living. Throughout the twentieth century, capitalism has consistently raised the average standard of living and also extended the commodity-form into previously uncommodi-fied areas of social life. Most significantly perhaps, this has involved the creation and commodification of a greater diversity of cultural needs. This defines cultural needs as an equally legitimate aspect of the average standard of living as those of a physiological nature and makes their satisfaction an integral dimension of the reproduction of labour-power. This increasingly forces capital to define the value of socially necessary labour in terms that tie the wage-labour relation to the broadly equivalent values embodied in both necessary material *and* cultural goods and resources. Consequently, culture is placed at the heart of the modern political economy. It becomes vital for the successful reproduction of capitalism itself that contemporary culture and cultural practice conform to, or at the very least do not hinder, the broad social trajectory of capitalist development. This, then, grants commodity relations and questions of consumption generally a far more significant status within the modern capitalist economy than merely that of the quantitative

calculation of financial expenditures needed for Keynesian strategies of demand management. The sphere of consumption and commodity relations are thus designated as equally critical and valid sites of modern class struggle as those within the sphere of production and wage relations. Accordingly, as capitalism has always attempted to control labour relations within the sphere of production, then so too has it increasingly attempted to control and regulate the activities of everyday cultural practice primarily through the commodity-form. But the transformation of cultural practices and attitudes in line with the broad needs of the prevailing mode of production is never routinely achieved. From the point of view of capital, traditional or established cultural practices tend to display a stubborn persistence in the face of material and economic change. The fact that established cultural practices cannot easily be dissolved and reformed by the forces of capital produces a significant time-lag between the slow moving transformations of the cultural milieu within which consumers behave, and the reasonably rapid transformations to the mode of production and the primary circuits of capital accumulation. It is by no means a piece of fanciful speculation, therefore, to suggest that the inability of capital to transform the dominant cultural landscape of capitalist societies represents a primary cause of overaccumulation throughout the present century.

The emergence of Fordism saw the most systematic attempts to date to develop a mode of regulation in which the cultural dimensions of consumption and commodity relations could be adapted and stabilised according to the requirements of production. In Fordism there is established a complex of regulating networks, the aim of which is to couple changes to the mode of production to a series of changes held to be appropriate within the cultural sphere. In short, Fordism saw the first attempt to establish a social consciousness based upon mass commodity consumption and which, it was hoped, would soon become inscribed throughout everyday life and its practices. This point is clearly recognised by Aglietta who argues that consumption:

> should not be seen in a principally functional sense. It concerns the position of the individuals concerned in social relations, and the representation of this position within the group of individuals who share it, as well as *vis-a-vis* other social groups with whom they share relations . . . this representation is effected in the form of a recognition which involves the perception of definite cultural attitudes . . . Such relations, which issue from social stratification and require specific reproduction, actively differentiate the process of consumption. They can be referred to as *status* relations. The concept of status is not merely needed to interpret social differentiations in consumption; it is equally necessary to understand their renewal over time, and the conditions of their stability or distortion which makes it possible to speak scientifically of a social process of consumption, or even a mode of consumption. The effect of status on the consumption process is expressed

in acquired habits which stabilise the maintenance cycle of labour-power into a routine. These habits are transmitted from one generation to the next.

(Aglietta 1987:157)

It is particularly unfortunate that none of the authors of the Regulation School address, at least in any systematic detail, the cultural composition and configuration of Fordist society. The tendency here, as with so much political economic analysis, is to rely upon a series of rather bold, speculative and often highly generalised claims in which the dominant cultural sensibility of a mass-consumption norm is simply 'read off' from the impact of certain material and economic changes to the lives of ordinary people. The temptation all too often has been to lapse into a problematic, overdeterministic and somewhat functional base/superstructure model of class and social relations, even within those accounts where the economic base is produced only in the famous 'last instance' of social determination.

In order that we may begin to explore the complex interrelations between culture and consumption as these have existed under Fordism, it is first necessary perhaps to identify those dimensions of social life from which culture and consumption both draw their distinctive characters. Chief amongst these are:

1 The organisation of domestic life; principally the organisation of the family and the status of prevailing gender relations.
2 The organisation and nature of labour markets and the constitution of the wage-labour relation.
3 The nature of consumption and the form taken by both individual and collective goods.
4 The organisation of the physical spaces of daily life.
5 The temporal organisation of daily life.
6 The dominant mode of aesthetics and representation which penetrates everyday life.
7 The allocation, provision and composition of everyday material and symbolic goods and resources.
8 The extent to which a common cultural heritage, which is materialised in distinctive customs, rituals, religious and other ceremonies, can endure, find a collective means of expression, or is affected and altered by processes of social change.

At the heart of Fordism's social impact lay a number of dramatic changes to domestic life. These involved a recognition by the agencies of capital and the state that the household and the organisation of its family members had become the critical site for the reproduction of both wage and commodity relations. Not only was the household seen to be that vital domestic space needed for the recuperation of labour-power from the daily fatigues of the intensive working practices demanded by Taylorism, but it

also became the hearth of modern commodity consumption. In traditional societies the role played by commodities in daily life was minimal. It could not be assumed, therefore, that merely by providing the working classes with the means to mass consumption, existing in the form of higher wages and greater periods of leisure-time, that there would automatically be established *the will to consume*. In *Captains of Consciousness* (1976), Stuart Ewen examines the way in the advertising industry of the early years of American mass production attempted to insinuate this will to consume into an everyday consciousness. The primary function of advertising at this time, Ewen suggests, was nothing short of the creation and stimulation of new consumer needs as well as to sell the system of mass consumption itself. Ewen's book provides us with a rich source of material illustrating the manner in which an emerging advertising industry unambiguously saw its purpose in modern society as chiefly ideological. Advertising, claims Ewen, took a leading role in constructing for the first time a national American identity which would be based upon the ideal of the mass-consumer market-place. To achieve this, advertising assumed the critical function of attempting to dissolve those cultural formations that had been founded upon the well-established agrarian ways of life and sensibilities that had long formed within the extended family networks and the immigrant communities of American society. Such cultures were to be replaced by an national and unified culture of mass consumption. In almost every respect, argues Ewen, traditional, heterogeneous and 'home-made' cultures stood directly opposed to those practices and values that were inherent within an embryonic consumer culture:

> Traditional family structures, agricultural lifestyles, immigrant values which accounted for a vast percentage of the attitudes of American working classes, and the traditional realms of aesthetic expression – all of which were historically infused with an agglomeration of self-sufficiency, communitarianism, localised popular culture, thrift and subjective social bonds and experiences that stood, like indians, on the frontiers of industrial-cultural development.
>
> (Ewen 1976:58)

It became important for an emergent Fordist regime not only to establish a new norm of familial relations which could provide for the steady and sustainable supply of labour-power, but also to find a way of allowing the spirit of modernity to penetrate everyday culture and so isolate and disperse the old values and practices of traditional life:

> It was these subjective experiences of traditional culture that stood between advancing industrial machinery and the synthesis of the new order of industrial culture. And it was incumbent on industry, in formalising the new order, to find a means to sacrifice the old. It was within this historical

circumstance that the creation of an industrialised *education* into culture took on its political coloration.

(Ewen 1976:58–9)

The passage of the new economic order into the domestic lifeworlds of ordinary people, the erosion of old and traditional practices, and the breaking of long-held communal bonds was, Ewen continues, assured by a systematic process of social planning on the part of corporate organisation in general and advertising in particular.

This strategic dissolution of traditional cultures found its principal focus in the household. Here the household was to be transformed from a domestic space of general self-sufficiency into a modern consumption unit. This would involve the dramatic reorganisation of the household in all its dimensions: physical, economic, demographic and cultural. Seen as central to the efficient management of consumer demand, a redefined household would become that necessary physical space required for the effective exercise of an administration and surveillance of individual patterns of financial expenditure, as well as providing for a certain measure of corporate-state influence over the many intangible cultural factors which in part determined those expenditures. Above all else, this meant a reorientation of established gender relations.

Of course modern capitalism did not invent the ideologies that we commonly associate with patriarchy and the division of labour according to gender. But capitalism did much to re-articulate those relations to constitute the sort of gender stereotypes we are so familiar with today. As early as the late nineteenth century some members of the American business world had begun to recognise the social impact of the mass-production system upon the domestic sphere. But the emergence of woman-as-consumer was not purely a functional product of the needs of the new economy; it had also resulted from a potent drive to give voice to a strong American ideology of equality which had been forged from the painful memories of the many years of struggle given over to achieving Abolition. Traditional patriarchal practices and values which defined man as the administrator and supreme governor of all areas of family life would increasingly come into conflict with the principles of democracy which lay at the core of the national American consciousness. That American society should not be seen to endorse overt social inequalities in part ensured that patriarchal dominance within the household was often forced into largely symbolic and ceremonial roles (although in reality it was no less powerful for this status). Instead, the legitimate position of masculine status was now displaced into the sphere of the workplace, and its valorisation became increasingly contingent upon a man's capacity to earn within this sphere. This fact, coupled with a powerful democratic rhetoric, cleared the way for women to be formally recognised as both homekeepers and consumers, and granted for them a legitimate, if ultimately subordinate, position as 'workers' within the new economic regime.

This position was of course greatly reinforced by the fact that 'women's work' was now formally addressed in the imagery and copy of advertising and other new media forms such as women's magazines. In particular, the principal function of advertising was to create a cultural bridge between a general feminine consciousness and the many material changes that were taking place to the daily lives of women at this time. Advertising became both the means by which women could be educated into the correct modes of consumption and shown the ameliorative benefits to be found in the functional and constantly improved use-values of new consumer goods, as well as a force by which those goods could be culturally legitimised within everyday life and its practices. Even under the most utilitarian of guises, however, use-value is always socially defined. The demonstration by advertising of the use-values of soaps, instant foodstuffs, vacuum cleaners, refrigerators, washing machines and many other domestic products was, at one instance, both a demonstration of modern functional utility *and* the attempt to objectify the social consciousness and the recently confirmed status of women firmly within the broad social relations that were required by Fordism. In this way advertising became a critical intermediary agency bridging the industrial process and everyday life. Its function was nothing other than that of easing the passage of industrial modernisation from the former into the latter domain.

Advertising was, however, not unique in the strategic redefinition of domestic and familial ideologies. The growing importance of the welfare state in many countries from the early years of the twentieth century onwards contributed greatly towards the cultural stabilisation of the new way of life. For the welfare state, as Elizabeth Wilson (1977) points out, 'is not just a set of services, it is also a set of ideas about society – about the family – and not least important, about women, who have a centrally important role within the family, as its linchpin' (Wilson 1977:9). Heralded under the banner of social progress and democracy, the welfare state sold a vision of a new and harmonious form of society. But this was to be a society steeped in ideological and legislative measures that were in truth little different in their net effects from those promoted by advertising and the mass media. The veneration of a nuclear family consisting of a wage-earning father/husband and a child-rearing mother/wife could now be given its official seal of approval by what appeared to be a modern and scientific state apparatus that claimed its popular authority from a basis of democratic and libertarian values. The state, it was claimed, had now been freed from the old dogmas and ideologies of feudal, religious and even class-based epochs. This meant that overt familial ideologies, such as those most famously espoused by John Bowlby (1963) who claimed that woman's natural place was at home with her children, could be given credence in their scientific discourse and hence easily infused into the new 'common sense' understandings of modern family life.

But the transformation of the household and the family into a modern consumption unit not only relied upon an effective communication of new domestic and familial ideologies by advertising, the mass media and the welfare state, such transformations were also underwritten by enormous material changes to the domestic living space itself. In short, these changes were dictated by the very principles which had been applied to the sphere of production, namely those of rationalisation, modernisation and the ceaseless drive to achieve efficiency within the place of work. The nature of domestic labour was seen to be little different in essence from that of productive labour. This meant that domestic labour could be subjugated to the same forms of general Scientific Management and mechanisation as those imposed upon productive labour. If this was to be the case, then the product of domestic labour; that is, a home environment and culture suitably adapted to meet the needs of the modern economic realities, was, like its industrial counterpart, also required to take a standardised format in order to accommodate recent developments in science and technology. This was most visibly materialised in the changed physical design and construction of the modern house and its internal living spaces. The technological historian Siegfried Giedion (1948) provides us with a fascinating account of the ways in which technology, science and mechanisation penetrated the spaces of the household during the pre-war years. Nowhere was this more apparent than in a reorganised kitchen. Continuous working surfaces, suggests Giedion, new forms of storage space, and integrated appliances and equipment such as multi-functional cooking ranges, refrigerators and food processors were all the effective product of a systematic policy of domestic restructuring, on the part of industrial planners and architects alike, to develop the home along the same principles of the factory and the office. Such changes were motivated by the urgent requirement to establish commodity consumption as the natural means to need satisfaction. This was a process in which traditional handicraft and home-production techniques (especially in the areas of food and clothing) were now to be presented as outdated and profoundly anti-progress.

The now familiar urban landscape of the modern world all grew out of the basic unit of the new domestic space. Plotted into rational suburban structures and complete with their centres of finance and administration, road and other communication networks, shops and places of public provision such as schools and hospitals, the reorganised spaces of everyday life constituted the socio-geographic response to the new productive forces of the age. At both a practical and an ideological level, the prevailing industrial ethos which sought the foreclosure of economic contingency via a process of bureaucratic planning and calculation was effectively mapped onto the physical living spaces of the everyday environment. In the words of David Harvey (1985), this was the era of the 'Keynesian City', 'shaped as a consumption artefact and its social, economic and political life organised around the theme of state-backed, debt-financed consumption' (Harvey 1985:205–6). This was to

achieve the 'mobilisation of effective demand through the total restructuring of space so as to make the consumption of the products of auto, oil, rubber and construction industries a necessity rather than a luxury' (Harvey 1985:207).

All these changes were of course hugely dependent upon the development of new aesthetic and representational forms. From the 1920s and the 1930s onwards, the introduction into the home of relatively inexpensive, mass-produced and standardised labour-saving goods, as diverse as cookers, vacuum cleaners, frozen and convenience foodstuffs, and off-the-peg fashions, also heralded the birth of a new commodity aesthetic. This was perhaps best represented in the phrase which has since become emblematic of the aesthetics of the modern era: 'form follows function'. For Aglietta, this functional aesthetic was nothing other than the logical extension of the material dimensions of the mode of production itself. It had, he suggests:

> firstly to respect the constraint of engineering and consequently conceive use-values as an assembly of standardized components capable of long production runs. It also had to introduce planned obsolescence, and establish a functional link between use-values to create the need complementarity. In this way, consumption activity could be rendered uniform and fully subjected to the constraints of its items of equipment.
>
> (Aglietta 1987:160–1)

These ideas about the functional aesthetic of Fordism are unfortunately relatively undeveloped in Aglietta's work. In fact it is disappointing, given the rich and broad ranging potential of Regulationist theory, that there have been very few attempts to carry this work over from the sphere of political economy in order to illuminate questions concerning the aesthetic and cultural regulation of Fordist society. (Philip Gunn's essay 'Frank Lloyd Wright and the passage of Fordism' (Gunn 1991) represents a rare and welcome, if somewhat brief, contribution to this theme.) Notwithstanding the absence of literature of aesthetic and cultural regulation, however, we can reasonably identify a number of important aesthetic movements of the period whose evolution appears to be closely related to industrial development.

Most obviously, perhaps, the aesthetic demands of the new industrial mode could be seen to blend with the much broader but far less unified ideals of a cultural modernism. While the numerous representational traits and practices which contributed to the many facets of modernism can in no way be regarded as simply co-terminous with, or reflective of, the dominant industrial and economic concerns of the age, they were in many respects extremely compatible with the ideals of energy, vitality and transformation found within capitalist developments. Modernism had not after all emerged as a cultural force independent of real world changes, but as a mode of expression that had been formed from the flux and tumult engendered by massive industrial transformations and their social, geographical and temporal effects.

But as a cultural sensibility that had started out life as the aesthetic response to the modern conditions of perpetual change and revolution brought about by industrialisation, modernisation could now be harnessed and used as a form of expression by the very forces against which it was initially responding. Consequently, now unbridled from the constraints and expectations of older, relatively static and undynamic forms of representation, capital could now freely develop its own unique brand of aesthetics through which the concepts of progress, speed, efficiency and functionalism could all be accommodated appropriately.

Nowhere can the sentiments of this new functionalist aesthetic be seen more clearly than in the design ethos of the Bauhaus. Indeed, the Bauhaus carried the veneration of the functionalist impulse to almost fetishistic extremes. As Daniel Miller (1987) explains:

> The *Bauhaus* is seen as the symbol of a drive to make all human creations serve the principles of style. In this new world, all architecture, furniture, clothing and behaviour are intended to relate to each other in a visibly coherent fashion. This works to break down all frames into a universal order of good design. The matching colour scheme is extended to all commodities, so that a given company may prefer machine tools manufactured by a firm with a reputation for design in microchips, attracted by that firm's modern hi-tech rather than its reputation for efficiency. Ironically, that set of ideas and ideals which expressed the legitimacy of form following function was most effective in ensuring that function followed form.
>
> (Miller 1987:129)

For many of those aesthetic movements, such as the Bauhaus, that were at the forefront of developing a new Fordist-modernist aesthetic during the early years of the twentieth century, the need to establish a purity of functionalist form became a directly political crusade. For such movements, the ideals embodied in technology, mechanisation, scientific objectivism and new forms of industrial organisation were seen to promise the best hope of resurrection for an embattled Enlightenment Project that was left withering in the wake of the destructive impulses and general sense of uncertainty that permeated the late nineteenth- and early twentieth-century consciousness. It was regarded as incumbent upon these leading artistic and cultural producers to give material and aesthetic form to that hope. Although extremely mindful of being seen to endorse any overt commercialism or vulgar populism that might also result from the technologies and methods of mass production, aesthetic movements such as the Futurists, with their unabashed celebrations of modern industrial achievement, and the bold architectural and design visions of such figures as Le Corbusier, Walter Gropius and Mies Van der Rohe, vigorously championed the need to develop a modernist aesthetic which would be able to break free from the narrow and regressive confines of

traditional aesthetic form. Encapsulated in maxims such as 'a house is a machine for living in' and 'by order bring about freedom', the spirit of the age could be infused directly into the material structures and social consciousness of everyday life.

But the virtues of sobriety and purity which could be found in this vision of the modern aesthetic represented, of course, only one half of the story. If the functional modernism that was emerging from a largely European centre eschewed the principles of consumerism and pleasure, then in America the new industrial ideals were seen in somewhat different terms. In the concept and practice of Streamform, for example, there was an altogether more populist, but no less legitimate, aesthetic rendering of modernity than that explored in the pure forms of Le Corbusier and others. Streamform, which took its name from the smooth, cigar-like or 'tear-drop' shapes pioneered in aviation technology, initially grew out of the search for solutions to purely functional problems (how to increase speed and efficiency, and reduce the air resistance of aeroplanes). However, by the early 1930s, according to Dick Hebdige (1988), Streamform design had been 'carried over into American car design' and 'by the end of the decade was beginning to be applied to commodities totally outside the transport field' (Hebdige 1988:59). By the time Streamform design had penetrated the world of everyday domestic objects, its functional appearances often seemed to owe more to matters of stylistic fashion than to those of utilitarian efficiency, to a purely symbolic rather than material function. But the stylisation of design in such a way by no means diminished the capacity of Streamform to bring to the consciousness of everyday life a contemporary ideal in which the once seemingly irreconcilable forces of stability and speed, rationality and revolution had been harmonised and made to accord to a strictly human-made plan. The symbolic values that were embodied in the streamlined appearances of goods as diverse as tape dispensers and electrical toasters became a potent means by which a mass-consumption ethic, built upon the foundation of standardised and uniform commodities, could be blended with everyday cultural sensibilities. Hence what began life as the functional solution to the problem of matter passing through air with the least form of drag became, as Stuart Ewen (1976) suggests, the symbolic solution to the problem of how the ideals of modernity would be able to cut through traditionally static and 'regressive' cultural practices with the least form of popular resistance.

The establishment of a certain hegemony over aesthetic practices during the period in question also suggests the existence of a similar cultural consensus over the issues of language, symbolic form and social meaning generally. As might be expected, this was a particularly distinctive feature of the language of consumption. In the fields of advertising, marketing and the newly emerging 'science' of motivational research, there was a growing feeling that the ethos which lay behind the principles of technological rationality and scientific objectivism, by now well enshrined within indus-

trial orthodoxies, could also be brought to bear upon the individual cognitive processes by which collective social meanings were achieved. Pioneered by such figures as Ernest Dichter and Pierre Martineau in the 1950s, motivational research in particular expressed a belief that human understanding of the symbolic capacities embodied in words and objects could be so analysed, and made to conform to certain general symbolic principles, that the production of collective social meaning genuinely common to all of society could at last be achieved.

Published in 1963, Dichter's *Handbook of Consumer Motivations* provides an exemplary illustration of this belief. Offering itself as an encyclopaedia of the world of things for the modern communications practitioner, the book is effectively an attempt to place a logical order upon the seemingly irrational processes by which people give symbolic meaning to things. In essence, Dichter's work can be seen as a specific attempt to concretise the relationships between signifiers and their signifieds, and thus to grant social meaning a sense of fixity and permanence. Hence, consisting of descriptive interpretations of literally hundreds of everyday objects and concepts, the book claims to represent a definitive taxonomy of everyday symbolism, a taxonomy in which the fluidity of social meaning is at last channelled into calculable and quantifiable patterns of a scientific order. What is remarkable about the book is not so much its contents (which actually amount to little other than a fairly superficial pop psychology of everyday objects), but simply the fact that the book is clear evidence of the view that the forces of modernity were, at that time, thought to be so powerful and irresistible that they could be brought to bear upon and master the dark and mysterious processes that determined the symbolic order itself. Indeed it is probably a testimony to the strength of the project of modernity that such a book was ever written at all, let alone taken seriously. For Dichter, language and the symbolic order were simply the tools for the furtherance of social progress, and advertising and marketing were to become the media through which this progress towards a more rational consumer could be administered effectively. By the early 1960s, so apparently successful had this hegemony over language become, in the world of consumer goods at least, that whole lifeworlds and states of being could be condensed into a single brand name that was pregnant with rich significations: Coca Cola, General Electric, Ford, Frigidaire, Kellogg, General Motors . . .

If the mastery of everyday language and cultural expression found its more optimistic articulations in the exaggerated claims of motivational research and advertising, then it surely found its pessimistic, but equally grandiose, responses in the intellectual and academic voices of the period. It is almost certainly a fair gauge of the general consistency and long-term continuity of the social consensus of the post-war years that so much of the critical debate of that time focused, often to the point of obsession, upon questions of mass society, dominant ideology and manipulationism. From the

moral indignations of F.R. Leavis (1930) and Denys Thompson (1964), the grave concerns over the abuse of psychoanalysis in advertising famously documented by Vance Packard (1957), to the omens of a decaying of public life that were foretold in the books of Richard Sennett (1976) and John Kenneth Galbraith (1985); from Richard Hoggart's requiem for the local community and its culture in *The Uses of Literacy* (1958), to the radical Marxism of the Frankfurt School, Louis Althusser and Jean Baudrillard, the new economic order had so ruthlessly and efficiently destroyed organic culture and any trace of a radical political action and thought, as to make the forces of capital and state appear to be truly awesome. At their extreme, such ideas offered a vision of contemporary society in which it seemed that everyday culture and social identity could now be manufactured at the whim of big business and the state apparatus. From this position it appeared that social consciousness itself could be produced almost as effortlessly as the assembly lines were producing automobiles or bars of soap.

Of course for Baudrillard this process was indeed little other than a purely functional, quasi-industrial mode of cultural production. Social consciousness, he suggests, is produced and manipulated by advertising and the media. Advertising in particular speaks a coherent language of consumer goods – a 'system of objects'. This system of objects articulates a system of consumer needs and desires in which the sign-values of commodities function according to principles similar to those governing the economic values of commodities. Just as the commodity has an economic exchange-value which is determined by the laws of economic equivalence and exchange, and which, in the modern world, is effectively regulated by the actions of cartels and price-fixing markets, then so too is the sign-value of the commodity determined by similar laws of linguistic equivalence, and regulated by the 'price-fixing markets' and 'cartels' of advertising, marketing and the media. This tyrannous form of 'sign-control' becomes for Baudrillard the true essence of contemporary capitalism. The exercise of power in the era of multinational capitalism, he continues, has shifted its centre of gravity from the realm of capital's domination of labour to its domination of the 'consuming masses', who are now subjected to all the terrors of meaning and signification transmitted by advertising and the media.

What such a totalising model as this tells us about the culture of Fordist society is just how naturalised and so securely inscribed into everyday (and academic) thought processes the ideologies around which Fordist hegemony had crystallised had become. When the aesthetic politics of design and architecture, the imagery and hyperbole of advertising, marketing and the media, the rhetoric of governments and the guiding principles of corporatism each seemed to imply a series of mutually compatible definitions of the social reality, then the sign of social discourse had indeed become, to borrow Vološinov's term, uni-accentual. This seemed to signal the triumph of the superclass over its subordinates, for not only did it appear that Fordism had

reorganised the spatial and temporal dimensions of the modern world via the production and consumption of standardised commodities, but it had also managed to establish a truly collective, social symbolic language that was designed firmly with the interests of the 'superclass' in mind. It was a period that saw, in the words of the Regulation School, 'the real subsumption of labour to capital'.

On the one hand, then, we are faced with all the celebratory rhetoric of social progress and cultural unification offered by the agencies of Fordist modernity. On the other hand, we find ourselves confronted with the impoverished social landscapes described in the mass society and dominant ideology theses of many of the academic literatures of the time. Between these two visions of 'official' Fordist culture it is perhaps easy to miss the fact the unity/domination of society captured by the post-war consensus was forged by a hegemonic (in Gramsci's use of the term), and not a functional or deterministic, process of social regulation. The use of Gramsci's concept is important here, for it reminds us that the mode of regulation around which Fordist culture took its distinctive form was forged through a process of *active negotiation*; a complex of alliances between strategic social formations with the view to winning the hearts and minds of subordinate groupings. Hegemony is therefore not a purely functional process. Neither can its reproduction, once it is established, be maintained unproblematically, for once won, hegemony must be reasserted and redefined according to shifting social and historical relations and conditions. This makes the ideology and language of Fordist culture an example of a powerfully effective hegemonic process, an extremely well-regulated culture.

However, while there can be no doubt that this period saw a remarkable stability over linguistic and symbolic forms, and did indeed produce a certain homogeneity in cultural value and belief, such conditions also provided the very real potential for new forms of social and cultural resistance to the established symbolic order. In short, Fordist culture also opened up the possibilities for its own critical interrogation. This general point has been well expressed recently by David Tetzlaff (1991). Tetzlaff argues that:

Ideology is not self evident; like any meaningful sign-system it must be decoded. Thus, ideological subjects must possess fairly sophisticated decoding skills. They must have the desire and ability to work through the rhetorical construction of arguments, to draw semiotic connections, to look beneath the surfaces of the signs and establish hermeneutic depth. In order to support these skills, the dominant system must foster in its subjects some forms of rationality and cultural literacy. It must also foster some form of social literacy, as the language of ideology is necessarily political. Ideology assumes an attention to social affairs, and an understanding of them in some form as well. In short, ideological control is problematic because it must address the relations of dominance in order to support

them, and must promote mental and cultural abilities which can also be turned around and used to generate analysis, critique and oppositional strategy.

(Tetzlaff 1991:14–15)

Given this position, Fordist culture was, like no other modern culture before it, steeped in the democratic principles of education, social provision and mass social and political literacy. It thus laid itself open to a potentially massive critique of its own foundations by the very 'subjects' its was attempting to recruit. Contra Baudrillard, Althusser, Marcuse et al., the cultural-ideological composition of Fordist society was not that smooth and impenetrable system which they proclaimed it to be, but one which did indeed walk a precarious tightrope between, on the one hand, the procurement of a mass social compliance to its ways and structures and, on the other, the triggering of a massive social disaffection with those ways and structures. Necessarily based upon a more equal allocation of material and symbolic resources, Fordism made available to many social groupings the potential means by which the very economic and cultural structures that undergirded Fordism could be placed under an enormous scrutiny. Indeed, it was a number of crises that beset the mode of regulation, and especially the regulation of culture, that contributed greatly to the crisis of Fordism generally throughout the 1970s. These, along with the more directly economic causes of the crisis, are examined in the next chapter.

Chapter 7

Decay and rejuvenation

AFFLUENCE AND ITS DISCONTENTS

The major crisis that was to beset Fordism towards the end of the 1960s and throughout the 1970s was not, as it has often been suggested, the product of some aberrant 'external' factor which destabilised an essentially healthy capitalist system. The crisis was not, for example, the result of the trebling of the price of oil by the Arab cartel and the ensuing oil crisis of 1973. Nor was it caused by the exhaustion of natural resources. In truth, the major crisis of post-war capitalism was far more fundamental to the logic of capital itself. Writing in the 1970s, Edmond Preteceille and Jean-Pierre Terrail (1985) have argued that the post-war crisis was:

> a universal crisis of capitalist society, a profound crisis arising within the very heart of that society from the dominant social relations which define it: the exploitation of labour by capital and the process of capital accumulation. The heart of the crisis lies in the *overaccumulation* of capital, the structural result of the recent period of rapid capital accumulation which continued until the late 1960s.
>
> (Preteceille and Terrail 1985:88)

Since the concept of overaccumulation refers only to a general organic malignancy inherent to the long-term processes of capital circulation and accumulation, it is necessary to consider the specific causes and appearances of the post-war crisis in some depth.

The first sure signs of impending crisis could be seen in failing and stagnant markets. By 1970, most advanced capitalist countries had begun to witness the first significant indications of falling rates of profit and declining profit shares in their key manufacturing sectors. Tables 7.1 and 7.2 trace the fortunes of these prime economic indicators in the manufacturing sphere from the start of the post-war boom in the early 1950s, through the golden years of the 1960s until the depression of the 1970s.

For over 30 years the scourge of overproduction had been success-fully offset throughout most advanced capitalist countries by the rigorous

Table 7.1 Manufacturing net profit rate (percentages) 1952–75

Year	ACC	Europe	Japan	USA
1952	30.2	24.3	17.1	33.9
1953	29.4	24.0	19.6	32.9
1954	26.6	23.9	26.0	28.4
1955	30.7	24.3	22.9	35.3
1956	26.6	21.8	27.9	29.5
1957	24.6	20.8	36.9	26.1
1958	21.1	20.8	30.6	20.6
1959	25.2	20.9	32.7	27.8
1960	24.7	21.5	47.3	24.8
1961	24.0	19.3	52.8	24.2
1962	24.3	16.7	42.6	27.9
1963	25.7	15.7	45.0	30.7
1964	27.5	16.8	50.6	32.3
1965	29.1	16.7	43.6	36.4
1966	28.2	15.9	43.3	35.2
1967	26.1	15.9	49.8	29.4
1968	26.8	17.4	52.8	28.8
1969	25.3	18.2	53.6	24.5
1970	21.9	16.8	52.7	18.0
1971	20.7	14.5	42.6	19.9
1972	21.3	14.7	39.3	21.6
1973	21.9	15.4	38.8	22.0
1974	16.4	13.8	26.1	15.1
1975	13.1	8.8	15.2	16.2

Note: ACC: all advanced capitalist countries
Source: OECD (1989); prepared in this format by Armstrong, Glyn and Harrison (1991:352).

application of macro-economic regulators. However, by the end of the 1960s overproduction had begun to resurface. The boom in the staple consumer-durables markets, which had for many years formed the foundation of stable profits, had only been achieved through a mixture of Keynesian demand management strategies and the steady expansion of those markets across new geographic and, particularly, social frontiers. By the late 1960s, however, a large percentage of homes had come to participate fully in the new democracy of mass consumption. The average standard of living was correspondingly raised to include many of Fordism's key consumer goods. This meant that while these markets remained important centres of manufacturing activity (largely ensured by planned product obsolescence and heavy advertising), they none the less began to approach a point at which any further acceleration of profit rates and accumulation could not easily be maintained. Saturation and declining rates of profit in such spheres as the automobile and white-goods markets inevitably had a knock-on effect in the primary indus-

Table 7.2 Manufacturing net profit share (percentages) 1952–75

Year	ACC	Europe	Japan	USA
1952	24.8	30.4	22.1	21.7
1953	23.7	29.3	24.2	20.5
1954	23.5	28.9	29.0	19.7
1955	25.2	28.6	26.1	22.9
1956	23.1	25.9	29.4	20.4
1957	22.8	25.8	36.0	19.5
1958	21.7	26.1	33.1	17.2
1959	23.5	26.0	33.2	20.6
1960	23.3	26.4	40.6	18.6
1961	23.1	25.0	43.3	18.6
1962	22.5	22.5	38.3	20.0
1963	23.3	21.9	39.4	21.5
1964	24.4	23.2	42.0	22.1
1965	25.2	23.1	38.3	24.3
1966	24.6	22.3	38.3	23.7
1967	24.2	22.7	41.1	21.8
1968	24.6	23.3	42.1	21.7
1969	23.8	23.4	42.3	19.3
1970	21.9	21.8	42.0	16.0
1971	21.6	19.7	37.5	18.3
1972	22.0	20.2	35.6	19.2
1973	22.1	20.7	34.9	18.7
1974	18.8	19.1	28.8	14.5
1975	16.2	12.9	19.8	17.4

Note: ACC: all advanced capitalist countries
Source: OECD (1989); prepared in this format by Armstrong, Glyn and Harrison (1991:354).

trial sectors that supplied those markets, most notably in the areas of steel, petro-chemicals, rubber and plate glass.

As these key markets began to show signs of failure when measured against falling rates of profit and productivity, the control and regulation of labour and its costs became absolutely critical to Fordism's reproduction. Keynesian economic policies were of course predicated upon the control of labour by a strictly administered incomes policy which tied wage increases to productivity. This, when coupled with important welfare guarantees, undoubtedly led to enormous mutual benefits for both capital and labour so long as productivity remained at a steady and constant rate of increase. But the Keynesian contract which brought together the agencies of capital and labour into a pragmatic acceptance of the legitimacy of each other's position was underwritten by the tacit agreement that wage-claim restraint would become the necessary corollary to falling productivity. For a workforce socialised over many years into the expectation of constantly improved returns in

exchange for their labour-power, the small-print of the Keynesian contract was hard to accept and, to a large extent, relatively easy to resist. Full employment rights and a strong and well-organised trades-union movement, which was of course now backed by certain legislative guarantees, had given the working classes perhaps their first real taste of political power in the history of capitalism (best illustrated by the almost powerless position of the Italian employers and government when faced with the crippling series of strikes and disputes during Italy's 'hot autumn' of 1969). Unable to regulate wage costs effectively, this meant that the only way for capital to reconcile its increasingly divergent interests with labour, and to maintain profit shares at a level anywhere near those of the peak boom years, was to pursue a vigorous policy of raising prices. By the early 1970s, the central principle of the Keynesian compromise had been flouted, producing a rapidly spiralling rate of inflation which was later to be combined with stagnant production and eventually stagflation.

However, it was not only in the regulation of wages that labour was to contribute directly to the crisis of Fordism during the 1970s. Inflexible and well-institutionalised working practices increasingly precluded the typical Fordist organisation from any innovatory redeployment of labour and technology. Taylorism, which had of course formed the cornerstone of Fordist successes, was based upon the systematic deskilling of the workforce by the repeated fragmentation of work-tasks which were then formalised by rigid job-demarcation boundaries. For many years each round of job fragmentation brought an increase in the efficiency of labour. But as work-tasks became simpler with each round of labour reorganisation, the lower became the efficiency yield of the sum total of abstract labour. Without any radical restructuring of the basic labour process this meant that Taylorism would eventually reach an optimum point of work-task fragmentation beyond which there would cease to be any effective or profitable increase in labour's efficiency.

According to Aglietta, these limits to Taylorism could be seen in three features. First, there was an increase in 'balance delay time' which resulted from the multiplication and wider displacement of individual tasks upon the assembly line. Inevitably, some of these tasks were of a longer duration than others. The disproportionate distribution of time per task when stripped across a whole plant led 'to a total time lost equal to the sum of those periods spent waiting by the workers with shorter cycles. This time increases with the further fragmentation of tasks' (Aglietta 1987:120). The net result of this was to be exactly the reverse of Taylorist objectives of work rationalisation: an increase in the 'porosity' of abstract labour-time; that is, a leakage of time from the total working day and an increase in the time that was occupied by idle labour. Second, the greater intensification of the work process which was required under Taylorism also compounded the negative psycho-physical effects upon individual workers. In the late 1960s and throughout the 1970s

this had led to greater levels of absenteeism through illness and indus-
trial injury. This also had the effect of galvanising the struggle over pay
and conditions as firms increasingly saw profit shares diminished through a
series of costly strikes and other labour disputes. Third, the greater frag-
mentation of work-tasks further eroded worker self-responsibility and finally
broke any bond that may have existed between the variables of effort, reward
and output.

In the light of these factors it was indeed ironic that from the late 1960s
onwards Fordism was met by the failures of its own brainchild – the now
highly inflexible, increasingly inefficient and unprofitable working practices
embodied in the concepts and principles of Taylorism. The image of poor
industrial relations and growing levels of unrest and absenteeism gradually
began to replace the idea of unprecedented productivity as the real hallmark
of Fordism. Although the picture of the bloody-minded, affluent British car-
worker, engaging in petty job-demarcation disputes, was no doubt falsely
amplified and certainly overstated in a number of sensationalist popular-
press reports and parodying comedy films of the period, it none the less had
its basis in a real decay within the manufacturing sector brought about
through a decline in labour relations. In short, by the late 1960s class struggle
had begun to reassert itself once again despite the many real material gains in
wages, goods and leisure resources that labour's subjugation had previously
bought.

Internal problems to the regime of accumulation were not, however, to be
the exclusive causes of crisis; there were also problems with the mode of
regulation. Ailing domestic markets began to force many multinationals to
engage in vigorous overseas competition and expansion in the spheres of
both production and consumption. From the early 1970s many advanced
capitalist economies began to witness a significant migration of capital to
Third World regions. This 'corporate flight', as Bluestone and Harrison
(1981, 1982) have labelled it, was brought about by the simple attraction of
the cheap labour-power, weak or non-existent labour and union organisation
and the favourable government fiscal policies of many Third World countries.
Thus began the major deindustrialisation of many western economies as
productive capital was displaced from the First to the Third World in an
increasingly internationalised situation. This rush to exploit the opportunities
provided by the untapped overseas labour and goods markets also triggered a
demise of the strongly protectionist principles upon which post-war Fordism
had laid its essential foundations, to say nothing of the devastation that it
wrought upon the workforces and communities of many established Fordist
industrial regions who were to be suddenly denied their livelihoods.

Additionally, the rise of a number of newly industrialising countries
(NICs), such as Brazil and the countries of the Pacific Rim, greatly destabil-
ised the world economy by following policies of expansionist, export-led
growth. The internationalisation of capital which had started to gather

momentum by the end of the 1960s thus began to crack the essential regulating mechanism upon which Fordism had relied for its stable repro- duction: protected domestic markets. These had previously ensured the stability and steady evolution of the inherently volatile relation between production and consumption by such means as minimum wage laws and price- fixing markets. But in a highly competitive global market this relation could not be adequately policed. As Richard Barbrook (1990) comments, the dissolution of the protected national market towards the end of the 1960s 'allowed certain countries to "cheat" by benefiting from mass consumption without themselves paying the wages needed to make this possible' (Barbrook 1990:96). Under such conditions of international competition, the sanctuary that was normally to be afforded in the dollar as the international reserve currency and a policy of fixed exchange rates could no longer be guaranteed. From the 1970s onwards, the result of this globalisation of capital was to be floating and extremely unstable rates of exchange as country was set against country and international corporation against international corporation.

Finally, the hegemony over cultural affairs that had proved to be the important social cement that bound together the interests of capital and labour and the spheres of production and consumption had, by the late 1960s, begun to dissolve. In *The Cultural Contradictions of Capitalism* (1976), Daniel Bell addresses the problematic nature of modern capitalist ideology. For Bell the essential contradiction which lay at the core of modern capitalist culture was the incompatible relation between capitalism's cultural origins and its present ideologies. As an economic system, suggests Bell, capitalism has always been fuelled by certain ascetic principles of self-denial to ensure that profits are not wasted but usefully reinvested into the production of further capital. But with the development of a mass-production economy, capitalism is actively required to endorse and foster a generally hedonistic, spendthrift and throw-away ethic in order to operationalise a greater accelera- tion of commodity and value turnovers that is implied in the principle of mass consumption. (For an informative discussion on the relationship between capitalism and romanticism implied in this dichotomy see Campbell 1987.) The tension that exists between these two polarised ideologies of capital can be tempered for a certain length of time; it cannot, however, be restrained indefinitely. Dominant ideology is eventually forced to reveal its contra- dictions and is ruptured in the face of the formation of particular subcultural sensibilities which come increasingly into conflict with the essential ideo- logical base from which modern capitalism still draws its inspiration.

Nowhere was this sort of culture clash more apparent than with the rise of youth cultures during the 1950s and 1960s. Effectively, modern capitalism developed and defined the social category of youth which became the most prominent materialisation of the new mass-consumption ethic. But in order to achieve this, capitalism and the modern nation state had also enfranchised youth with the material and symbolic resources which could be used as

potential weapons of cultural subversion. At one level, the democratisation of consumption and the opportunities made possible by the affluent society opened up fertile teenage markets and made available for youth the now familiar material and symbolic objects by which they could objectify a common structure of feeling. From this perspective, teenage fashions, recorded music, cars and motorcycles, new forms of meeting places and centres of consumption such as clubs, cinemas and milk bars, all provided a rich source of potentially subversive cultural resources. At another level, the massive expansion within public education provided for some sections of youth culture a powerful political and social literacy from which new insights into the economic and political system could be gleaned. The combination of a radical political consciousness and the easy availability of teenage consumer goods, ripe for use as symbolic markers of a new subcultural status, supplied for youth culture as a whole a powerful means by which they could establish a critical social distance from, and negation of, the values that were espoused by their parent culture – values such as work, sobriety and moderation which were of course co-terminous with those of the social system into which youth was to be integrated and eventually asked to serve.

Youth can be seen here as perhaps the primary manifestation of the fundamental cultural contradiction of Fordist society. They were, as John Luc Godard had christened them, the children of Marx and Coca Cola: at once extremely lucrative and immediate marketing opportunities, but also highly volatile in their values and beliefs. At their most innocuous, the spectacle of youth subcultures represented for the parent culture a somewhat bizarre, exotic and often puzzling display of cultural difference; an 'otherness' tolerated only in so far as it could be explained away as forming some part of the modern process of 'growing up'. At its most subversive, youth provided a potent political force for social change, and, under some extreme circumstances, even a potential trigger for revolution itself (as witnessed in the pivotal role played by the student movement during the momentous events of the Parisian spring of 1968, or by their numerous demonstrations against American military involvements in south-east Asia).

Important though the energies of youth were in laying bare the ideological contradictions of official Fordist culture, they were, in the final analysis, only one aspect of a much broader sense of social disaffection that was forming throughout the 1960s. The hegemony that was secured by Fordist culture had by no means included all social groups. Many of those groups who, for a variety of reasons, had found themselves displaced at the margins of the bold utopian vision of affluence and democracy began to find powerful and collective voices to express their sense of exclusion and subjugation. To the radical politics of student society and the shocking consumer hedonism of the teenager we can further add to the factors that tore apart the post-war consensus over culture the following: the tremors that must surely have been felt within the established seats of power and government by the rise of the

civil rights movements; the overtly aggressive affirmation of cultural differ-
ence expressed in the ideology and actions of the Black Power movement; and,
of course, the substantial impact of the force of feminism as it clashed head-on
with many of the centres of patriarchal authority. All of these groups and
movements began to ask quite fundamental questions about the real validity of
the much-vaunted principles of social democracy and consumer freedom that
had been used ideologically to undergird Fordist society for many years.

All of these factors fused with the more general rumblings of discontent at
the further entrenchment of what Henri Lefebvre (1971) has called 'the
bureaucratic society of controlled consumption'. Together they formed an
unpredictable and explosive mixture of cultural force. By the time that the oil
crisis erupted during the winter of 1973–4, it was already more than evident
that, both economically and culturally, Fordism, as a stable and reproducible
system, was fatally weakened. The oil crisis tipped western economies into a
sharp nosedive and a widespread depression from which they were not to
show significant signs of recovery until the mid-1980s. It is from this time
that many commentators choose to identify the first indications of a new
regime of capital accumulation.

FLEXIBLE POST-FORDISM OR PRIMITIVE CAPITALISM?

Over recent years there has emerged a significant body of literature addressing
the social and economic transformations that have taken place within most
advanced capitalist economies during the 1980s. Although the precise effects
of new technologies, reorganised labour processes and reconstituted labour
markets, geo-political transformations, and new forms of distribution, supply,
exchange and consumption may have been hotly contested in the debate
conducted through this literature, a basic consensus can none the less be seen
to have evolved here. That consensus can be simply put: if the Achilles heel
of Fordism was its inability to respond swiftly to changing economic
circumstances, then the hallmark of the new 'Post-Fordist' economy can be
seen, above all, in its flexibility throughout all of the above spheres. A
glimpse at some of the terminology used to describe the formation of this new
economic system illustrates this point well. David Harvey (1989:147), for
example, has described the 'the early stirrings of the passage to an entirely
new regime of accumulation', a regime which, he tentatively suggests, can
best be described as *flexible accumulation*. Harvey is rightly suspicious of
overextending the implications and conclusions that may be drawn from the
various commercial and industrial practices that we would wish to associate
with flexible accumulation, both in its guise as a regime of accumulation and
as a mode of regulation:

Whether or not the new systems of production and marketing, char-
acterised by more flexible labour processes and markets, of geographical

mobility and shifts in consumption practices, warrant the title of a new regime of accumulation, and whether the revival of entrepreneurialism and of neo-conservativism, coupled with the cultural turn to postmodernism warrant the title of a new mode of regulation, is by no means clear. There is always the danger of confusing the transitory and the ephemeral with more fundamental transformations in political-economic life.

(Harvey 1989:124)

Instead, Harvey prefers to see flexible accumulation as an embryonic, but none the less significant, development within capitalism, arguing that it may, or may not, flower to reach its full status as a mature regime of accumulation and mode of regulation at some future point.

Unfortunately, Harvey's caution in assessing recent political, economic and social changes has not generally been a feature of most other accounts of the issues under discussion. In *The Second Industrial Divide*, for example, Michael Piore and Charles Sabel (1984) see the potential that is contained within recent developments to the manufacturing sphere in altogether more utopian terms. For Piore and Sabel, the arrival of *flexible specialisation*, as they refer to the new production processes, is seen to herald little other than the opportunity for a complete epochal shift in economic organisation. Flexible specialisation, they argue, generally comprises of a multiskilled or flexible workforce whose working practices owe their character more to the artisanal skills of an older craft-assembly method of production than they do to the highly routinised and disciplined work organisation of Taylorism. In a similar reversal of Fordist orthodoxy, economies of scale and the mass production of standardised, uniform commodities are here replaced by economies of scope, small-batch production runs and high levels of product differentiation. These developments are now made possible by the intro- duction of flexible or multi-operational technologies (especially those pion- eered by Japanese firms such as Honda and Toyota). These technologies can be reset swiftly to meet any changes to the needs of production. This tends to reduce investments of constant capital while simultaneously eradicating much of the wasted production time lost under Fordism by the costly resetting and replacement of inflexible and dedicated machineries. Flexible specialisation is also seen to involve a geographical shift from those urban complexes characteristic of industrial society to the new, high-tech regional centres of production (such as the Prato or Emilia-Romagna areas of central and north western Italy or the many high-tech silicon valleys which became such a geographical feature of the 1980s).

The new model of manufacturing outlined in *The Second Industrial Divide* is clearly at the core of the sort of Post-Fordist system described by Robin Murray, Stuart Hall and other writers associated with the New Times Project of the British journal *Marxism Today* (see Hall and Jacques 1989). For these writers, however, the implications of Post-Fordism are seen to extend well

beyond the direct economic concerns of the manufacturing sector. Post-Fordism here signals the rise of a new mode of social organisation generally; it marks the maturation of new forms of 'post-industrial' labour (primarily service and white-collar work), whilst marking the beginning of the end for the traditional blue-collar workforce and the older class system to which it was wedded. At the core of these changes lie quite massive technological innovations to the production processes. These not only transform the nature of modern working practices and industrial relations, but also mark the onset of new forms in the construction, surveillance and interpretation of markets and consumption (with all of the social, cultural and aesthetic implications that these changes entail). Stuart Hall (1988) provides us with a useful summary of some of the main features of Post-Fordism as viewed from the perspective of the New Times Project. For Hall, Post-Fordism is, he argues, a term 'suggesting a whole new epoch distinct from the era of mass production', it includes:

A shift to the new 'information technologies'; more flexible, decentralised forms of labour process and work organisation; decline of the old manufacturing base and the growth of the 'sunrise', computer-based industries; the hiving-off or contracting-out of functions and services; a greater emphasis on choice and product differentiation, on marketing, packaging and design, on the 'targeting' of consumers by lifestyle, taste and culture rather than by the Registrar General's categories of social class; a decline in the proportion of the skilled, male, manual working-class, the rise of the service and white-collar classes and the 'feminisation' of the workforce; an economy dominated by the multinationals, with their international division of labour and their greater autonomy from nation-state control; the 'globalisation' of the new financial markets, linked by the communications revolution, and the new forms of the spatial organisation of social processes.

(Hall 1988:24)

A similar, although to my mind a more thoroughgoing analysis of the transformation to a new socio-economic order is presented in Lash and Urry's *The End of Organised Capitalism* (1987). Lash and Urry, however, tend to characterise the nature of the current transformations within capitalist economies less in terms of specific changes to the basic labour and production processes and more in terms of a general reconfiguration of the broader geo-social dimensions of contemporary capitalism and the political and cultural implications that follow from this. Leaving aside for the time-being some of the less concrete cultural significances involved in the current transition to *disorganised capitalism*, Lash and Urry identify the following as amongst the most important of contemporary changes. They argue that there has been a decline in the effective powers of the nation state to regulate its internal economic affairs. This has occurred in the face of continued growth

in the world market where the central players are increasingly those of the modern multinational corporations whose economic activities transgress national geographical boundaries. The penetration of capital globally has also involved a gradual deindustrialisation of the advanced capitalist countries whose economies are increasingly centred around the service and white-collar sectors with their new forms of post-industrial urban development. This has meant a displacement of the basic Fordist industries, producing such commodities as steel, coal, oil, petro-chemicals, rubber, and automobiles, to production sites within the Third World. Finally, the rise of the service and the white-collar sectors, and those involved in intellectual labour in the advanced capitalist societies, in tandem with an expansion within the sphere of education that is needed to fuel such labour, has problematised the whole notion of social class. Amongst other things, this has tended to fragment the constitution of mass party politics into a growing number of 'catch-all' parties and special-interest groups which include such powerful voices as feminists, national and ethnic separatist movements, civil-rights groups, ecology and anti-nuclear groups, student activists and the like.

It is easy, perhaps, when presented with the views of Piore and Sabel, to regard flexible specialisation as the established economic orthodoxy of the current moment; or, when faced with the sort of clean-cut polar-oppositional categories offered under the rubrics of Fordism/Post-Fordism and organised/ disorganised capitalism, to see such models as the fully developed systems of the 1990s. These notions need to be tempered. In assessing the significance of numerous changes to the mode of production, it is first important to counter any exaggerated claim that we are already living through a new and fully mature regime of accumulation. In particular, those innovatory practices of production, such as a multiskilled workforce and the technological marvels of robotic automation, that we may wish to place at the heart of the emergence of a new economic and social order remain, at best, at a developmental stage and far from representative of the standard norm for contemporary production. Indeed, many of the old ideals and methods which drove the Fordist regime not only remain intact but, as Hall himself rightly acknowledges, are, in sectors such as the fast-food industries, 'clearly just entering their "Fordist" apogee' (Hall and Jacques 1989:127).

The tendency to lapse into a rather totalising 'end of mass-production thesis' (perhaps best exemplified in Piore and Sabel's *The Second Industrial Divide* (1984), and certainly alluded to by the New Times Project) has compelled several commentators (e.g., Callinicos 1990; Williams et al. 1987; Levidow 1990; Peláez and Holloway 1990) to cast serious doubt upon the very validity of the concept of Post-Fordism itself. In short, the argument that the sort of mass-production/mass-consumption economy which dominated the post-war years is now in rapid decline simply does not stand up to empirical scrutiny. According to Williams et al. (1987), while the key white-goods markets of the 1950s and 1960s are now no longer located at the

leading edge of manufacturing progress, many new staple consumer-durables markets based on micro-chip technology (such as hi-fis, videos, CD players, microwaves, etc.) have emerged to replace them. Similarly, nor have the old models of economic and political regulation disappeared. While the internationalisation of capital, and the corresponding diminution of the powers of the nation state to regulate effectively its national economy and domestic markets, has continued apace since the late 1960s, over recent years there have been several important signs of a rebirth of the sort of collective and macro structures of financial and political regulation that were themselves the leitmotif of the Fordist–Keynesianist alliance. The implementation of the various bureaucratic and financial structures in Europe towards a monetary union, a common exchange-rate policy and a legal and political framework that seeks to harmonise many of the vagaries that currently exist between the systems of individual member states, can be seen in this context as an attempt to introduce a sort of super or international Keynesian mode of regulation to the political instabilities and fluidity of a new internationalised and increasingly global economy. Armed with this sort of empirical evidence, Callinicos (1990), Levidow (1990) and others are able to launch a powerful attack on the *Marxism Today* New Times Project, claiming that the much celebrated notions of flexible production and deregulated labour processes and markets, both of which are claimed to herald a decisive break with an older Fordist–Keynesianist order, have been greatly exaggerated, prone to a rather crude economic-technological determinism and tending to rely upon largely unsubstantiated abstractions which have been drawn from highly superficial evidences.

It is important to acknowledge the persistence into the 1990s of many of the key economic and political constituencies of Fordism. We must also be more than mindful of the obvious temptation to overstate the extent and impact of recent economic and political change. However, I believe that simply to reduce those changes to mere superficial adjustments to the essential nature of capitalism would also be to deny the importance of the very dynamism and revolutionary nature of capitalism that Marx himself saw as so fundamental to any proper and sensitive understanding of the processes by which social transformation occurs. In my view, the undeniable trend towards an economic flexibility in all spheres of capitalist activity can be seen to have had a twofold character: first, what can best be described as the sort of 'ideal-type' Post-Fordism outlined in the highly fashionable models produced by the likes of Piore and Sabel and echoed in the New Times Project literature; second, a return to a 'quasi-primitive capitalism' in which labour is treated, not as the sacred basis of national or corporate prosperity, but in ways which are not dissimilar to those of early industrialisation.

Paul Bagguley (1991:155) provides a useful summary of the significant changes to production and markets which mark the visible signs of the

transition from Fordism to Post-Fordism. 'Ideal-type' Post-Fordism for Bagguley comprises of fragmented niche markets; the use of flexible machinery; short-run batch production; multiskilled workers; 'human relations' management strategies; the demise of mass trade unions and the rise of 'company unions' based upon no-strike deals; decentralised, local or plant-level bargaining; and the establishment of geographically concentrated new industrial districts and flexible specialist communities. To this basic characterisation of Post-Fordism we can add two further points. First, many firms are seeing the enormous advantages to be had in building-in a certain flexibility to the regulation of labour costs by increasingly contracting out many services and functions (that were previously undertaken in-house) to independent or franchised sub-agencies. This gives many firms an extensive manœuvrability in being able to hire and fire labour according to the precise market conditions of the day. This avoids the potentially devastating losses that result from the inflexible or fixed labour costs that were a primary cause of the crisis of Fordism. Second, the highly disciplined and authoritarian work ethic of Taylorism is now replaced, in some innovative companies at least, by a new ethic of labour which encourages team work and worker co-responsibility. This is reinforced by longer on-the-job training schemes and the greater availability of fringe benefits.

For Robin Murray (1989) this ideal-type Post-Fordism has been best realised in companies such as the Italian clothing manufacturer Benetton. Murray writes:

> [Benetton's] clothes are made by 11,500 workers in Northern Italy, only 1,500 of whom work directly for Benetton. The rest are employed by sub contractors in factories of 30–50 workers each. The clothes are sold through 2,000 tied retail outlets, all of them franchised. Benetton provide the designs, control material stocks and orchestrate what is produced to computerised daily sales returns which flow back to their Italian head-quarters from all parts of Europe.
>
> (Murray 1989:57)

Murray's illustration highlights the manner in which new, high-technology-backed, flexible systems of production and distribution are able to lubricate the flow of commodity and value circulations. Overseen by practices such as the Just-In-Time principle of resource management, these new systems are able to provide a close coordination between the numerous agencies involved in supply and demand-side activities, and such practices go a long way to reducing the costly build up of idle stocks at plant which became so redolent of the bankruptcy of Fordism.

These principles of flexibility also find themselves thoroughly interwoven within the structures of the modern corporate organisation. For John Sculley (1989), erstwhile marketing guru of both Pepsi and Apple, the modern corporation is undergoing a radical structural redesign. Disappearing rapidly,

he suggests, are the old corporate principles of stability, structure, hierarchy and a centralised, bureaucratised command apparatus which typified the average Fordist (second-wave) organisation. These principles are increasingly replaced in the (third-wave) corporate network by new models in which power and responsibility are generally devolved throughout the organisational structure as a more effective means of meeting the challenges of external change and localised economic contingencies. These contrasting paradigms, although here presented in a highly schematised format, are usefully summarised in Table 7.3, and they provide a clear impression of the general nature of the structural-ideological changes currently taking place within the corporate world.

Table 7.3 Contrasting management paradigms

Characteristic	Second wave	Third wave
Organisation	Hierarchy	Network
Output	Market share	Market creation
Focus	Institution	Individual
Style	Structured	Flexible
Source of strength	Stability	Change
Structure	Self-sufficiency	Interdependencies
Culture	Tradition	Genetic code
Mission	Goal/Strategic plans	Identity/Direction/Values
Leadership	Dogmatic	Inspirational
Quality	Affordable best	No compromise
Expectations	Security	Personal growth
Status	Title and rank	Making a difference
Resource	Cash	Information
Advantage	Better sameness	Meaningful differences
Motivation	To complete	To build

Source: Sculley 1989:142

The ideal-type Post-Fordist model is also characterised by a number of important changes to the demand-side spheres of the economy. These have been galvanised by the growing preponderance of niche or highly segmented markets. Contrary to popular belief, however, the rise of niche markets has not been a result of some sudden awakening of discerning consumers requiring that their needs are more sensitively addressed. In truth, niche and segmented markets are nothing other than the corollary of short-run batch production which has itself only been the development of a particular strategy of economic survival for manufacturers. In fact the trend towards product diversification as a means of safeguarding profit share was highlighted as long ago as 1972 by Paul Sweezy in his pioneering analysis of monopoly capitalism. The essential difference, however, between Fordist and Post-Fordist models of market diversification concerns the ways in which today's markets are constructed and analysed. Although Fordism had always

identified the analysis of consumer demand as critical to successful pro-
ductivity and growth, preoccupations with consumption rarely extended
above and beyond a purely quantitative aggregation of individual con-
sumption activities into the construction of relatively homogenous market
sectors. These were based around a few key indices of generally known socio-
demographic factors (most notably those of financial status and income,
gender and age). In short, while the motor of Keynesianism was undoubtedly
the concept of demand management and the manipulation of consumption,
Fordist ideology was still deeply committed to the principles of productivity,
industry and work as the core of national economic prosperity. Hence,
despite a huge investment into consumer motivation, analysis and advertising
throughout the 1950s and 1960s, and notwithstanding the work of marketing
pioneers such as Ernest Dichter or Pierre Martineau, efforts to address
markets normally consisted of little other than relatively unsophisticated
attempts simply to clear the continuous stream of commodities being
produced in the first instance, with little evidence of the qualitative composi-
tion or indeed the quantitative extent of these markets being apparent.

This situation has changed dramatically during the 1980s. The basic socio-
demographic indices that are now used to construct markets are often seen
only in terms of a base-line upon which far more sophisticated analyses and
construction of markets can take place. The typical consumer market of today
will probably be intersected at numerous points by a wide variety of consumer
targeting strategies. These may include a mixture of the 'hard' demographic
and socio-economic indices such as income, occupation, class position and
residential location, but they are also more than likely to include an analysis
of the 'softer' variables of consumer taste, attitudinal orientation, psychology
and lifestyle. This fact probably goes a long way in accounting for the
diversification of aesthetics, style and design in consumption during the
designer decade of the 1980s and also partly explains the shift away from the
purely functional aesthetic of Fordism. It also helps to explain what Carl
Gardner and Julie Sheppard (1989) have called the rise of 'retail culture' in
which the birth of the niche retail outlet has been seen to have fine-tuned its
approach to selling in parallel with the now fine-tuned classifications of the
discrete market segments it addresses. Finally, the fracturing of the market
into what often seems a bewildering matrix of interconnected market segments
has greatly propelled the development of new forms of media and communi-
cation. The massive investments into a wide diversity of specialist periodicals
and journals, and the proliferation of cable, satellite and terrestrial broad-
casting (narrowcasting) networks, for example, have been, first and foremost,
driven by the imperatives of advertising to address the now divergent and
highly segmented tastes, needs and sensibilities of the modern marketplace.

Much of what currently stands for ideal-type Post-Fordism has of course
been greatly facilitated in its arrival by the rebirth of a political philosophy of
individualistic enterprise and an unabashed veneration of the free market.

This has undoubtedly been best embodied in the policies and rhetoric of the Thatcher and Reagan administrations of the 1980s. However, whilst the systematic attacks on the principles and structures of Keynesianism and state regulation may have provided fertile conditions for the blossoming of many of the innovative and entrepreneurial ventures that are so characteristic of the glossy, high-tech world of Post-Fordism, they have also been in part responsible for a resurgence of the sort of labour and social conditions generally that capitalism was long ago supposed to have banished. The steady dismantling of established labour and welfare-rights legislation in many countries therefore reveals to us the other face of the modern flexible economic situation: a disfranchised, that is, a more malleable, labour pool who, now systematically denied legal, welfare and real trades-union representation, are increasingly powerless to resist new and more severe forms of exploitation and are often forced to work under extremely sweated conditions of employment. It is unfortunate, therefore, that so much emphasis in the debate over the nature of Post-Fordism has been placed upon such concepts as multiskilling, human-relations management and team work (important though such developments have undoubtedly been). The 'core' work-force that is represented here constitutes only a small fraction of the total labourforce of advanced capitalist countries. The vast bulk of labour-power is to be found in an expanding peripheral workforce. This may be composed of either temporary, part-time, job-share or public-subsidy employees who are usually denied pension, holiday, union and bargaining rights generally; or of those disadvantaged social groups, such as women or ethnic groups, who are more often than not given the most menial and lowly paid tasks. Such groups may also find themselves employed in homeworking schemes, which not only greatly reduces the costs of fixed or constant capital investment, but also serves to isolate workers from one another and thereby further erode worker solidarities and class consciousness. In the case of women especially, homeworking may also take advantage of an already subordinate status within their domestic or community life. Alternatively, this peripheral workforce may be comprised of those employees of patriarchal or small family firms. Here the struggle between capital and labour is more often than not greatly complicated by the fact that the relations of production are also contingent upon other structures of rank and power that have evolved according to kinship and family systems that often date back many generations.

An equally misleading assertion that is bound up with issues of Post-Fordism and the shift to a post-industrial society is the identification of an expanding service class and its occupational structures. This is often claimed to signal the demise of an older, more barbarous, mode of industrial capitalism, a thesis most famously advocated in Daniel Bell's *The Coming of Post-Industrial Society* (1973). But, as Krishan Kumar (1978) suggests, the mistake here has been to equate service work with the somewhat idyllic image of 'trim surroundings, neat dress or prestigious uniform, [and] constant

exposure to a "clientele", coffee breaks, telephone calls', all of which are commonly associated with white-collar work. Kumar continues:

> It is misleading to equate, in a simple way, the move to a service economy with the explosive growth of white-collar work. The average garage mechanic or night cleaner does not wear a white collar . . . Moreover the conditions of manual work in the service sector – in areas such as catering, cleaning, maintenance, transportation – are often more unpleasant, dirty or dangerous than in the manufacturing sector. Where it is not actually sweated labour it is very often sweaty labour.
>
> (Kumar 1978:207)

Descriptions such as these, however, tend to pale in comparison with the sort of conditions associated with the emergence of what Lipietz (1987) has called 'peripheral Fordism' throughout many Third World countries. The crisis of labour that followed from the bankruptcy of Taylorism in the west during the 1970s forced many companies to export the most labour-intensive aspects of their production to sites in the newly industrialising countries. Here labour-power was cheap and generally unprotected by state legislation or any systematically organised union power. Thus began the massive expansion of an internationalised, Fordist-style factory and industrial complex throughout many regions of the Third World. Such a system found a captive body of unskilled workers who were already gathered *en masse* in the townships and ghettos of countries such as South Africa, Brazil and the Indian subcontinent. This labour pool could be relatively easily corralled into the factories and mines and forced to endure new forms of super-intensive or 'bloody Taylorism' in which the harsh work disciplines, rigorous surveillance procedures, the monotonous routines of the machine, and extremely long hours of work have pushed the exploitation of labour to some of its most barbarous forms. In many ways peripheral Fordism has subsequently become the dark, dreadful heart of the new world economic order. For those of us who live in the relative comfort and affluence of the First World, such a primitive form of capitalism is only allowed to surface to our consciousness at those times of large-scale industrial disaster, such as that witnessed in the terrible events at Bhopal in 1986.

In view of the many issues outlined above it may be difficult to assemble any clear or coherent picture of the nature of the changes taking place to capitalism as we approach the end of the twentieth century. When seen in their totality, the sum of recent developments to labour and production often seem unconnected and, in many instances, even contradictory. They far from form logical pieces in a smooth, unproblematical process of economic transition. As Kevin Robins (1989) rightly observes:

> projected futures cannot simply and effortlessly dissolve away the solidity of inherited social structures, infrastructures and relations. The process of

transformation is complex, and it is genuinely difficult to establish whether the present period marks the emergence of a post Fordist society, whether it should be characterised as neo Fordist, or whether, in fact, it remains a period of late Fordism.

(Robins 1989:147)

Consequently, if there have been any significant changes to the regime of accumulation and its mode of regulation, then in the first instance this may ultimately be revealed, not in the aggregation of a number of extremely diverse and disparate changes to labour, production and the political and spatial reorganisation of capitalism, but in the very composition and design of the commodity-form itself. Chapter 8 attempts to trace recent economic and social changes as these may have materialised in the form of the contemporary commodity.

Chapter 8

Time, space and the commodity-form

THE COMMODITY-FORM AND THE MEANS TO GROWTH

It was neither chance nor a mere whim that led Marx to begin *Capital* with an analysis of the commodity. Commenting on this, Sut Jhally (1987) has stated that:

> Marx started with the commodity because he thought that if one could understand how the commodity was produced, distributed, exchanged and consumed, then one can unravel the whole system, because objectified in the commodity are the social relations of its production. They are part of the information that the commodity contains within itself. They are part of its communication features. If we can penetrate down to this information, then we can understand and unravel the whole system of relations of capitalism.
>
> (Jhally 1987:26)

The real significance of the commodity, then, rests upon the fact that it tends to reflect the whole social organisation of capitalism at any historical and geographical point in its development. We can, for example, say that the commodity embodies the technical and organic compositions of capital; that is, the relationship and ratio between labour-power and means of production. Equally as important, the commodity also represents the pre-eminent material and symbolic form by which labour-power is reproduced through consumption. This makes the commodity a vital touchstone in any analysis of the social relations of capitalism, and, by considering real changes to the commodity-form over time, an important indicator of any historical shifts in strategies of capital accumulation and modes of production and consumption. Accordingly, if the term Post-Fordism is truly to signify important developments within capitalist production, and if these developments genuinely herald major reconfigurations within contemporary culture, then in the first instance we should expect to see such transformations materialised in a changing commodity-form. An examination of some of the changing features of the modern commodity-form will therefore provide the basis for this chapter.

In its most fundamental guise, perhaps, the commodity-form can be said to be an objectification of a mode of production at a given phase of development. Likewise, the concept of a regime of accumulation describes the manner in which the mode of capitalist production assumes, during a certain historical period, a particular industrial character adopting a distinctive productive process and unique organisational features. This process may be regarded as being expedient for an efficient and reproducible schema of accumulation and growth throughout the period in question. If, during the lifespan of an established regime of accumulation, there is seen to emerge an aggregation of individual commodities which appear to share certain recognisable material and non-material characteristics, then this would suggest some correlation between the organisational features of the regime of accumulation and the particular manifestations of the commodity-form. We may say that such a unique appearance of the commodity-form as it arises from a given regime of accumulation is the *objectification of that regime of accumulation*. I shall call this distinctive appearance of the commodity-form the *ideal-type* commodity-form of the regime of accumulation.

In order to better understand how this relationship between a regime of accumulation and its ideal-type commodity-form is forged, it is first necessary to consider the relationship between the mode of production and the dimensions of time and space. This is necessary because any particular organisational form that is taken by the mode of production may, in a basic sense at least, be defined as a distinctive utilisation of these two dimensions. In short, capitalist production, in its attempts to increase the rate of accumulation, seeks to make the most cost-effective use of the time and space upon which that production occurs. In order to understand how a particular organisational schema for the dimensions of time and space helps to determine the composition of the commodity-form we shall first need to reconsider the two essential strategies by which growth is generated, namely through the acquisition of absolute and relative surplus-value.

The procurement of absolute surplus-value, it may be recalled, is obtained through an extension of the working day. Here socially necessary labour-time within the working day remains constant whilst the surplus labour-time contained within that same working day is increased. This is not to say necessarily that labour receives less as a wage-value when absolute surplus-value is achieved, only that there is an expansion of the difference between the value of socially necessary labour and the value created by that labour in its product (Marx 1956:77).

However, expanding the duration of the working day is not the only means by which to achieve increases in absolute surplus-value. Any increase in the magnitude of production through time and space, so long as such increases do not raise the rate of variable capital inputs to a level which reduces the rate of surplus-value, will inevitably multiply the magnitude of surpluses yielded by that production. Consequently any productive regime which increases in

scale, either through the adoption of shift systems, increases in plant size, or through an expansion into new geographical spaces, will achieve growth through the appropriation of absolute surplus-value. Broadly speaking, then, we can say that absolute surplus-value may be defined technically as any increase in the sum of surplus labour-time worked, regardless of the form that this takes, and without any alteration of the rate of variable capital that is required to generate that surplus labour-time.

Whatever form the appropriation of absolute surplus-value assumes, however, it will always eventually run up against certain concrete limits of time and space (not least, of course, because workers always require some proportion of non-working time in a 24-hour period in order to reproduce their energies for the next day's work). This fact has compelled capital to explore the alternative means to growth at its disposal: the appropriation of relative surplus-value. Indeed, it has been the appropriation of *relative*, rather than *absolute*, surplus-value that has historically provided the truly revolutionary motor for capital accumulation, making it perhaps the most destructive and violent economic system in world history.

Relative surplus-value differs from absolute surplus-value in one important respect: while absolute surplus-value expands the scale of productive capacity and leaves the essential conditions of production unchanged, relative surplus-value stimulates growth through an 'increase and development of the productive forces' (Marx 1973b:408). In other words, the appropriation of relative surplus-value has a tendency to *alter the essential conditions of production*.

Relative surplus-value is obtained by increasing surplus labour-time without extending the duration of the total working day. In order to achieve this, the duration of socially necessary labour-time must, as a matter of course, be decreased. The appropriation of *relative surplus-value* therefore derives from 'the curtailment of the necessary labour-time, and from the corresponding alteration in the respective lengths of the two components of the working day' (Marx 1976:432). A decrease in socially necessary labour-time can only be achieved by increasing labour's efficiency; that is, by raising labour's inherent productive capacity through the reorganisation of the mode of production. This will involve the rationalisation or redeployment of the activities of labour. It also usually entails the introduction into the productive process of new technologies and materials. By reducing the amount of time that is needed to reproduce the value of socially necessary labour, the value of labour-power itself falls. However, surplus labour-time, and hence its value, is increased.

We can see a vivid illustration of the effectiveness of raising surplus yields by the appropriation of relative surplus-value in the example set by Henry Ford at the time he was producing the Model T. In 1913, prior to the introduction of assembly-line techniques, the production of the Model T chassis required 12.5 hours. Less than one year later, and following the implementation of flowline assembly, this figure had been cut to a remarkable

1.5 hours per chassis (Arnold and Faurote 1972: 419). It was, then, precisely through such dramatic reductions to the labour–time ratio that Ford was able to reduce the basic selling price of the Model T from \$850 in 1908 to \$360 in 1916 (Nevins 1954: 419). This ensured that Ford remained at the leading edge of manufacturing innovation and made him an important figure in setting a target rate of accumulation for other car manufacturers to follow, thereby forcing up the social average rate of accumulation for the period in question.

Implicit in the two means of surplus generation outlined above are the two forms of logic upon which growth is based. First, capital can pursue a logic based upon the appropriation of absolute surplus-value and which entails a *quantitative expansion* or *massification* of the productive process; a logic whereby the time and space upon which production occurs is multiplied, creating an increased surplus product and value. Second, in the quest to achieve relative surplus-value the circuits of capital accumulation can be *intensified*, made more efficient by *innovation* through the use of new technologies, redesigned working practices, labour redeployments, methods of distribution, etc. In this way the potential for increased surplus products and values is created from the unchanged absolute temporal and spatial dimensions of production.

The implications which follow from each logic of growth are important for any proper understanding of the transformational impulse inherent to capitalism. These implications, while never explored in any systematic detail by Marx, have certainly been well noted. Commenting upon the consequences of growth by means of absolute surplus-value, that is, growth through an expansion and massification of the productive process, Marx states in the *Grundrisse* that:

> The creation of capital by absolute surplus-value . . . is conditional upon an expansion, of the sphere of circulation. The surplus-value created at one point requires the creation of surplus-value at *another* point, for which it may be exchanged; if only, initially, the production of more gold and silver, more money, so that, if surplus-value cannot directly become capital again, it may exist in the form of money as the possibility of new capital. A precondition of production based on capital is therefore *the production of a constantly widening sphere of circulation*, whether the sphere itself is directly expanded or whether *more points within it are created as more points of production*. While circulation appeared at first as a constant magnitude, it here appears as a moving magnitude, being expanded by production itself. Accordingly, it already appears as a moment of production itself. Hence, just as capital has the tendency on one side to create ever more surplus labour, so it has the complementary tendency to create more points of exchange . . . The tendency to create the *world market* is directly given in the concept of capital itself.
>
> (Marx 1973b:407–8)

It should be evident from this that the absorption of an expanded surplus product will always require an expansion within the sphere of consumption. This is normally to be achieved through the extension of consumer markets across new geographical regions or by their extension into new social spaces. In either instance growth is realised by an increase in the magnitude of both production and consumption without necessarily altering the basic conditions of the productive process and the composition of the commodity-form.

By contrast, the appropriation of relative surplus-value resulting from the reorganisation and intensification of the productive process changes the essential conditions of production. Accordingly, the introduction into the productive process of new technologies and redefined working practices have perhaps their most visible impact upon the commodity-form itself, creating the potential for real material changes within the composition of the commodity. Consequently, the absorption of the surplus product which results from the attempt to gain relative surplus-value requires not merely the quantitative expansion of the sphere of consumption, but rather a *qualitative reconfiguration* of consumption if potential relative surplus-values are to be fully realised. For Marx, the accommodation of a changed commodity-form by the sphere of consumption involves: 'firstly quantitative expansion of existing consumption; secondly: creation of new needs by propagating existing ones in a wide circle; *thirdly: production of new needs and discovery and creation of new use-values*' (Marx 1973b:408; my emphasis). The inevitable drive towards efficiency in the search for relative surplus-value can be seen, therefore, to lie at the heart of social transformation under capitalism, changing not only the social relations of production, but, by altering the primary source by which labour-power is reproduced, also re-determining the composition of human needs, to say nothing of the cultural consequences that such changes may entail.

In summary, then, each logic of growth has a particularly distinctive impact upon the spatial and temporal dimension of both the spheres of production and consumption. Broadly speaking, the logic of massification entailed by the pursuit of absolute surplus-value tends to expand the absolute spatial and temporal dimensions of production and consumption. The logic of intensification which results from the extraction of relative surplus-value redefines the relative spatial and temporal dimensions of production and consumption.

It may be tempting, given this rather schematic conceptualisation of the social impact of growth, to treat each logic of growth as mutually isolated phenomena. Indeed, such a temptation is clearly evident, and constitutes a significant empirical error, in Aglietta's conceptualisation of extensive and intensive regimes of accumulation. Here the specific industrial character of each form of regime appears to be almost exclusively determined in terms of whether the appropriation of absolute surplus-value (extensive) or relative surplus-value (intensive) predominates. As I shall argue, however, it would

be wrong to treat either logic of growth as the exclusive determinant in the development of a regime of accumulation, or even to regard either as being functionally independent of the other (see Brenner and Glick 1991 for a critique of Aglietta's ideas on these grounds). The ongoing drive towards both the massification and intensification of the process of capital, and the establishment of absolute and relative strategies of surplus generation are nearly always co-requisite features in the successful maturation of any regime of accumulation. As David Harvey (1989:186–7) correctly states, 'in the end, of course, it is the particular manner in which absolute and relative strategies combine and feed off each other that counts'.

Given this, it would be inaccurate therefore to theorise the nature of recent economic transformations since the 1970s in terms of some unproblematical switch from the pursuit of growth via strategies of absolute to relative surplus-value or vice versa. Attention must focus instead upon the particular social character of capital which results from the interaction of expansionist and innovatory patterns of industrial development. For it is in the precise nature of the manner in which the processes of capital massification and intensification interact with each other that determines the particular structural order of the spatial and temporal dimensions of a regime of accumulation, a structural order which is accordingly objectified in the major commodities of the period. As a consequence, we find in the various material and symbolic characteristics of these commodities those typical features that, when taken cumulatively, constitute the *ideal-type commodity-form of the regime of accumulation*. Moreover, it is against the particular spatial and the temporal configurations produced by the regime of accumulation that there arises a specific mode of regulation, or a supportive and interlocking network of economic, political, aesthetic and cultural structures, the primary function of which is to achieve the stabilisation of the regime of accumulation.

TOWARDS A NEW IDEAL-TYPE COMMODITY-FORM: THE 'FLUIDISATION' OF CONSUMPTION

The phenomena of absolute and relative surplus-value and their impact upon the commodity-form provide us with a firm conceptual basis from which to interrogate the patterns of economic and social development that occurred within capitalism during the Fordist period. They also allow us to speculate with some authority upon the manner in which those patterns of development that were established in the Fordist period are in the process of transformation today. Set against this background, the argument that I now want to suggest is that during the 1980s there has been a noticeable alteration in the ways in which the mix of expansion and innovation within the process of capital accumulation has impacted upon the spheres of production and consumption. Most noticeably in a transformed commodity-form, the changing constitution of capital has begun to have its effect upon the broader social world.

The particular manner in which the combination of strategies of absolute and relative surplus generation manifested itself under Fordism was undeniably in an *increase in the physical scale of capital circulation*: an unprecedented expansion of the temporal and spatial dimensions of production and consumption. The crisis of Fordism beginning towards the end of the 1960s and continuing throughout the 1970s triggered a transition in industrial and commercial affairs towards more flexible patterns of accumulation which in many respects broke significantly with the old orthodoxies of monopoly regulation that were established under the Fordist–Keynesian alliance. Whether there yet exists a coherent mode of regulation which can be described as properly supportive of and fully integrated with recent economic developments is highly doubtful. None the less, I believe that such developments within the economic infrastructure have triggered a number of important changes within the commodity-form itself. Cumulatively, these changes are sufficiently important, I believe, to warrant the status of a new, ideal-type commodity-form. Moreover, the net effect of these changes has been to spark a paradigmatic transition in the very structure and composition of needs and consumption. This may also have led to the formation of a new, albeit at this stage embryonic, consumer culture; that is, a radical and vital constellation of cultural sensibilities, value systems and behaviours brought about by new cognitive modes in the understanding and articulation of the experiences of everyday life, or, to borrow a phrase from the critic Fredric Jameson, a new form of 'cognitive mapping'.

This new consumer culture, however, cannot be collapsed into the new, ideal-type commodity-form simply as its functional product. Neither can it be held up as representative of late twentieth-century culture as a whole. It exists, I will suggest, primarily within certain social formations who may be seen in this respect as pioneers in the development of a new culture of consumption.

Before these issues may be considered in some detail however, it is first necessary to examine some of the important changes to the commodity-form itself. Tables 8.1 and 8.2 attempt to summarise some of the key features and methods of application entailed by both strategic means to growth within the spheres of production and consumption during the Fordist era and what, for the sake of analytical expediency, may be referred to as the new Post-Fordist era. Table 8.3 illustrates the impact of the changing ratio of capital investment, into both means to growth, upon the formation of a new ideal-type commodity-form.

Table 8.1 The impact of the contrasting means to growth on production and consumption: Fordism

	Production	Consumption
Growth via expansion (absolute surplus-value)	Massification of production. Increase in magnitude of absolute surplus-value. Widened sphere of circulation. Highly centralised economic organisation: Keynesianism.	Massification of consumption. Uniformity and standardisation of consumption. Penetration of commodity consumption into new (geographical and social) spaces. Penetration of commodity consumption into new periods of the non-working day.
	Production of more commodities.	Consumption of more commodities.
Growth via intensification (relative surplus-value)	Increase in productive capacity of mode of production via decrease in the value of necessary labour. Increase in the rate of relative surplus-value. Increased efficiency of labour via Taylorism and investments into means of production. Increase in net surplus yield per production unit.	The production of new needs and use-values via reorganisation of daily life (e.g., labour-saving goods) and erosion of old ways of life and practices. Material and aesthetic obsolescence intensifies the stimulation of needs.
	Production of new commodity forms.	New forms of consumption

The particular combination of absolute and relative strategies of surplus generation that formed the basis of Fordism made possible an unparalleled period of stable growth and led to a 'golden age' of post-war prosperity. Regulation theory rightly stresses the critical significance of Taylorism and technological innovation to the successful emergence of Fordism as a mature regime of accumulation. At the core of the Regulationist account of Fordism, therefore, is an emphasis upon the decisive change in the essential conditions of production and the enormous intensification of the rate of relative surplus-value. Unfortunately this emphasis on relative surplus-value in Regulation theory has had the effect of marginalising the critical role that absolute surplus-value was to play in this process. While the initial introduction of Fordist practices undoubtedly created a barbaric and alienating working environment for the labourforce, it none the less standardised the duration of the working day and therefore tended to foreclose, as a general strategy of

Table 8.2 The impact of the contrasting means to growth on production and consumption: Post-Fordism

	Production	Consumption
Growth via expansion (absolute surplus-value)	Massification of production. Increase in magnitude of absolute surplus-value. Widened sphere of circulation. Expansion of production globally caused by the need to procure cheap labour. Increase in rate and magnitude of absolute surplus-value.	Massification of consumption. Penetration of commodity consumption into new (geographic and social) spaces (e.g. the children's market, increased commodification of the body, exploration of Third World markets). Penetration of commodity consumption into new periods of the non-working day.
	Production of more commodities.	Consumption of more commodities.
Growth via intensification (relative surplus-value)	Increase in productive capacity of mode of production via decrease in the value of necessary labour. Increase in the rate of relative surplus-value. Increased efficiency of labour via JIT, multiskilling, investments into means of production (robots, computerisation etc.). Greater diversity of commodities. Decentralised organisation. Increase in net surplus yield per production unit.	Production of new needs and use-values via reorganisation of daily life (e.g., labour-saving goods). Erosion of old ways of life and practices. Diversification and fragmentation of needs and consumption: individualised and hybrid consumption patterns. Compression of individual consumption times and spaces in order to accommodate increased consumption. 'Fluidisation' of consumption. Material and aesthetic obsolescence intensifies the stimulation of needs.
	Production of new commodity forms.	New forms of consumption.

capital accumulation, growth via the typical means by which absolute surplus-value is obtained. But, as I have suggested earlier, the lengthening of the working day is only one way to achieve absolute surplus-value; the physical expansion of production and consumption through space and time (without lengthening the duration of an individual worker's day) are equally important methods for raising absolute surplus-value. The changing conditions of

Table 8.3 Ideal-type commodity-forms of Fordism and Post-Fordism

	Fordism	Post-Fordism
Metalogic of growth:	Expansion Massification	Intensification Innovation
Characteristics	Durability Electro-mechanical Material Solidity Structure Collective Homogenous Standardised Hardware Fixity Longevity Function Utility	Non-durability Electro-micro Experiential Fluidity Flexibility Individualistic Heterogeneous Customised Software Portable Instantaneous Form Style
Examples	Automobiles Standardised housing White goods Physical primary commodities (steel, rubber, petro-chemicals and plate glass)	Hi-tech commodities (e.g., videos, camcorders, microwaves, Walkmans, personal computers etc.) Cultural services and events (e.g., heritage, theme parks, sports etc.) Financial services Non-physical primary commodities (information, data and access to means of communication)
Suitability for growth	Geared to the expansion and stabilisation of new markets.	Geared to the deeper penetration of existing markets and creation of new needs via the compression of the times and spaces of consumption

production which led to the formation of relative surplus-value under Fordism were also responsible for the creation of the ideal conditions for the spatial and temporal expansion of capital based upon absolute surplus-value. The production of relatively cheap, standardised consumer goods made possible the penetration of capital and consumption into new geographical and, particularly, social spaces. Despite the revolutionary transformations that it entailed to the mode of production and to daily life, the true hallmark of Fordism was surely a process of expansion and massification, an economic strategy upon which growth was to be assured primarily through an increase in the *scale* of economic activity and an expansion of the influence of the commodity-form throughout everyday life.

The scale of Fordism was of course complemented in the mode of

monopolistic regulation, which was, in all its dimensions, a mode of regulation geared towards the stabilisation and the material and cultural accommodation of the new magnitudes of social life: in macro-economics; in the 'Keynesian city' with its mass housing projects and huge public spaces and facilities; in the spread of suburban architecture and planning, and in the flourishing of the complex network of highways and motorways; in social provision and the allocation of collective consumption; and in the mass party-political apparatuses mobilised to address the large-scale, class-conceived constituencies of the modern electorate. This mode of regulation, as we have seen, even extended to include the attempt to give social meaning a sense of permanence and fixity through the various aesthetic and cultural structures by which social experience itself was to be 'officially' communicated.

It was around these features that a new ideal-type commodity-form was eventually to crystallise. Of the important commodities that were to emerge under Fordism perhaps two are worthy of special note: those of *standardised housing and the car.* The urgent need for cheap housing most obviously provided a massive stimulus for the construction industry which was soon established as one of the core industrial sectors under Fordism. But in a much broader social role, housing was to play a vital part in the success of Fordism: standardised housing was to become the 'privileged site of individual consumption' (Aglietta 1987:159), literally providing for the sort of physical demarcation of private space that was needed to 'house' the new needs of the basic component of the mass-consumption economy: the small family unit. In two important respects, the relationship between the family and their house was critical. First, modern housing was so functionally designed as to accommodate with the greatest ease and efficiency the new commodities of Fordism, most notably the many labour-saving goods and domestic appliances that were to serve as its staple market sectors. As Philip Gunn writes about American Fordism during the 1920s:

The dwelling stock in fact became the functional containers for the new consumer durable products which became part of the kitchen revolution of the new 'Radio Era'. Sixty thousand families owned a radio in 1922. Ten million radios were sold in the next ten years. In the home the volume of vacuum cleaner sales arrived at US$40 million in 1925. Sales of electric cookers were valued US$20 million in 1927 and fridges earned us$167 million in 1929. Domestic electrical energy prices fell by 33–50% in many cities during the decade when output rose from 41 to 97 billion kWh between 1920 and 1929 ... To interlink homes, workplaces, towns and homesteads the length of telephone wire increased from 28 to 70 million miles in the twenties. These lines supported the growth of appliances from 13 to 20 million. The fast expanding growth was also present not only in patterns of stock-exchange share ownership but also on the neighbourhood

block where new soda parlours helped raise the consumption of ice cream 62% in the decade.

(Gunn 1991:86)

Second, in its physical size, its standardised features and the manner by which it was organised and plotted within the boundaries of urban and suburban geography, the modern house was a form that became ideally attuned to the sort of quantitative calculation of individual financial expenditures and assessment of consumption patterns required by the new macro-economic orthodoxy of Keynesian demand management.

If the modern house was to provide the stable space for mass consumption, then the car became the means *par excellence* by which the newly defined spaces of Fordism were able to become interactive. Importantly, the car became 'the means of transport compatible with the separation of home and workplace' (Aglietta 1987:159). But more than this, the car was also to become the critical utility through which the modern family could be connected to a vast social network of consumption and welfare; a sort of life-blood that flowed between the newly dispersed 'organs' of the state and the market alike (schools, hospitals, out-of-town shopping centres and super-markets, and the new leisure complexes which included cinemas, holiday resorts, sporting venues and other social and cultural provisions that were fast being established during the post-war years). Importantly, the car also promised, and in many ways delivered, a way to bypass the threatened social alienation which was said to result from the geographical dispersal of localised communities and from the physical rupture of traditional kinship bonds that followed from the ease of modern spatial mobility. The car, then, was to become a vital instrument in the realisation of a new spatial utopia, where, from 'north and south, east and west a new homogenous production and reproduction space for capital is created' (Gunn 1991:89).

From these illustrations it would seem reasonable to suggest that the ideal-type commodity-form of Fordism represented an unambiguous objectification of the practices and requirements of the production processes themselves. The extremely high costs embodied in plant and machinery that were needed to establish a given production run could only be recouped and expanded if that production run could operate unchanged and uninterrupted for the longest possible period of time. The common fears of wastage and loss from unnecessary 'down time' as machinery was reset or repaired forced Fordist production to adopt an ideology in which the features of 'structure', 'solidity' and 'reliability' became all but sacrosanct. It was no mere coincidence therefore that these very features were to be found embodied within the ideal-type commodity-form of Fordism. They could be seen, for example, in that sense of fixity, permanence and sheer physical presence which stamped itself symbolically in the form of the functional aesthetic on to the design and appearance of domestic goods as diverse as radios, television sets, cookers,

refrigerators and music centres. Similarly, such features were also to be materialised in the emphasis on the commodity's durability, longevity, performance and utility that were so often presented by manufacturers to be the commodity's chief selling point.

Economic change since the 1970s has often been based upon the attempt to overcome the many structural rigidities that were to prove the eventual fatal flaw of the Fordist–Keynesian regime. As we have seen, the flexible economics of the 1980s has taken two central forms: first, a revolution within the organisation of many aspects of the productive process by the strategic introduction of new flexible technologies and deregulated patterns of labour and labour markets. Second, the 1980s has seen the displacement of many of the old Fordist models of standardised production to a peripheral, but by no means less significant, position within the world economy. This distinctive mix of 'core Post-Fordism' and 'peripheral Fordism' has created the conditions that make it possible to increase the rates at which both absolute and relative surplus-values may be procured. The rebirth of a sort of 'primitive capitalism' which sees, in the advanced industrial countries, an expanding peripheral workforce increasingly denied labour representation and welfare rights, and, in the newly industrialising centres of the Third World, an intense concentration of the basic extractive and Fordist-style industrial processes, means that this flexible economics is highly suited to the appropriation of absolute surplus-value through the imposition of hugely exploitative labour conditions. Most commonly this has involved a fall in the real value of labour-power through the systematic lengthening of the working day without any corresponding increase in wage-value for the workers (a strategy ironically often denied under Fordism by the labour–capital 'accord'). This ensures a continued expansion of the scale of production and an aggregate increase in individual commodities.

There is of course no neat, one-to-one correspondence between particular moments of physical productive expansion and instances of expansion within the sphere of consumption. None the less, if potential absolute surplus-value is to be realised, a net newly created surplus product, when taken across the economy as a whole, must find its accommodation within a physically expanded consumer market-place. To this extent the physical expansion of the circuits of capital has continued apace throughout the 1980s. Geographically or socially, on a macro- or micro-level, new markets have been created and existing ones extended. These range from the export of consumer capitalism to many regions of the Third World and the construction of an enormous children's market in the First, to the deeper commercial penetration and commodification of the body, self and identity in the form of new health foods, and expanded cosmetics and fashion markets.

Significant though such developments have undoubtedly been in the process of securing growth, it has surely been the intensification and reorganisation of the labour process (through new flexible technologies,

redesigned working practices, new methods of stock and inventory control
and the like) in the attempt to re-energise strategies of relative surplus-value
that has given rise to a *qualitative change* in the essential conditions of
capitalist production. It is this development, I believe, that has proved to be at
the true heart of many recent social transformations.

Practices such as the multiskilling of workers, Just-in-Time strategies of
inventory and resource management, franchising, the contracting out and
hiving off of services and functions, the widespread use of part-time and
temporary labour, and the introduction of new technologies into the work
process have been adopted with one specific function in mind: to drive out
idle time from the working day. Cumulatively, these attempts to reduce the
porosity of production time and to enable the far more efficient utilisation of
productive time and space have radically restructured modern patterns of
work and much of the entire productive process in some advanced industrial
sectors. The appropriation of the relative surplus-value which has been
acquired as a result eradicating previously idle, productive time and space has
undoubtedly contributed towards the changing fortunes of many advanced
economies during the mini boom of the 1980s. Tables 8.4 and 8.5 show the
extent of this boom in respect of net profit rates and shares for manufacturing
and business in the advanced industrial world between the years 1975 and
1987. While these figures in no way compare with those of the golden years
of Fordism, they none the less signal an important reversal in the poor
economic health of advanced capitalism since the crisis of the 1970s. (This
has been particularly pronounced in the case of European growth.)

Table 8.4 Net profit rate (percentages) for manufacturing and business
(excluding agriculture) combined (manufacturing rate plus business
rate ÷ 2) 1975–87

Year	ACC	Europe	Japan	USA
1975	12.4	10.1	14.9	13.6
1976	13.8	11.6	16.7	15.0
1977	14.5	12.1	24.2	15.0
1978	14.7	12.7	18.2	15.3
1979	13.8	13.6	17.0	12.8
1980	12.2	12.8	16.8	9.9
1981	11.5	11.1	15.2	10.5
1982	10.4	11.1	14.9	8.2
1983	11.5	12.1	14.2	10.1
1984	13.7	13.2	15.6	13.3
1985	13.8	14.3	15.9	12.4
1986	14.3	16.2	15.3	12.7
1987	14.8	17.0	15.2	13.3

Source: OECD (1989); manufacturing and business rates prepared in this format by
Armstrong, Glynn and Harrison (1991: 350–3).

Table 8.5 Net profit share (percentages) for manufacturing and business (excluding agriculture) combined (manufacturing share plus business share ÷ 2) 1975–87

Year	ACC	Europe	Japan	USA
1975	17.7	16.0	22.9	17.3
1976	19.1	18.1	24.6	18.2
1977	19.7	19.1	24.0	18.9
1978	20.0	19.8	26.2	18.2
1979	19.2	20.5	25.5	15.9
1980	18.0	19.5	26.4	13.5
1981	17.5	17.7	24.6	14.5
1982	16.8	18.3	24.6	12.5
1983	18.3	19.7	23.7	14.9
1984	20.3	21.1	25.5	17.5
1985	20.4	22.3	26.0	16.5
1986	20.9	24.1	25.7	16.7
1987	21.4	24.9	25.8	17.2

Source: OECD (1989); manufacturing and business rates prepared in this format by Armstrong, Glyn and Harrison (1991:350–3).

Qualitative changes to the intensity and structure of labour and means of production tend to be reflected in changes to the commodity-form. This in turn implies some form of change to the composition of needs and to the structure of consumption itself, to say nothing of any commensurate changes to the social, political and cultural framework within which needs and consumption are housed. We have, I believe, seen throughout the 1980s a transformation in the commodity-form; from an ideal-type Fordist commodity-form which objectified the attempt to stabilise or solidify the newly colonised times and spaces of Fordist consumption we have moved towards a commodity-form which, in several important respects, objectifies the flexible character of modern production and consumption. The key commodities of the 1980s have been those goods that were best attuned to the freeing-up of the previously static and relatively fixed spatial and temporal dimensions of social life. This drive towards the 'fluidisation' of everyday life which is captured in the modern commodity appears in several forms. Some of these are outlined below.

The liberation of consumption from previously static, or relatively inflexible, spatial and temporal spheres

Temporal and spatial mobility (time-shift and space-shift), or the ability to use and consume goods in a variety of locations and time-frames, have become significant features of contemporary consumption. Such developments are often based upon the application of new micro-technologies, the

original development of which springs directly from the productive sphere in its need to rationalise the labour process by replacing living labour with dead labour. This has resulted in the mass production of such commodities as the personal stereo, the cellular telephone, the video cassette recorder, the camcorder, and the portable computer. In many instances, commodities that were once anchored to a designated physical space, or services, such as television and radio broadcasting, whose usage was dictated by certain predetermined time schedules, have been re-adapted in order to make their patterns of use far more flexible.

The temporal compression of existing consumption

By this I mean that the physical duration of the consumption or usage time of the commodity is reduced in order that the existing routines and activities that occupy daily domestic time can be compressed. The net effect of this is a rationalisation of consumption time in order to create new periods of time within domestic life which become available for new forms of consumption. Again micro-technologies have played a leading role. The microwave oven and its associated foodstuffs, for example, has drastically reduced the time needed to satisfy a basic necessity. It should be noted of course that this development is by no means unique to the contemporary situation, but represents a continuation of processes that were previously initiated by many of the mechanical labour-saving commodities that were characteristic of Fordism.

Miniaturisation: the spatial compression of commodities

This represents the spatial equivalent of temporal compression. Here the physical size of commodities is reduced in order to create new physical space, especially within the domestic environment, which may subsequently be used to accommodate new commodities. Contrast, for example, the physical size some of today's electronic consumer goods, such as hi-fi systems, television sets or even video recorders, with their physical size at the time they were initially introduced onto the market.

Compound commodities

By this I mean the merging of two or more previously discrete commodities into a single good. The unification or compression of previously discrete needs effectively opens up both the ontological and physical spaces that are required for the creation and development of new needs and therefore new use-values. Although illustrations here may initially appear to be somewhat inconsequential and trivial (e.g., combined shampoos and hair conditioners, washing powders and fabric softeners, and alcoholic spirits and mixers), they

are none the less wholly commensurate with an overriding contemporary logic in which the activities of consumption have been structurally reorganised to allow for new forms of production.

Continuous exchange

Throughout the 1980s there has been a marked increase in those commodities which involve the continual renewal of the process of exchange rather than a single, one-off payment. Most notable examples here have been the increase in financial services, especially in the growth of private pension funds and life-assurance schemes, as well as a growth in subscription schemes such as book, record and other monthly clubs.

The transition from material to experiential commodities

This has surely been one of the most significant developments within the commodity-form over recent years. Effectively, there has been a marked 'dematerialisation' of the commodity-form where the act of exchange centres upon those commodities which are time rather than substance based. The push to accelerate commodity and value turnovers has triggered a transition from the characteristic durable and material commodities of Fordism (washing machines, vacuum cleaners, automobiles, television sets, etc.) which have a lifespan extending well beyond the actual moment of exchange, to nondurable and, in particular, experiential commodities which are either used up during the act of consumption or, alternatively, based upon the consumption of a given period of time as opposed to a material artefact. There is of course an added advantage for capital in concentrating activity upon experiential commodities; for unlike material goods markets such as those for washing machines which eventually reach a point of saturation, the act of exchange associated with the commodification of experiential goods, not being based upon any physical ownership of the good by the consumer, is potentially always renewable and the market far less prone to exhaustion. This development may in part account for the enormous increase in the commodification and 'capitalisation' of cultural events during the 1980s. It also helps explain the permeation of an enterprise culture into many of those cultural forms that were previously state- or community-backed (e.g., the heritage 'industry', the phenomenal rise of the theme park, the further commercialisation of sporting and other public spectacles, etc.).

A similar illustration of this shift can be seen in the growing emphasis on the production of software rather than hardware products. Given that one of the prime causes of falling rates of profit towards the end of the 1960s was the long, and therefore uneconomical, lifespan of many electronic consumer durables, then investment today is increasingly channelled into those product sectors with a relatively short lifespan. Key developments in this respect

have tended to focus upon the new electronic consumer-goods markets, and in particular those of video, computer and laser software. It is by no means coincidental that, in foreseeing the shape of manufacturing futures, Sony recently bought out the giant American corporation Colombia in order to provide the necessary software supplement for their traditional hardware products.

Aesthetic obsolescence

The intensification of aesthetic obsolescence and a more rapid turnover of styling changes and fashions has continued to accelerate the rate of consumption and perpetuate needs throughout the 1980s. Small-batch commodity production enabled by more flexible working practices, technologies and means of distribution has made it possible for a greater plurality and diversification of commodities. These are often distinguished from each other only by stylistic and aesthetic differences, rather than by material or utilitarian functions. One of the clearest illustrations in this respect has been the rise of heavily branded designer clothes.

It may be one thing to identify some of the central characteristics and appearances of the new commodity-form, but it is much more problematical to disentangle those features of contemporary life which may possibly constitute the emergence of a new mode of regulation. This said however, at least two seemingly unconnected developments immediately suggest themselves as significant here. First, there has been an enormous extension of the socialisation of finance and the reorganisation of retailing. These have been introduced in order to make more flexible the acts of purchase. Notable features in this respect have involved, in retailing, the continued growth and diversification of mail-order retail outlets and the birth of home and tele-shopping schemes. In finance, changes have entailed the widespread introduction of in-house credit facilities and the relative ease with which personal loans may now be obtained. In Britain, for example, between the years 1982 and 1989, the national consumer-credit debt rose threefold to reach a total of £45.4 billion (*Social Trends* 1990). In this context, the linguistic switch from 'debt' to 'credit', which has been vigorously endorsed by banks and governments alike, coupled with its effect in dissolving much of the social stigma surrounding borrowing, is by no means coincidental.

Second, it is possible to argue that, to some extent, the 1980s have seen a dismantling of the more traditional social and cultural status relations as demarcated by commodity consumption. If many aspects of the social dimensions of consumption under Fordism saw a clear correspondence between brand loyalty and social status, then during the 1980s this correspondence has become far more ambiguous and fluid. This development may in part account for such a recent phenomenon as the 'cult of the individual' which is said to be based upon individualistic consumption patterns (the

marking out of a unique or individual lifestyle by commodities). It may also illuminate a phenomena recently described by John Sculley (1989) as 'hybrid consumption', where, as Sculley suggests, today's 'consumers are not middle class or upper class; they are hybrids. These days someone might buy a cheap digital watch, yet drive a BMW. Or drive to a fast-food restaurant in a Mercedes' (Sculley 1989:87).

The net result of many of the changes and features described above has been to make more flexible and fluid the various opportunities and moments of consumption. But the success of such a new logic of consumption ultimately rests upon the establishment of a far more thoroughgoing mode of regulation than the mere changing social perception of consumer debt, or such marketing clichés as the rise of individualism and hybrid consumption. In short, for this new logic of consumption to become anything other than a merely temporary mechanism to solve the problem of surplus realisation, the mode of regulation must accomplish a general resocialisation of everyday consciousness and establish a new culture of daily life. While there can be no doubt that contemporary culture has undergone significant changes over recent years it is by no means an easy task to interpret such changes. Since the most persistent debate around the issues of contemporary culture has for some time now concentrated upon the questions of postmodernism and postmodernity, it would seem to be appropriate to assess the extent to which the emergence of a supposedly radical postmodern culture throughout advanced capitalist societies is also representative of the emergence of a new mode of cultural regulation.

The culture of deregulation

POSTMODERNITY, OR THE END OF REGULATED CULTURE

To read an account of postmodern culture as it is presented by such academic luminaries as Frederic Jameson, Jean Baudrillard and Jean-François Lyotard is to read an account of the dissolution of a mode of social life in which everyday social consciousness is given shape and a sense of collective meaning by the assurances of solid cultural structures. From the cultural debris of what is essentially a 'Fordist structure of feeling' there rises a new postmodernist culture. Although notoriously impervious to stable or consensual definitions, postmodernism is seen to include at least some of the following features: a resurgence of cultural plurality, difference and otherness; a fragmentation and diversification of cultural values, beliefs and sensibilies; a certain abandonment of notions of interpretive depth and meaning in culture; and the foregrounding and celebration of the spectacular, the ephemeral, the façade, and the simulation. So redolent of today's consumer culture, it is the combination of many of these features that Fredric Jameson (1984, 1985), in particular, sees as the central element of a new 'cultural dominant' of contemporary or 'late' capitalist society. Since, far more than Baudrillard or Lyotard perhaps, Jameson's basic epistemology is premised upon the fundamental Marxist assertion that the production of culture is closely associated with economic production, it is well worth exploring his ideas in some detail.

Drawing upon the central thesis outlined originally by Ernest Mandel in *Late Capitalism* (1975), the basis of Jameson's argument is as follows. The broad history of capitalism can be seen to comprise of three distinctive or 'fundamental moments'. Each of these moments, suggests Jameson, marks a 'dialectical expansion over the previous stage'. They can be categorised as 'market capitalism, the monopoly stage or the stage of imperialism, and our own – wrongly called postindustrial, but what might better be termed multinational capital' (Jameson 1984:78). Corresponding to each of these moments is a particular stage of technological development. Market capitalism thus corresponds to steam technology, monopoly capitalism to electricity

and automobiles, while multinational capitalism corresponds to computer technology and nuclear power. In a similar vein, Jameson argues that each industrial era also has its corresponding dominant cultural aesthetic. Market capitalism is seen to parallel the rise of realism, monopoly capitalism corresponds to modernism, and multinational capitalism finds it aesthetic correlate in postmodernism. It is the emergence of this latest aesthetic mode which is, for Jameson, the direct efflux of 'the purest form of capital yet to have emerged, a prodigious expansion of capital into hitherto uncommodified areas' (Jameson 1984:78). For this reason, postmodernism is not seen here to be a discrete stylistic form, or, for that matter, an isolated aesthetic movement in the way that Impressionism or Romanticism, for example, might be so described. Rather, postmodernism is held to be a 'periodising concept' which articulates a certain contemporary cultural condition and is expressed through a distinctive mode of aesthetics and cultural practice.

This dominant mode of aesthetics associated with a particular social era does not evolve at random, but it represents the objectified appearance of the social organisation of the era in question. For within a dominant mode of aesthetics there is to be found embodied the characteristic patterns by which the social realities of the era are commonly perceived, understood and subsequently represented in culture. In this respect we may speak of a dominant mode of aesthetics as being the aesthetic materialisation of a shared, cultural world-view.

Seen from this perspective, realism can be characterised as the attempt to render naturalistically through a particular medium the experience of some external reality. Realism, therefore, tended to assume the aesthetic medium in question to be utilitarian; that is, merely a functional conduit for the unproblematic passage of an objective experience. The experiences of temporality in, for example, the classic realist narrative, perhaps best typified by the nineteenth-century novels of Jane Austen and George Eliot, or even in a musical work such as Beethoven's 'Pastorale' Symphony, presents us with the illusion of time unfolding in a linear manner as the narrative moves logically through its various spaces and episodes.

In contrast to the assured beliefs that were expressed in the realist aesthetic, modernism generally eschewed the core assumption that social reality could be somehow represented accurately and truthfully through the mere naturalistic transcription of events and experiences. After all, modernism was forged from the crucible of massive social, scientific and industrial upheaval which had so characterised the mid to latter part of the nineteenth century and the early years of the twentieth. It was not surprising, therefore, that a central, although an often unconscious, motivation behind the numerous practices of modernism should have been that of the search for new aesthetic forms – forms that were better able to accommodate and represent the unsettling disturbances of a fundamentally new world experience.

Modernism, suggest Bradbury and McFarlane (1976), was an aesthetic born first and foremost of contingency, and from the maelstrom of tumult and commotion that was left in its wake. Modernism:

> is the art consequent on Heisenberg's 'Uncertainty Principle', of the destruction of civilisation and reason in the First World War, of the world changed and reinterpreted by Marx, Freud and Darwin, of capitalism and constant industrial acceleration, of existential exposure to meaninglessness or absurdity. It is the literature of technology. It is the art consequent on the de-establishing of communal reality and conventional notions of causality, on the destruction of traditional notions of wholeness of individual character, on the linguistic chaos that ensues when public notions of language have been discredited and when all realities have become subjective fictions.
>
> (Bradbury and McFarlane 1976:27)

Modernism was both an aesthetic response to and a cartographer of the massive structural reconfigurations that had taken place within the twin dimensions through which all social life is experienced and constructed: those of time and space. As David Harvey (1989) puts it:

> The brushstrokes of Manet that began to decompose the traditional space of painting and to alter its frame, to explore the fragmentations of light and colour; the poems and reflections of Baudelaire that sought to transcend ephemerality and the narrow politics of place in the search for eternal meanings; and the novels of Flaubert with their peculiar narrative structures in space and time coupled with a language of icy aloofness; all of these were signals of a radical break of cultural sentiment that reflected a profound questioning of space and place, of present, past and future, in a world of insecurity and rapidly expanding spatial horizons.
>
> (Harvey 1989:263)

In short, modernism attempted to resolve the problems of objective representation via a radical experimentation in aesthetic form. Its quest was the capture of essential truths hidden from immediate sensory perception, and its means was the development of a critical aesthetic language that would be able to cut through the mere surface appearances and details of a modern world in chaos in the hope of penetrating its essential realities. Modernism was also the search for a certain mode of representation that could ultimately transcend the frailties of mere human perspective. It was in this preoccupation with the issues of form and language, code and medium, that a wide variety of bold aesthetic experiments were ultimately to be united. These included James Joyce's stream of consciousness writing; the detached alienation of Kafka's prose; the musical experimentations of Schoenberg, Webern and Berg which saw the steady dissolving of tonality and the birth of the new musical (anti-) language of serialism; the evocation

of a raw primevalism presented in Stravinski's *Rite of Spring*; Brecht's revolutionary epic theatre and aesthetics of praxis; the often bizarre explorations of the unconscious that were pioneered in Dada and Surrealism; the purity of aesthetic form that was embodied within the architecture of Le Corbusier, Mies van der Rohe and Walter Gropius; the parodic poetry of T.S. Eliot; and the abstract expressionism of painters such as Mondrian and Pollock.

Eventually the dominant thrust of modernism was to transcend the turbulence of its origins and, when integrated with the impetus provided by twentieth-century Fordist culture, crystallised as a relatively stable consensus over 'legitimate' aesthetic form. This was perhaps most visibly illustrated in the aesthetics of the International Style or in the design orthodoxy of Functionalism. To those in the vanguard of aesthetic and cultural production during this period, not only must it have appeared that the modernist aesthetic had mastered the vagaries of time and space, but had also managed to harmonise their seemingly dialectical forces of stability and speed merely through the proper and rational application of appropriate form.

The transition to postmodernity, however, shatters this confidence in social and aesthetic progress. In sentiments that readily became emblematic of the experiences of the earlier years of modernity, W.B. Yeats's poem 'The Second Coming' spoke of a world without ontological direction, a world where anarchy is loosed and all spiritual and moral structures begin to disintegrate. But such sentiments could be applied just as easily, and in many ways with as much validity, to the experiences of postmodernity. Indeed, if modernism egressed as an aesthetic force directly from the socio-economic turmoil of the late nineteenth century, then postmodernism too is a product of a similar instance of historical and social flux. At the very moment when there appeared to have emerged a mode of aesthetics capable of solidifying and making meaningful the enormous social upheavals that had followed the birth of a new (super) form of monopoly capital, the productive apparatus, or at least a significant and much publicised aspect of it, has, in its search for more efficient means to growth, once again altered its course and entailed a new round of social transformations: the production of a new, ideal-type commodity-form and modes of consumption; reconstituted forms of identity and patterns of life; greater social mobility and changed demographies; new political structures and their corresponding ideologies; redistributed geographical constituencies; and intensified rates of communication and market activity – all of these changes have impacted significantly upon our perceptions and common experiences of the everyday social reality. The net result of such changes would seem to be that daily life itself appears as more fluid, instantaneous and immediate, more cosmopolitan and intersected at every conceivable juncture by other lifeworlds and cultural influences than ever before. In view of this it is sometimes argued that our understandings of

what it means to be located as a conscious subject, existing at a particular time, within a particular place, and articulated by a whole network of social and cultural relationships, has been destabilised or, to borrow a term from post-structuralist discourse, 'decentred'.

How to render the experiences of this turbulence in a manner which gives them meaningful form has proved to be equally problematical. For unlike the (albeit nervous) optimism that was embodied in early modernist belief that certain essential truths and meanings could be captured objectively and brought to light via the appropriate aesthetic form, the new cultural dominant of postmodernism is actually predicated upon a rejection of the notion that objectivity and essential truths can ever be articulated successfully. In the postmodern schema, aesthetic form and content come to represent the disappearance of collective structures of social meaning, and they articulate a schizophrenic experience of everyday life.

Jameson, drawing upon Lacan's usage of the term, understands schizophrenia essentially in terms of a 'language disorder', a 'disease of communication'. In the clinical sense, schizophrenia 'emerges from the failure of the infant to accede fully into the realm of speech and language' (Jameson 1985:118). The generation of social meaning from language is, of course, predicated upon the successful inter-articulation between the sign and its referent; that is, between the two components of the sign (the signifier and the signified) and their subsequent connection to the referent, or the 'real' object existing within the 'real' world. According to structuralist orthodoxy, the successful inter-articulation between these linguistic components depends upon the conventionalisation of, or the consensual agreement over, the systems of linguistic difference which ultimately produce the value (meaning) of each individual sign. For this reason, schizophrenia is here seen as the breakdown of the relationship between individual signifiers. It is, therefore, the effect that is produced by the breakdown of previously stabilised systems of linguistic difference. This leads to a disturbance and, in some cases, a dissolution of the temporal order itself:

> the experience of temporality, human time, past, present, memory, the persistence of personal identity over months and years . . . is also an effect of language. It is because language has a past and a future, because the sentence moves in time, that we can have what seems to us a concrete or lived experience of time. But since the schizophrenic does not know language articulation in that way, he or she does not have our experience of temporal continuity either, but is condemned to live in a perpetual present with which the various moments of his or her past have little connection and for which there is no conceivable future on the horizon. In other words, schizophrenic experience is an experience of isolated, disconnected, discontinuous material signifiers which fail to link up into a coherent sequence. The schizophrenic thus does not know personal identity in our

sense, since our feeling of identity depends upon our sense of the persistence of the 'I' and the 'me' over time.

(Jameson 1985:119)

It is thus the immediacy, instantaneousness and intensity of our experiences of the contemporary social landscape that has led Jameson to describe contemporary or postmodern culture as an essentially schizophrenic culture:

New types of consumption [he suggests] planned obsolescence; an ever more rapid rhythm of fashion and styling changes; the penetration of advertising, television and the media generally to a hitherto unparalleled degree throughout society; the replacement of the old tension between city and country, centre and province, by the suburb and by universal standardisation; the growth of the great networks of superhighways and the arrival of automobile culture.

(Jameson 1985:124–5)

Such developments have all contributed towards a radical disruption of our sense of time and place. This renders the possibilities of there being formed stable, not to mention revolutionary, forms of collective social meaning increasingly unlikely. This sense of loss is then objectified in a postmodern aesthetic which plagiarises, and therefore effaces the significances of histories, to the extent that previous styles, symbolic codes, cultural movements and artefacts, now stripped of their original contexts and meanings, are juxtaposed into a bricolage or 'pastiche' of retro-chic and nostalgia. Such an aesthetic also invites a fascination, rather than a contemplation, of its contents; it celebrates surfaces and exteriors rather than looking for or claiming to embody (modernist) depth; it foregrounds the materiality of, and the discontinuity between, signifiers while dissolving the hermeneutic possibilities of the signified; it renders the critical distanciation between high cultural forms and popular culture obsolete; and it erases several of the key boundaries of separation that have previously existed between discrete cultural forms. In short, the postmodern aesthetic transforms all cultural content into objects for immediate consumption rather than texts of contemplative reception or detached and intellectual interpretation.

Postmodernism is here regarded as the cultural response to the new, or at least the most recently evolved, logic of capital. But in the move to make the experiences of social life instantly consumable, this new logic of capital has only succeeded in producing a form of cultural representation which has become detached from those aesthetic and linguistic structures which previously gave shape and substance to social meaning. At its most innocuous this diminution of aesthetic form to the mere banal fascination with surfaces and exteriors may be just eyecatching, amusing or simply bizarre (one notes immediately many of the stylistic excesses and indulgences of recent postmodern architecture, design and fashion, or the parade of glossy images

and technological wizardry displayed in that archetypal postmodern form: the pop video).

But the frontiers that exist here between style and chaos, between the pleasures and the terrors of the text, are not ones that are easily policed. Sometimes the effects that can be wrought by the immediacy and intensity of contemporary renderings and perceptions of time and space, and the results of what David Harvey (1989) has called 'time-space compression', can, quite literally, be terrifying. Anyone, for example, who witnessed on their television screens Iraq's first SCUD missile attack on the Israeli cities of Tel Aviv and Haifa during the early days of the Gulf War must have been well aware of the hermeneutic frailties of contemporary mass communication. The instantaneous depiction of the frightening events of the early hours of 18 January 1991 meant that what was transmitted to western audiences was not a carefully scripted, well framed or professionally structured piece of news. It had not been possible to construct the events of that morning into a narrative form and apply to them all of the usual values of standard journalistic practice. Rather, what was transmitted were the realities of terror, panic and confusion of journalists who were themselves as unsure as to the events unfolding before them as their audiences.

For the anchormen and women based in the TV news studios of New York, London and Paris, the broadcast material transmitted live from Israel was not, for them, fully processed and packaged news. Rather it was 'uncooked' (and hence 'inedible') information: a series of unstructured, highly impressionistic eyewitness contents without any sense of the broader picture on the ground, let alone any semblance of a 'preferred reading'. Against this background the opportunities for the imagination to run riot through several 'worst-case scenarios' were substantial: had a fully occupied block of flats taken a direct hit? Had chemical or biological warheads been used? Were the Tel Aviv hospitals filled with the dead and injured? Indeed, had Israel already launched its (nuclear) response against Baghdad? Over the space of at least two hours all of these scenarios were at first confirmed, then contradicted and finally proved to be bogus. It was during this period that the television viewer became aware of an almost unprecedented collision between two discrete and normally polarised spaces. The sudden compression of time that had, at a single stroke, effaced the usual delay needed to transform raw imagery and sound from the field of combat into meaningful news content had also collapsed the safe and comfortable space of the living room, the familiar and secure environment of everyday western domestic life, into all of the horrors and brutalities of the modern war zone. Moreover, such terror was compounded by what seemed to be at the time the obscenity of a regular punctuation of pictures from Israel with the usual advertising breaks. The juxtaposition of immaculately structured and highly meaningful texts promoting washing powders, designer lagers, life-assurance schemes, and telephone chat lines, with the horrific speculations and imagery of terrified

journalists was perhaps one of the most potent illustrations of the powerful effects of a new (anti-) aesthetic upon the perceptions of contemporary time and space. This had the effect of laying bare the massive incongruities of a non-logical, but, under less extreme circumstances perhaps, a perfectly familiar form of juxtaposition that exists today between the various, non-sequential, fragments that compose the everyday, postmodern, social reality; that is, the uneasy coexistence of multiple lifeworlds that are married only by an assemblage made possible by new micro-electronic technologies.

It is just such an unreal, 'hyper-real', experience of the (post-modern world that Baudrillard (1980, 1983, 1988b) has in mind when he takes the sort of ideas expressed by Jameson to their ultimately distopic extremes. For Baudrillard the logic of late capital has succeeded in producing an experience of social reality which is destabilised by a continual bombardment of signs and images generated by the new mass-communications technologies. Today, he suggests, there is a surfeit of information, an abundance of meaning, and an overwhelming exchange of signs and signifiers. Like any form of currency, the currency of signs is devalued once its distribution is too widely allocated. Under these conditions, meaning and significance 'implode' in the babble produced by the ceaseless and overwhelming production of communication. It is because the construction of meaningful social and cultural categories depends upon a stabilisation and a widely recognised hierarchisation of social signs – the hegemony of sign-value – that any destabilisation of this system results in a loss of the social itself as a meaningful point of reference. In Baudrillard's schema the logic of mass culture has been revealed and capital has finally shown itself in the form of its true objective: the systematic corralling and domination of 'the masses' by the manipulation of social meaning to the demands of the Code. Within this moment of revelation, 'the masses' have themselves now refused to play the game of culture, meaning and interpretation:

> the objective of information is always to circulate meaning, to subjugate the masses to meaning ... The masses remain scandalously resistant to this imperative of rational communication ... They intuit the terrorising simplification behind the ideal hegemony of meaning and they react to it in their own way, by reducing all articulate discourse to a single irrational, groundless dimension, in which signs lose their meaning and subside into exhausted fascination.
>
> (Baudrillard 1980:142–3)

In a so-called post-revolutionary, post-Marxist, and post-feminist world, the only form of social resistance that remains open to these masses is that of a deregulated or unstructured consumption; a mindless consumption of 'infantilism, hyper-conformism, total dependence, passivity, [and] idiocy' (Baudrillard 1980:147). This consumption remains a form of resistance only by virtue of the fact that it does not constitute a conscious and active compliance

to the system. Within this scenario, cultural identities may be assumed and assimilated with all the ease of an act of economic exchange, and, of course, they may just as easily be relinquished. Here the System of Objects and the tyranny of the sign has reached its true structural limits and cracked under the strain of its own overbearing logic and incoherence.

A somewhat similar position to this is presented by the French philosopher Jean-François Lyotard (1984, 1986). For Lyotard the bankruptcy of an older, more stable social order is today highlighted by the collapse of the very epistemological foundations upon which western civilisations have evolved from the period of the Enlightenment. Since this time, Lyotard argues, the construction of a social order has been predicated upon a number of 'legitimising concepts', or what he terms *Grands Récits*. These *Grands Récits* or 'great master narratives' have included such concepts as causality, rationality, harmony and logic. They have traditionally been used to shape our moral, ethical, legal, political, scientific, philosophical and aesthetic codes of conduct and practice for over three hundred years. Since the mid-nineteenth century, however, the seemingly unshakeable faith in the knowledge that could be drawn from these *Grands Récits* has increasingly come under an intense scrutiny. Darwin's theory of evolution, for example, Marx's analysis of social conflict, Freud's 'invention' of the unconscious, Einstein's theory of relativity, the shock of the new in most of the art forms, to say nothing of recent theories of chaos and fractal geometry, have all begun to beg serious questions of the very legitimacy upon which the social order of the modern nation state has been based. The tumult, upheavals and horrors of the twentieth century – which include two world wars, the death camps, nuclear outrages, the tyrannies and brutalities of the Stalinist state and those of Ceauşescu, Pol Pot, Saddam Hussein and many others; the inability of science and medicine to rid the world of disease and epidemic; and the abject failures of economic organisation to free the world of famine and scarcity – all have effectively redrawn the mental maps of the modern social consciousness. We now live, it is said, in an age of great unreason and uncertainty. We inhabit a largely chaotic, unknown and, ultimately, unknowable universe. The promise that under the guidance of the *Grands Récits*, western civilisations could achieve substantial progress towards verifiable definitions of universal truths, the ultimate organisation and mastery of the objective world, and eventually establish the long-held dreams of achieving a utopian society and the emancipation of all humanity, would not only seem to be an unfulfilled dream but also a quickly diminishing hope:

> This idea of progress as possible, probable or necessary was rooted in the certainty that the development of the arts, technology, knowledge and liberty would be profitable to mankind as a whole.
>
> After two centuries, we are more sensitive to signs that signify the contrary. Neither economic nor political liberalism, nor the various

Marxisms, emerge from the sanguinary last two centuries free from the suspicion of crimes against mankind . . . What kind of thought is able to sublate . . . Auschwitz in a general (either empirical or speculative) process towards a universal emancipation?

(Lyotard 1986:11)

One of the consequences of this loss of faith in social progress is an erosion of the once-stable distinctions and categories that have existed between such concepts as moral and amoral behaviour, high and low culture, the valuable and valueless, and even those of truth and falsity themselves. The meanings of these concepts have now either been rendered extremely ambiguous or else dissolved altogether. As such firm distinctions and values recede then in their wake is found the postmodern condition, a condition where all values and meanings are held to be relative, conditioned by time and space and therefore perceived as increasingly ephemeral and interchangeable. The collapse of such 'fixed, fast-frozen relations' (to re-quote Marx) has, for Lyotard, made eclecticism the 'degree zero of contemporary general culture: one listens to reggae, watches a western, eats McDonald's food for lunch and local cuisine for dinner, wears Paris perfume in Tokyo and "retro" clothes in Hong Kong; knowledge is a matter for TV games' (Lyotard 1984:76).

In the face of some of the overblown rhetoric offered by Baudrillard and Lyotard it may be difficult to approach the issues of contemporary cultural transformation with much critical sensitivity. Indeed, it may be readily concluded in the light of such literature that the end of capital as an organising force is at hand. Yet we should not be so quick as to assume automatically that the ceaseless march of capital has brought with it anything as dramatic as a collapse of the older structures and institutions that give meaningful shape to social experience and reality. With very few exceptions (and here I would cite Harvey 1989), the theorisation of postmodernism *vis-à-vis* the evolution of capital has been addressed extremely poorly. This failure to theorise properly the manner in which capital acts as a mediating force upon culture is particularly disappointing in the case of Jameson (see Kellner 1989b), whose work otherwise establishes him as a major intellectual figure of twentieth-century western Marxism. Capital, in the works cited above, is more often than not treated as an unproblematic given of social analysis. Reduced to a self-evidency by such phrases as 'the quest for growth' or 'a greater acceleration of commodity and value turnovers', the precise mechanisms and strategies by which growth and accumulation are actually achieved by capital, and which were with very valid cause so painstakingly analysed by Marx, are lost to the totalising and sometimes banal notion of the 'logic of the marketplace'. This means that the precise effects of capital upon the cultural sphere are also lost. The result of such analytic insensitivity in so much writing about postmodernism is that the concept is, in the words of Fred Pfeil (1990:3) 'like Pascal's God, everywhere and nowhere at once'.

This, then, begs two fundamental questions. First, to what extent have recent economic and social transformations within the western world succeeded in dismantling the old, Fordist modes of cultural and aesthetic regulation only to replace them with a new cultural dominant of postmodernism, and which seems to indicate a new form of cultural deregulation and destabilisation? Second, if there has been such a shift in contemporary culture, then how can we begin to locate precisely the new cultural sensibilities within concrete social structures and formations? In order to begin to unpack these questions it would seem sensible to turn our attention to the changes that may have taken place within one of the key regulating networks which so characterised Fordism, namely the advertising industry. The following section therefore is an exploration of contemporary advertising practice, and it considers a number of important changes that have taken place to the contents and formats of contemporary British advertising.

ADVERTISING FOR A NEW AGE OF CAPITAL

In previous chapters I have argued that from the early years of the twentieth century the modern advertising industry has emerged as one of the most potent and visible elements in the Fordist mode of economic and cultural regulation. While Stuart Ewen's intentionally provocative description of the advertisers as latter-day 'captains of consciousness' may overstate somewhat the ideological power of advertising to condition a mass social consciousness, the phrase none the less neatly encapsulates one of the primary functions of the modern advertising industry. In the words of Leiss, Kline and Jhally (1986:3), advertising exists as a 'privileged discourse', it is a discourse 'through and about objects'. These are objects produced by, and in the first instance for, capital. It is for this reason that contemporary advertising practice is one of the most obvious areas where we might expect to find aesthetic and cultural evidence of any change to the manner in which capital is accumulated and the patterns by which this process of accumulation is regulated. Given this basic proposition, and further given that the condition of postmodernity is regarded by many to be the cultural dominant of contemporary society, then what, if any, is the nature of the relationship between the cultural and aesthetic dimensions of modern advertising practice and postmodernism?

On the face of it advertising and postmodernism would appear to have much in common. For example, both often share a certain fascination with the visual image and celebrate the spectacular, the ostentatious and the rhetorical. Similarly, each is also concerned to impress its contents upon the subject in the most direct manner possible. This often produces a formal composition so designed as to display those contents with the greatest sense of immediacy and with the least possible concentration and interpretation required by the subject. By the same token, neither form is afraid to draw upon or make reference to the cultural codes and symbols of other discourse:

both advertising and postmodernism are prone to violate the nominally sacrosanct, and neither feels any compunction in decontextualising 'great' works of art and established aesthetic conventions, raiding the iconographies of religious beliefs and political struggles, or incorporating the forms of other cultures into its own discursive frame and for its own ends.

Advertising and postmodernism, then, do have many aesthetic features in common. To the extent that the periodisation of culture is always closely associated with the prevailing mode of commodity production, and that advertising is clearly the most immediate bridge between commodity production and cultural life, then it is quite proper to expect to find important connections existing between these two discursive forms. But it would also be both a mistake and highly oversimplistic to reduce the aesthetics of contemporary advertising merely to another manifestation of the ubiquitous postmodern condition. We should therefore not be blinded to the far more significant *differences* that exist between advertising and postmodernism. On the one hand, postmodernism is said to represent the surrender of meaningful and significant communication to a playful, but ultimately insignificant, patchwork of 'empty' or 'discontinuous' signifiers. These result in a schizophrenic aesthetic and a loss of the solid and coherent structures of collective social meaning that once characterised other, more stable, cultural moments. Modern advertising, on the other hand, was born out of just such a cultural moment and has its roots firmly embedded within a much older hermeneutic tradition: that of rational and 'utilitarian' communication.

By its nature advertising has always been governed by a need to produce meaningful forms of communication that would seem to make any adoption of a truly postmodern aesthetic wholly incompatible with this overriding purpose. In seeking to promote commodities and maximise their sales, advertising has unconditionally entered into a mode of communication that subordinates its choice of aesthetic form to its wider commercial aims. In short, advertising must adhere to an aesthetic logic in which sign relations are constructed in such a way as to articulate much broader and more common cultural codes in order to reproduce established patterns of social meaning. In this light, the base-line of all advertising is surely *the production of social meaning*. This point has been recognised and well documented, both by the advertising practitioners and the consumer analysts themselves as well as by those literatures that have been critical of advertising for its ideological functions. So to read Ernest Dichter's *The Strategy of Desire* (1960) and Judith Williamson's *Decoding Advertisements* (1978) for example, is, essentially, also to read an account of exactly the same symbolic processes, albeit given from polarised political positions:

If I can describe a cake, a cigarette, a fishing rod, or a bottle of whisky in such a way that its basic soul, its basic meaning to the modern man, becomes clear, I shall, at the same time, have achieved direct communi-

cation, I shall have established a bridge between my advertisement and the reader and come as close as possible to motivating the reader or listener to acquire this experience via the product which I have promised him.

(Dichter 1960:92)

Advertising . . . has a function, which is to sell things to us. But it has another function, which I believe in many ways replaces that traditionally fulfilled by art or religion. It creates structures of meaning.

For even the 'obvious' function of advertising – the definition above, 'to sell things to us' – involves a meaning process. Advertisements must take into account not only the inherent qualities and attributes of the products they are trying to sell, but also the way in which they can make those properties *mean something to us*.

(Williamson 1978:11–12)

In a similar vein, Robert Goldman (1987) has suggested that:

Of all the media forms, ads constitute the most formulaic, condensed and overstructured communications in the search for interpretive closure. Unlike reading a book or other printed matter, ads rely on the encoding of visual images; are tighter, briefer, and receive less concentrated attention from readers.

(Goldman 1987:694)

Similarly, even in his desire to demonstrate the empowering possibilities of reading, John Fiske (1987) rightly acknowledges that the encoding of advertisements is always undertaken within established and easily recognisable patterns of social meaning:

The intention of the advertiser is to engage and channel the desires of the viewer, not to give them free play. Inevitably, then, there is an attempted closure around the product which is designed to aggregate meanings and encapsulate the style.

(Fiske 1987:263)

In a less academic tone, perhaps, David Ogilvy, for many years the doyen of pragmatic advertising, has recently commented: 'as I see it, advertising has only one purpose: to sell a product for a manufacturer. That's what it's all about' (Ogilvy 1990:24).

What each of these views hold in common is the observation that advertising is necessarily more utilitarian in its aesthetic and symbolic forms, more hidebound by its need to impart some sense of commonly recognisable social meaning, and, consequently, more functionally adapted to this role than perhaps any other form of symbolic communication. Prior to the 1980s such a view would have been met by very few dissenting arguments, both from within the advertising industry itself or from those critical of it.

However, the 1980s have seen the steady emergence of a new aesthetic sensibility within certain quarters of the advertising industry. This is a sensibility which would in some respects seem extremely compatible with a postmodern aesthetic and, therefore, paradoxically incompatible with stand-ard advertising orthodoxy. The rise of this new sensibility has been perhaps most pronounced in Britain. It initially corresponds to the rise of a number of radical advertising agencies.

In 1979, appropriately the year that Margaret Thatcher won her first term of office as Conservative Prime Minister, the advertising agency Wight Collins Rutherford Scott was formed. With it there was also born a new breed of advertising agency which soon became known within advertising circles as *second-wave* advertising. Together with WCRS, a number of relatively small, independent, London-based agencies quickly established for them-selves a reputation as the *enfants terrible* of modern advertising. These agencies included Boase Massami Pollitt, Abbott Mead Vickers, Gold Greenlees Trott, Lowe Howard-Spink and, most notably, Bartle Bogle Hegarty.

Prior to the formation of these second-wave agencies, British advertising had been dominated by the large, 'first-wave', American multinational corporations. These included subsidiaries of J.Walter Thompson, Young and Rubicam, Ted Bates, McCann Erikson, Yellowhammer and Ogilvy and Mather. Seen as too conservative, and their campaigns increasingly in-effectual, first-wave orthodoxy soon came to be regarded in the creative departments and boardrooms of the second wave as profoundly outdated. The second wave saw it as incumbent upon themselves to transform what they held to be the then common, and rather negative perception of advertisements; to overturn the popular common sense which said that mass advertising was, almost by definition, a bland, uncreative and relatively crude form of consumer propaganda. Advertising, they argued, continued to follow slavishly a number of extremely restrictive and inefficient 'golden rules' that had been established during the boom years of the 1950s and 1960s. Above all, these golden rules stipulated the necessity to promote products by highlighting their functional and utilitarian strengths. Indeed, it had become almost obligatory advertising practice to stress the material benefits of the product on offer, demonstrate its unique selling points and insinuate the inadequacies of rival products. All of this was to be com-municated through a symbolic form that should be instantly accessible to the greatest number of viewers or readers of the advertisement. In many ways the second-wave agencies sought to transform these beliefs and the then common perception of advertising as an outmoded form of commercial propaganda. Advertising was to become, they argued, some of the most creative, entertaining, innovative and eye-catching forms of contemporary communication.

Operating under the rubric of 'advertising that offers creative bravura',

those creative departments following in the footsteps of the second-wave revolution soon began to produce a string of highly arresting campaigns. These were often for such up-market products as expensive jeans, 'designer' lagers, banks and other financial services, and expensive cars. What was notable about many of these campaigns was the way in which the original 'golden rules' of mass or 'blanket' advertising were transgressed. Second-wave agencies argued that by producing campaigns which focused the viewer's attention upon the highly innovative and often unusual visual and narrative devices, the product would, simply by association, benefit from this automatically. In the process, advertising would also begin to lose some of the stigma that it had attracted as crude consumer propaganda and also become a genuine artefact of popular culture or, at a pinch, a work of contemporary art. Making full use of many of the new pyschographic, lifestyle and other market segmentation techniques that had been developed during the 1970s, the second-wave agencies were able to identify and reproduce certain distinctive cultural sensibilities and visual literacies that were shared by the various members of a given target group. The net result of this approach was a series of campaigns in which the product often became all but incidental to the imagery, the narrative and to the soundtrack.

By the mid-1980s the impact of the second wave's approach to advertising had extended well beyond a number of relatively small, independent agencies, and had begun to influence the creative departments of the normally conservative multinational agencies such as J.Walter Thompson and Ogilvy and Mather. Increasingly, many campaigns began to abandon the notion of supplying product information at all. Instead, they began to concentrate upon the production of highly studied, stylised and often esoteric advertising texts which, more and more, required readers to possess a sophisticated visual awareness and relatively high amounts of cultural capital for successful decoding. Just as importantly however, such campaigns were regarded as having an improved chance of winning one of the prestigious and much-coveted prizes awarded annually by the advertising industry.

Often these advertisements would discard any attempt at producing a direct or rational appeal to the consumer at all, instead subordinating such an approach to a concentration on the glossy visuals and stylistic effects. Commenting upon a campaign for Silvikrin shampoo, Richard Auton of the agency Ogilvy and Mather enthused:

> what is noticeable to the outsider is that the ad is totally about image. The fact that the product is Silvikrin is almost irrelevant, and it could just as easily be used to promote any hair care range. All that matters now is style.
>
> (Quoted in Edwards 1987:56).

Almost as interesting as the arrival of second-wave advertising was the critical response it received in some of the more conservative quarters of the advertising industry. David Ogilvy, for example, the figure perhaps above all

others responsible for articulating publicly the original 'golden rules' of advertising, has commented that:

> Advertising at the moment is haunted by a terrible epidemic . . . Today, people who are paid to write advertising are not interested in selling. They consider advertising to be an art form, and talk about creativity all the time . . . sooner or later clients will find out that advertising made by these smart, pretentious and ignorant people does not sell anything. And then they'll stop it . . . The other day I was shown about a hundred TV commercials from all over the world. I was shocked. In many cases I could not understand what they were trying to sell. They didn't tell. Neither did they say what the product was supposed to be good for. They didn't give me one good reason for buying.
>
> (Ogilvy 1990:24)

What, then, are we to make of the emergence during the 1980s of this new form of advertising? Does it, for example, mark the first signs of capitalism's immanent failure to reproduce a necessary aesthetic language that is ultimately required to give ideological substance to its economic practices? Or, alternatively, does such a trend mark the initial permeation of a destabilising postmodern aesthetic into one of the last great bastions of a Fordist/modernist symbolic functionalism? Neither of these suggestions, I believe, are in themselves correct. The rise of this new mode of advertising, which seems to be predicated upon a certain stylistic and formal self-consciousness, that apparently disregards many of the older, common-sense advertising orthodoxies, or the embittered responses to this advertising from within the industry's old guard, does not signal anything as dramatic as a crisis in consumer capitalism's mode of aesthetic regulation. However, I believe this development to be significant. This is by no means to speculate that the advertising styles that have developed from the influences of the second-wave agencies can, in any straightforward sense, be regarded as postmodern. The use, for example, of non-conventional, anti-realist formats in advertising (non-linear narratives, the (mis)appropriation of surrealist and other avante-garde artistic techniques, etc.), the obvious exclusion of purely utilitarian forms of communication, as well as the direct absence of product information does not, as Robert Goldman (1987) rightly points out, necessarily lead to any failure to reproduce social meaning:

> Pepsi's recent TV ads string together oblique, tight close-up shots in a way which makes interpretive closure impossible, a fact which in no way imperils production of commodity-signs since Pepsi's prime concern is that readers associate their own interpretations of the different format (or narrative structure) to the product.
>
> (Goldman 1987:696)

Neither should it be assumed that the rise of second-wave advertising

has rendered the more orthodox first-wave advertising formats obsolete; clearly it has not. Many campaigns continue to employ the tried and tested techniques of product demonstration and the validation of use-values with recourse to scientific discourse. Rather, I believe that recent changes to the form and content of some of today's advertisements can be seen in many ways as symptomatic of the much broader social transformations that are currently taking place within consumer capitalism in general and its mode of cultural regulation in particular. The concentration upon style, form and image, rather than use-value, content and substance, in some of the more radical sectors of contemporary advertising can be viewed as an aesthetic response to the new intensity in market activity outlined in Chapter 8. In order to explore the nature of this aesthetic response, it may be useful to consider in some depth one of the more extreme illustrations of this new mode of advertising.

When the British subsidiary of the American advertising agency Grey acquired the Brylcreem account from the pharmaceuticals giant Beecham in 1985 they were faced with an enormous marketing problem: how to reposition a product that had not been advertised for nearly 20 years, whose recalculated target market of the under-35s represented less than 2 per cent of its current users, and how to transform the symbolic perceptions of a product that seemed to be irreversibly wedded to a number of extremely negative connotations originating from another age and from another cultural structure of feeling. In seeking to adapt an outdated and extremely jaded brand image into a fashionable and stylish accoutrement for the young man of the 1980s and 1990s, Grey subsequently embarked upon an advertising strategy that was, by advertising standards at least, revolutionary in both its format and its scope.

Grey's solution to the problem of how to reposition Brylcreem to appeal to a certain 1980s sensibility was not to dissolve the old brand image and its connotations, but rather to accentuate them. In a very self-conscious and deliberate manner, Grey were to re-articulate the 'smart modern look' of a bygone era. This, in itself, was not a particularly novel marketing ploy in the mid-1980s, for as Dylan Jones (1990) points out: 'after revivals of Bass Weejun loafers, Levis 501 jeans, Ray-Ban Wayfarer sunglasses, and countless retro-active consumer durables, why not Brylcreem?' Neither, of course, was the use of nostalgia to sell merchandise particularly specific to this period of advertising history. What *was* notable about the campaign for Brylcreem was the manner in which the variable of time was actually articulated.

Traditionally, nostalgia has been used in advertising to establish a logical continuity between the past, the present and the future. Its function has been that of fashioning a meaningful relationship between each discrete temporal moment. In advertising, the past becomes an aspirational ideal which can be reclaimed for a potential consumer in the future by the purchase of the

product. By associating this idealised past with an imagined future through the use of the product to signify this connection, the advertisement promises a positive transformation of the mundane and unsatisfactory realities of the consumer's present. The use of nostalgia in advertising, therefore, traditionally assumes a chronological and sequential articulation of time so that time may become meaningful, and individual moments of time may function as signs and exchange with one another to produce significance. In order that this exchange of temporal signs may occur successfully and that they may become meaningful, each of these signs must first be framed discursively within the text in order to establish a recognisable temporal distance between each of them. It is only through the symbolic construction of time in this way that the text itself may become meaningful and achieve the necessary closure around the commodity it promotes. The commodity, therefore, assumes the role of a symbolic fulcrum around which the social meaning of time may be successfully activated.

The Brylcreem campaign, however, violently dislocates the temporal flow and continuity of the traditional use of nostalgia in advertising narrative. This it achieves through the effacement of the boundaries of separation that normally exist between the temporal constructs of past, present and future. The result is a number of advertisements which appear to the reader as displaced across one undifferentiated plane of time.

The campaign is based upon a series of original 1960s advertisements for Brylcreem. In the television commercials these are reworked with 1980s video technology and a soundtrack by the Art of Noise, while in the magazine advertisements there is a curious juxtaposition of old and new layout techniques, typography and aesthetic styles generally. But for the reader of these texts there are no carefully constructed signposts to signify a preferential social meaning of time; no hint that a carefully articulated, idealised past, and an equally well-articulated but unsatisfactory present can be reconciled in an imaginary future through the use of the product. Within the advertisements there are no overt cues to inform readers as to whether or not the texts exist as contemporary or original advertisements for Brylcreem. Instead we as readers are left with, to use Jameson's term, a 'pastiche' of symbols and iconography; a visually arresting but narrativeless series of texts which, in the television commercial for example, randomly stitch together the signs of one period (black and white imagery, typeface, fashion, hairstyles, mode of address and, indeed, the connotations of the product itself) with the signs of another period (the electronic soundtrack and video-trickery) in a manner that confuses the temporal origins of these signs. The diffusion of the symbolic potency of these signs has the effect of destabilising the time-frame of the advertisements themselves. The advertisements thus seem to flicker and alternate between one period of time and the other. The effect they produce is a temporal equivalent to that sense of visual disorientation produced by the ambiguous face/vase illusion: any attempt by the reader to

focus cognitively upon one temporal dimension immediately finds the reader's concentration flooded by symbols (and meanings) that signify the other period. The result of this is that neither period of time finds a firm symbolic anchorage within the text but becomes free-floating and displaced.

Subsequently detached from their referents (i.e., specific moments of time), the individual signs become, if not meaningless, then at least drained of any preferred or ideological meaning. They effectively become the embodiment of Jameson's 'discontinuous signifiers'; disembodied or 'hollow' signifiers of a schizophrenic text. The dissolution of temporal continuity in the text means that the signs assume a larger-than-life appearance and become, as Jameson himself puts it, 'powerfully, overwhelmingly vivid and "material". The world comes before the schizophrenic with heightened intensity' (Jameson 1985:120). Seen from this perspective, the texts present us with neither the sensitive, 'ideologically sound' New Man of the 1980s, nor with the original Brylcreem Boy of the 1950s and 1960s, but with a curious hybrid of both forms of masculine discourse. The advertisements are therefore neither overtly sexist in their portrayals of women (despite the signifiers that would often seem to imply the contrary in the television commercials), nor are they overt statements of anti-sexism. Instead the advertisements offer us what is fashionably called a 'decentred reading position'; a plurality of reading positions based upon an unstructured combination of signifiers and a narrative form that does not invite ideological recognition, identification or closure.

Viewed from the prism of an older hermeneutic depth, the Brylcreem advertisements would appear to make very little 'sense'. Yet the advertisements still 'work'. Brylcreem was successfully relaunched through the advertising campaign and, with the aid of several slightly less radical follow-up campaigns, has since established itself once again as a market leader in the hair-care product range. This implies that the original 1985 advertisements had some 'effect', and that they at least produced in their intended viewers certain visual and textual pleasures. It might be useful in this context to distinguish between the two forms of pleasure that are outlined by Roland Barthes (1975): namely those of *plaisir* and *jouissance*.

For Barthes *plaisir* is the pleasure that is produced by culture. It is materialised as the moment when cultural identity is recognised (and hence reproduced) within a social text. It is, then, the pleasure that is (re)produced when we recognise in some cultural form or practice our own distinctive cultural beliefs and values, our group-specific ways of seeing and reading the world or, in short, some aspect of our own structure of feeling. *Plaisir* is therefore the reward for confirming a solidarity with a particular cultural formation. It is not surprising, therefore, that for many critical analysts, the pleasures that are often produced from mass-mediated texts, and in particular those of advertising, are said to function in an ideological manner.

Jouissance, however, represents an entirely different form of pleasure.

Jouissance is produced by an intensity of experience which has less to do with an act of cultural recognition and more with a quasi-erotic interaction with the text. It is a pleasure that is produced through an engagement with the materiality of the text and with the physicalities of the signifiers within that text. It is a pleasure of the body, not of language, of physical sensation and not of social meaning. *Jouissance* therefore transcends the cultural dimensions of the text. It is:

A text where we can hear the grain of the throat, the patina of consonants, the voluptuousness of vowels, a whole carnal stereophony: the articulation of the body, of the tongue, not that of meaning, of language . . . [Jouissance] crackles, it caresses, it grates, it cuts, it comes: that is bliss.

(Barthes 1975:66–7)

There are clearly significant connections to be made here between Barthes' notion of *jouissance* and the aesthetic features of the so-called postmodern text. Both, it could be argued, produce a form of stylistic pleasure which relies upon the reader 'consuming', rather than interpreting, the signifiers of the text; that is, treating those signifiers as 'pure' symbolic objects without concern for their signifieds. Since the intention of all advertising is surely to articulate cultural discourse, reproduce social meaning and thereby also reproduce a certain social ideology, advertising has historically been that media form which has been more conductive in the generation of *plaisir* rather than *jouissance*. But the illustration of the Brylcreem advertisements would seem to indicate the opposite manifestation of pleasure; a pleasure that is more likely to be of a type which has its origins in *jouissance*. The Brylcreem advertisements seem to invite a pleasure of physical sensation, of consumption and of the senses, and not one of reading, interpretation or of cognitive understanding.

There is an obvious analytical temptation here, a temptation that has been embraced enthusiastically, albeit in different ways, by writers such as Baudrillard and Fiske. In its broadest terms, the argument may be summarised as follows: capitalism is driven by an economic logic that, from one period to the next, compels it to seek out more efficient (i.e. more profitable) modes of production and consumption. When new and more efficient modes of production and consumption have been established over a defined period of time as a generalised condition for capital accumulation, then capitalism is able to achieve its ultimate goal of a sustained economic growth. However, in order that the social conditions which nurture a particular period of growth may be reproduced, capitalism also relies upon the institutionalisation of a number of regulating networks. The primary function of such networks is that of the building of a series of social structures which may ease the passage of, and accommodate, the many social changes that have been demanded by the new conditions of capital. One dimension of this mode of regulation is a cultural-aesthetic dimension. The function of this dimension is to give

meaningful form to lived experience and establish a common social consciousness that does not generally come into conflict with capital's broader economic practices and objectives. Regulation in the cultural sphere, therefore, is essentially also the regulation of language. It is essentially the policing of the linguistic boundaries within which social meaning is allowed to form and be articulated – the establishment of certain cultural or linguistic codes which can, for example, define and delimit the social meanings of gender, nationhood, labour, politics or, for that matter, any social practice or discourse. When social meaning is produced within the limits of these linguistic or cultural frames, when the sign appears as uni-accentual and seems incapable of generating a plurality of meanings, then we might say that there has been a successful reproduction of a particular ideology of capital.

But today, it could be suggested, capital has overextended itself: it has succeeded in establishing a new form of political economy which, while embodying the desired end of highly intensified modes and rates of production and consumption needed for a new round of economic growth, has failed to develop these modes culturally. The new political economy has outstripped the capacity of capital to develop adequately commensurate structures of cultural regulation, and, especially, aesthetic and linguistic forms attuned to the need to stabilise the system. As a result, capital increasingly fails to guarantee the sort of mass social consciousness and patterns of subjectivity demanded to stabilise and reproduce itself. Social meaning thus becomes unanchored from the sort of solid cultural structures into which it was previously corralled. At such a moment in modern social and economic history the system itself creaks, and consumers and readers alike begin to evade the tyrannies of the capitalist text. It could be argued, therefore, that such a crisis of language and representation is one of the less direct, but still extremely important, effects of a contemporary crisis of overaccumulation (see Chapters 4 and 7).

John Fiske would seem to agree with many elements of just such a position. Despite its desire to produce meaningful and ideological discourse, argues Fiske, the logic of modern advertising has compelled it to generate ever more elaborate and stylistic visual/aural textual compositions. These make 'the high production values, the glossy sensualities of the image, and the tight editing carry a stylistic pleasure of their own that is easily detached from the commodity on offer' (Fiske 1987:263). The result is more likely to be the production of a pleasure from the text that is more akin to *jouissance* than to *plaisir*; a pleasure, therefore, that is more reliant upon the sensual physicalities that are embodied within the text and less with the text's cultural dimensions. To escape the cultural dimensions of the text is, of course, also to escape the possibilities of a reproduction of capitalist ideology or a confirmation of a certain subjectivity that may be inscribed within that text. It is effectively the negation of advertising's function as an agency of cultural regulation.

In the final chapter I argue against just such a position which sees in new aesthetic and linguistic forms the moment for the evasion of a social order dictated by capital, and instead argue for a position that sees such developments as part of a broader move by capital to extend and restructure its mode of cultural regulation in alignment with changes to the political economy.

Chapter 10

Consumer culture reborn

This, then, is the project of the Post: to replace the dominant (Platonic) regime of meaning – that is, representation – by a radical anti-system which promotes the articulation of difference as an end in itself. It is sometimes argued that this involves the multiplication of those transitory points from which a divinely underwritten authority can be eroded and questioned.

(Hebdige 1988:163)

THE STORAGE OF CULTURAL VALUE AND THE CRISIS IN REPRESENTATION

In order that we may better understand the manner in which the transformations of capital have impacted upon contemporary culture and the politics of representation, we shall first need to consider the forms by which culture is measured and objectified. This involves some preliminary discussion of the concept of *value*.

For Marx, value was not merely an abstract form useful for quantifying economic exchanges, but a real, concrete phenomenon. Value represented the sum totals of abstract labour needed to produce a given quantity of use-values in a particular time and place. Value, however, never appears in its 'pure' form. In capitalism, value always takes material shape in a process of commodity production where, objectified as capital, it assumes the form of money, production in process (i.e., living labour and means of production) and commodities. As we saw at the start of this book, the function of capital is the appropriation of a surplus-value from living labour. This effectively represents the means by which capital can *produce itself*, and thus makes capital the objectification of self-expanding value: *'value valorising itself*, value that gives birth to value' (Marx 1976:1060). Accordingly, the prime reason for the circulation of values in capitalism is nothing other than that of the creation of value itself. In the final analysis, this objectification of value in capital is materialised in the commodity. The commodity is firstly an exchange-value, and an exchange-value is simply the ratio at which

commodities exchange with one another under given market circumstances. Normally one dimension of this exchange takes the form of money. The ultimate function of money is thus the facilitation of the self-expansion of value. As the 'absolute' or 'master' commodity, money is therefore the supreme authority governing the flow, circulation and expansion of value.

We may apply the essence of Marx's logic of economic value to the concept of *cultural value*. Cultural value may be defined as the objectification of relationships of cultural difference which materialise as cultural objects and practices. Similar to the model of economic value outlined by Marx, cultural value too never appears in its 'pure' or abstract form, and it cannot be recognised as such prior to the moment of its *materialisation as a social sign*. We may say, therefore, that cultural value is always objectified in the form of the social sign. Again, like economic value, cultural value too only becomes visible when the social sign within which it is stored exchanges with other social signs in the framework of a cultural code. To take a simple example: a cultural value of the colour green (e.g., green = go) may only become active as a commonly recognisable meaning when the sign 'green' exchanges with other signs in the general system of colour (such as the signs 'red' or 'yellow'). It is in this moment of symbolic exchange, or in the moment of equivalence that exists in the inter-articulation of social signs, each of which is the bearer of a cultural value, that social meaning is produced and cultural value is reproduced.

Perhaps more than any other writer on cultural theory, the work of Bourdieu has been successful in extending Marx's original logic of capital into the cultural domain. Bourdieu has suggested that it is not possible to distil the totality of social relations under capitalism to an essence of economic production relations. Instead, social relations are both economic and *cultural*, with the latter having a 'relative autonomy' of action from the former. Similar to Marx's schema, Bourdieu argues that the prime function of the circulation of cultural values in modern society is predicated not only upon their own reproduction, but also upon their own self-valorisation: the circulation of cultural values in capitalist societies is ultimately a process attuned to the valorisation of cultural value, of adding cultural value to cultural value. Bourdieu suggests that the relative distribution of cultural capital throughout capitalist society provides for different social groupings a differential capacity for the investment of cultural value into symbolic goods. Symbolic goods function within culture as social signs (of prestige, status and of relative social standing). As social signs, symbolic goods are thus the objectification of the specific capital investments of their users. From this position we may speak quite legitimately about a *political economy of symbolic goods* in a manner similar to that described by Baudrillard. In order that this symbolic economy may function successfully, and that signs may be able to exchange with one another with some fluidity, the broader social codes within which these signs are framed must first have to have been

interiorised and conventionalised by the community of users. For just as the market within which commodities exchange is predicated upon certain predetermined economic rules (the rules governing the determination of the value of abstract labour and of economic equivalences), then so too is the 'market' within which social signs exchange (the cultural codes) also required to assume a number of broad rules agreed in advance by all of the 'traders' in symbolic goods. It is only under such predetermined conditions that cultural value can be added, 'cultural profits' procured, and a surplus meaning (surplus-value) generated for those whose investments of cultural capital have been the greatest, the most propitious or the most shrewd.

What happens, however, in a social era where the markets within which these symbolic exchanges occur – the codes of social discourse – are flooded with currency? Under such conditions, the symbolic forms in which cultural value is normally stored are themselves devalued and social signs lose their capacity to provoke or articulate a desired social meaning. Value cannot be added to capital, cultural profits are 'written-off' and surplus meaning fails to materialise as symbolic markets are 'devalued'. Under such conditions does culture itself lose its value? Recent theories of postmodernism and post-modernity would seem to indicate the existence of just such a condition of 'market' crisis.

The connection between cultural forms of value and Marx's definition of economic value is by no means simply an analogous one. In some of the most striking passages of David Harvey's *The Condition of Postmodernity* (1989), Harvey demonstrates how the intensification of market activity since the early 1970s has resulted in a crisis of representation in the ways in which economic value now gets depicted. Fordism, suggests Harvey, attained a regular financial stability under the guarantee of the US dollar, 'technically backed by a fixed convertability into gold, and backed politically and economically by the overwhelming power of the US productive apparatus. The space of the US production system became, in effect, the guarantor of international value' (Harvey 1989:296). But today, Harvey continues, a destabilising internationalisation of capital and the widespread deregulation of financial markets have given the representation of value an overly fluid and, for this reason, a problematical nature. Since the circulation of value can only occur when value takes an objectified form through some specific instance of representation, then this crisis in representation has also made the circulation of value, and hence value itself, problematical:

The question of how value should now get represented, what form money should take and the meaning that can be put upon the various forms of money available to us, has never been far away from the surface of recent concerns. Since 1973, money has been 'de-materialised' in the sense that it no longer has a formal or tangible link to precious metals . . . or for that matter any other tangible commodity. Nor does it rely exclusively upon

productive activity within a particular space. The world has come to rely, for the first time in its history, upon immaterial forms of money – i.e. money of account assessed quantitatively in numbers of some designated currency (dollars, yen, Deutsch Marks, sterling etc.) . . . The question of which currency I hold is directly linked to which place I put my faith in. That may have something to do with the competitive economic position and power of different national systems. The power, given the flexibility of accumulation over space, is itself a rapidly shifting magnitude. The effect is to render the spaces that underpin the determination of value as unstable as value itself . . . The delinking of the financial system from active production and from any material monetary base calls into question the reliability of the basic mechanism whereby value is supposed to be represented.

(Harvey 1989:297)

From this sort of perspective we may be able to glimpse the reasoning behind why the 1980s saw such intensive financial speculations into certain material market forms – market forms that are generally perceived as better able to accommodate a more stable storage of value:

collectibles, art objects, antiques, houses and the like . . . the growth of the art market (with its concern for authorial signature) and the strong commercialisation of cultural production since around 1970 have had a lot to do with the search to find alternative means to store value under conditions where usual money forms were deficient.

(Harvey 1989:298)

I shall now, by way of conclusion, put forward an argument which suggests that a similar crisis of representation has afflicted the processes by which a stable storage of cultural value may be achieved in symbolic and cultural goods. Moreover, this crisis of representation; that is, the crisis in aesthetics and language in part articulated by the catch-all term of 'post-modernism', has also engendered a quest within some newly formed social classes and class fractions of contemporary capitalist societies to seek out new forms of signification and mechanisms of symbolic exchange that might be better able to protect their investments of cultural capital and symbolic profits alike. In short, I shall argue that these 'new consumption classes', as we may refer to them, have attempted to develop particular symbolic practices and new forms for the valorisation of those practices that may store more securely the cultural value that is needed to operationalise their investments and profits.

THE NEW CONSUMPTION CLASSES

During the remainder of this chapter I shall argue that the rise of so-called 'postmodern' cultural goods during the 1980s can be identified as a symbolic property of, first, the new ideal-type commodity-form that was outlined in

Chapter 7 and, second, a new, class-based mode of consumption which is characteristic of this new commodity-form. The relationship between these postmodern cultural goods, the new commodity-form and its mode of consumption is, I shall suggest, most closely associated with the rise of certain social formations within contemporary consumer society. These new social classes have been identified in the recent work of Pfeil (1988, 1990), Bourdieu (1984), Featherstone (1989, 1991), Lash and Urry (1987), and Betz (1992). Let me first sketch some of the main social and cultural characteristics which may identify these new social formations.

For Fred Pfeil (1988, 1990), the social grouping in question is a new professional-managerial class and is composed:

> primarily of middle-class whites from around eighteen years of age to upwards of forty, mostly college educated, with a greater parity of females to males than has ordinarily been the case in markets for 'avante-garde' works. We are speaking, then, of a significant minority within a generation and a half of consumer society, a group that has either lived its childhood or come to maturity through the long crisis and congealment of the sixties and seventies; a generation and a half, moreover, whose social destiny has remained clear: we are to be the switchpoints between capital and labour, the intermediary, administrative and reproductive component of a vast apparatus of exploitation and valorisation.
>
> (Pfeil 1988:383)

Drawing upon Raymond Williams's seminal concept of 'structure of feeling' – a 'community of experience', internalised and re-articulated as cultural practice and consciousness – Pfeil sees the distinctiveness of this new social formation as focused upon a 'postmodern structure of feeling'. This postmodern structure of feeling is both an experience and its articulation that has been born of the bitter-sweet effects generated by the social conditions which have come to characterise so many facets of the contemporary middle-class (American) lifestyle. So it is, in part, the direct cultural product of various modern social enfranchisements: it stems from that sense of liberation which arises from newly acquired social and geographical mobility, from a relative economic affluence, an access to the full means of modern commodity consumption and to the material and cultural opportunities that such consumption may afford. It also derives its character from the relative linguistic and cultural competences which flow from the investments of time into higher or college education. Just as importantly perhaps, it is that feeling of ontological freedom which is gained when the standard social hierarchies, ideologies and the deeply conventionalised politics and morality that characterised a previous cultural era are dissolved under the steady processes of consumer and social democratisation that have occurred since the Second World War. It is also partly the result of a process of 'de-Oedipalisation', which has, perhaps much more effectively than in

working-class life and culture, penetrated the politics of parenting and seen a collapse in traditional patterns of parental authority.

But this postmodern structure of feeling is also born of the sense of panic and uncertainty that results from the corollary of these freedoms and enfranchisements. It is, therefore, the product of a contemporary social fragmentation, of polyculturalism, and of a cultural hybridity resulting from the material and cultural opportunities provided by the fluidity of the modern commodity-form and contemporary patterns of consumption. It is the typical social consciousness that is produced from that feeling of ontological absence and lack which ensues when cultural identity becomes unbridled from the previously fixed, or at least the relatively stable, class, racial, sexual, religious and other social coordinates that have traditionally given meaning to an individual's experience of time and place. It is also the product of a loss of the social roots and the dissolution of a common cultural heritage that has normally shaped identity and self-concept, and it is, therefore, the result of the failure to secure a fully centred subjectivity. As Pfeil argues: 'just as the vision of the boundlessly dispersed self is caught up with the fear of dissolution, the flip side of the ease of "breathing" and "staying open" is the terror of a contingency from which all possibility of eventful significance has been drained' (Pfeil 1988: 386).

Like Pfeil, Mike Featherstone (1989, 1991), and Scott Lash and John Urry (1987), have also identified the rise of a similar middle-class formation. However, for these writers analysis is based initially upon two new major middle-class social groupings outlined by Pierre Bourdieu: the *new bourgeoisie* and the *new petit bourgeoisie*. For Bourdieu, what initially unites these two groupings is their typical occupations which are almost entirely a product of the massive expansion within the service and white-collar sectors that has taken place since the time of the Second World War. According to Bourdieu, members of the new bourgeoisie can be seen particularly in those service and white-collar occupations that are concerned with the production of symbolic goods and services. They are, like Pfeil's conceptualisation of them as 'the switchpoints between capital and labour', a new class of cultural intermediaries. For Bourdieu, these cultural intermediaries find 'ardent spokesmen in ... the directors and executives of firms in tourism and journalism, publishing and the cinema, fashion and advertising, decoration and property development' (Bourdieu 1984: 310–11).

The nature of these typical occupations means that the new bourgeoisie find themselves in possession of relatively high amounts of both economic and cultural capital. But the relative parity that exists here between both forms of social capital is coupled with the fact that their occupational practices are unfamiliar to the eyes of others. This locates the new bourgeoisie within a cultural space which sits somewhat uneasily between the lifestyles of the old bourgeoisie and those occupied by the intellectual classes. Their cultural capital distances them from that rather inflexible

approach to culture displayed by the old bourgeoisie, which may be characterised as a rather rigid adherence to 'rules' and formal etiquette as well as a certain cultural philistinism. But the relatively high amounts of economic capital possessed by the new bourgeoisie also distances them from the typical habitus-type shared by the intellectual classes, who, although relatively impoverished in economic terms, hold that ultimate power over the symbolic economy which is to be found in a 'disinterested' and distanced appreciation of Culture. Located between these two polar dimensions of the dominant class, Bourdieu suggests that the new bourgeoisie embody the ideal manifestation of a new social consciousness. This draws its character from both economic and cultural resources equally. The new bourgeoisie is thus:

the initiator of the ethical retooling required by the new economy from which it draws its power and profits, whose functioning depends as much on the production of needs and consumers as on the production of goods. The new logic of the economy rejects the ascetic ethic of production and accumulation, based upon abstinence, sobriety, saving and calculation, in favour of a hedonistic morality of consumption, based on credit, spending and enjoyment. This economy demands a social world which judges people by their capacity for consumption, their 'standard of living', their life-style, as much as by their capacity for production.

(Bourdieu 1984:310)

If the new bourgeoisie hold the most prestigious positions in their occupations of symbolic goods and services production, then the new petit bourgeoisie are to be found within 'the lower echelons of the service class' (Lash and Urry 1987: 295). This grouping finds itself in possession of less social capital than that of their more wealthy counterparts in the new bourgeoisie. They do, however, tend to share very similar occupational backgrounds:

The new petit bourgeoisie comes into its own in all the occupations involving presentation and representation (sales, marketing, advertising, public relations, fashion, decoration and so forth) and in all the institutions providing symbolic goods and services. These include the various jobs in medical and social assistance (marriage guidance and sex therapy, dietetics, vocational guidance, pediatric advice etc) and in cultural production and organisation (youth leaders, play leaders, tutors and monitors, and TV producers and presenters, magazine journalists) which have expanded considerably in recent years.

(Bourdieu 1984:359)

What motivates the new petit bourgeoisie in their various symbolic struggles over the cultural distinction is the profound sense of unease that is generated by the relative instability of the social space within which this

class fraction finds itself located. There are several important factors which contribute towards this sense of cultural instability. Most importantly, this is the class fraction which, perhaps more than any other, has been the chief recipient and beneficiary of an unprecedented expansion within the educational sector that has taken place within most post-war advanced industrial societies. This expansion in education followed directly as the co-requisite intellectual component for the new forms of labour (the bureaucratic, administrative, technical and service occupations) that were evolving from and were needed to service the maturation of Fordism and organised capitalism from the 1950s onwards. This has meant that the education of the typical individual from the new petit bourgeoisie has not been pursued for the cultivation of a generally enlightened intellect. Rather, it has been undertaken with far more pragmatic and utilitarian ends in mind: namely those dictated by the direct and immediate needs of occupational vocation.

The cultural implications that follow from this are twofold. First, since educational capital is regarded by Bourdieu to be the chief means of accreditation and validation of cultural capital, then the vocational quality of the educational capital possessed by the new petit bourgeoisie is, in this respect at least, of a relatively impoverished form. Its narrow focus on 'training' and the acquisition of discrete occupational skills and knowledges does not befit it well for the cultivation of the sort of all round cultural competences normally needed to valorise cultural capital. This form of educational capital generally denies the cultural actor from the new petit bourgeoisie the opportunities to develop those transformational skills that are usually to be found embodied in the cultural capital possessed by those, such as artistic producers, higher-education teachers or intellectuals for example, who have learnt, not merely the discrete skills that their work demands, but a number of advanced, highly abstract and extremely transposible ways of thinking about and classifying their specific world perceptions. Second, this distinctive background in education none the less provides the critical site for the formation of a new habitus-type. It has laid the ground for a new matrix of interiorised dispositions and unconscious motivations that, over time, have allowed for the formation of a lifestyle that has been able to break free from the various class spaces from which the members of new petit bourgeoisie have originally been drawn. It has been the democratisation of this form of education throughout many industrialised countries since the Second World War that has not only provided a natural home for many of the children of the massively expanded middle classes since that time, but has also given to many working-class children an alternative life path to the typical blue-collar, manual occupations normally associated with their class. Similarly, it has also offered a 'fall-back' route for those children from the higher or professional classes who may have failed to meet their parent's expectations of them and have been unable 'to

make the grade' in their anticipated professions or gain acceptance into the top universities and academies.

This distinctive relationship to the educational field and the peculiar composition of its class membership gives the habitus of the new petit bourgeoisie class fraction a germinal or not fully formed quality. It also grants the new petit bourgeoisie themselves an extremely ambiguous relationship to the cultural field as a whole. In essence, the lifestyle of the new petit bourgeoisie remains, as yet, to be fully validated, yet to be properly integrated into the overall dynamic of symbolic class struggle and, more importantly, *seen* to be as such by most other social groupings. This sense of unfamiliarity in the eyes of others produces in the new petit bourgeoisie a certain anxiety in the adoption of their particular discursive codes of cultural classification and practice. This is an anxiety which stems from the threat of failure to accede to the mechanisms and means of power within the field of symbolic struggle itself. It is an anxiety which results from the fear of a refusal to be taken seriously as legitimate players in the 'game' of cultural struggle, to be denied the essential status of worthy traders in the market of symbolic goods. It is this factor which forms the distinctive cultural character of the new petit bourgeoisie. This, suggests Featherstone (1991), produces in the new petit bourgeoisie a particular sense of unease with the body, itself a prime site for the materialisation of the habitus, and which ensures that each actor is 'constantly self-consciously checking, watching and correcting him/herself':

> Hence the attraction of body maintenance techniques, the new Californian sports and exercise, cosmetics, health foods where the body is treated as a sign for others and not as an instrument. The new petit bourgeoisie is a pretender, aspiring to more than he is, who adopts an investment orientation to life; he possesses little economic or cultural capital and therefore must acquire it. The acquisition of the latter makes him open to being perceived as an autodidact, the product of the education system, who betrays an anxiety about using the right classification, who is always in danger of knowing too much or too little . . . The new petite bourgeoisie therefore adopts a learning mode to life; he is consciously educating him/ herself in the field of taste, style and lifestyle.
>
> (Featherstone 1991:90–1)

What this threat of failure to gain an acceptance to the broad symbolic codes, which frame all forms of cultural struggle, produces in the new petit bourgeoisie, is the very real danger of some massive devaluation in that cultural capital which this class fraction has already been able to accumulate. The new petit bourgeoisie continually run the risk of having their cultural capital denounced as 'worthless' or deemed by the symbolic markets in which they seek to trade and prosper to be an 'illegitimate currency' incapable of generating cultural profit.

SYMBOLIC VIOLENCE AND CONSUMER MADNESS

It should now be possible to identify a number of factors which contribute towards the objectification of the group identity common to the new consumption classes.

The dangers of falling into a condition of cultural illegitimacy make the clear objectification of the habitus of the new consumption classes and the social spaces occupied by their specific lifestyles absolutely critical. But how to achieve this objectification is by no means a straightforward operation. Because the new consumption classes have no exclusive origin as a cultural grouping in either a working-, middle- or upper-class social formation, they consequently find themselves situated upon a social terrain that is generally unfamiliar to the perceptions of all other social groupings. From this terrain they must hew for themselves a space of cultural recognition. This may then be used to house the appropriate symbolic forms which are themselves needed to store adequately, reproduce and valorise the cultural capital of the group. However, finding many of their cultural practices not as yet fully integrated into the field of symbolic class struggle, and therefore having foreclosed to them many of the traditional 'outflanking' manœuvres normally commensurate with a cultural position such as theirs, the new consumption classes, if they are to attain the sort of cultural prestige they feel that their social position warrants, are compelled to adopt a strategy of cultural valorisation that makes a virtue out of this unclassified status. It is thus the threat of a cultural ostracism which looms large before the new consumption classes that subsequently galvanises their members into a radical action of symbolic objectification and contributes towards the development of a new form of cultural politics.

In the first instance, this cultural politics is based upon a group self-perception of a denial of any attachment to the social field itself. It is, therefore, a cultural politics which claims to evade all of the traces of social classification which so characterise all other social groupings: 'a sort of dream of social flying, a desperate effort to defy the gravity of the social field' (Bourdieu 1984:370). In the case of the new petit bourgeoisie in particular, Bourdieu conceptualises this status in the following manner:

> Classified, déclassé, aspiring to a higher class, they see themselves as unclassifiable, 'excluded', 'dropped out', 'marginal', anything rather than categorised, assigned to a class, a determinate place in the social space. And yet all their practices, cultural, sporting, educational, sexual, speak of classification – but in the mode of denial.
>
> (Bourdieu 1984:370)

This attempt to deny the classifications of the social field finds perhaps its clearest expression in many of the typical practices and ideologies of the modern counter-culture: in the sort of alternative comedy, press and theatre whose forms and contents are specifically constructed upon a critique of

established forms and contents; in the anti-establishment and anti-realist forms of independent music and cinema; and in all of the political causes and movements which can be identified by such prefixes of negation as 'non-' or 'anti-', and that, since the 1960s onwards, have been shored against the established political, social, cultural and moral orthodoxies of modern times: non-racist, non-sexist, anti-nuclear, anti-war, anti-psychiatry, etc.

Ultimately, however, what truly distinguishes the radical character of both the new petit bourgeoisie and their more erudite cultural relations in the new bourgeoisie, is not their specifically chosen objects of symbolic consumption, but rather the *manner* by which those symbolic objects are actually consumed. Initially, this radical mode of consumption is enabled by the group's distinctive investments into the educational field. For the new petit bourgeoisie of course, the relatively impoverished quality of their educational capital by no means guarantees them a position within a traditionally legitimised cultural space. None the less, such investments do at least provide them with a certain 'cultural capital of familiarity and a social capital of "connections"' (Bourdieu 1984:360); a sort of 'introduction' to legitimate modes of consumption and culture. This means that in certain contexts the new petit bourgeoisie, in the attempt to valorise their social position, are able to assume the sheen or appearance of a legitimate mode of consumption. Such knowledge can be employed, therefore, as a means of adopting many of the mannerisms and poses of the legitimate lifestyle, of being able to speak some of its vocabulary and to follow some of its practices, this in order to grant an air of authority to the unsure and not-yet-crystallised lifestyle it urgently seeks to objectify.

Being inadequately adapted to deal with true legitimate cultural forms, however, this quasi-legitimate, semi-intellectualised mode of consumption is more often than not turned upon those forms still in the process of a cultural consecration: 'jazz, cinema, strip cartoons, science fiction . . . jeans, rock or the avante-garde underground' (Bourdieu 1984:360). Such symbolic forms of course have the substantial advantage over fully legitimised forms of being generally far less demanding of their audience's interpretive capacities. But even here, in the group's cultural shortcomings, inadequacy has often been made to seem a source of symbolic power; for what greater mark of social distinction can there possibly be than when the cultural 'otherness' of a group existing on the margins of the social field is successfully valorised by a process in which an apparently cultivated mode of consumption, a seemingly privileged form of reading, is trained upon an otherwise 'uncultivated' and commonplace symbolic form? For not only does such a cultural practice appear to adopt many of the affectations of the sort of intellectualism that always claims to view the social world only through the prism of an opaque, difficult and detached vocabulary, and which would rarely be so vulgar as to simply reproduce the immediate meanings or the obvious symbolic functions of the cultural text in question, but by embracing the sort of symbolic objects not normally associated with such an intellectual mode

of consumption – the mass produced, the popular, the unsophisticated, the overtly lavish, the text of the senses or the body and not that of the intellect or the mind – it may also achieve the sleight of hand necessary to confound the true intellectual classes themselves. This form of 'cultural bluff' thus has a dual expediency: by collapsing the otherwise sacrosanct and clear distinctions that separate the objects of popular consumption from certain modalities of highbrow and legitimate decoding, and thereby fusing the categories of mass and élite culture, the new consumption classes are able to objectify and stabilise a meaningful social space between both taste formations. This is perhaps most clearly demonstrated when, for example, certain popular films, in themselves having no greater textual intent than that of the reproduction of common forms of audience pleasure and identification, are viewed as 'important statements on the postmodern condition' or described as 'pre-Oedipal dramas', or the music and video performances of Madonna, or the face of Julia Roberts, are treated as texts and subjected to the scrutiny of the analysis of the 'expert' of popular culture.

This mode of consumption may achieve its most efficient execution in those individuals of the new bourgeoisie possessing the highest amounts of cultural capital. In such instances the mode of consumption may strongly resemble many of the features of what Bourdieu has already described as *pure taste*. Pure taste, a disposition normally attributed only to the traditional intellectual classes themselves, is defined by Bourdieu as asserting:

> the *absolute primacy of form over function*, of the mode of representation over the object represented, [it] *categorically* demands a purely aesthetic disposition which earlier art demanded only conditionally. The demiurgic ambition of the artist, capable of applying to *any* object the pure intention of an artistic effort which is an end in itself, calls for unlimited receptiveness on the part of an aesthete capable of applying the specifically aesthetic intention to any object, whether or not it has been produced with aesthetic intention.
>
> (Bourdieu 1984:30)

The essential beauty of being able to adopt the disposition of pure taste as a cultural strategy of distinction is twofold. First, such a disposition claims to embody such a rare and sublime form of decoding that it becomes an extremely valuable positional good in its own right. Second, pure taste valorises the cultural capital of the group and asserts its sense of cultural superiority through the ease of its operation. Its classifications are achieved with the appearance of an absolute economy of effort, and these are effectively underwritten by the solid guarantee and authority which is produced by the great sense of self-assurance, purpose and confidence in the actor concerned. This makes pure taste an extremely fluid and adaptable mode of consumption, for it retains the capacity for the sort of symbolic manœuvrability needed to reposition (regardless of their normative symbolic

domains) a diverse range of cultural goods, the successful execution of which is in itself enough to objectify the cultural competences of the group concerned. When adopted by the most articulate fractions of the new consumption classes, such an action is greatly facilitated by the fact that the habitus of these groups is generally 'untrammelled by the constraints and brakes imposed by collective memories and expectations' (Bourdieu 1984:370). Hence, unbridled from the ties of a solid social history and not as yet hidebound by any firm allegiance to a well-rehearsed, well-worn and interiorised cultural repertoire of practice, there would seem to be no limits to the rules governing the selection and exclusion of objects and practices which may be held up as representative of the distinguished cultural locale of these new class fractions.

It is for this reason that the objects of popular, middlebrow or élite culture may conceivably find themselves assembled together as the object indices of a new lifestyle of aesthetic liberation. For these 'new aesthetes', such a mode of consumption posits the object of consumption as nothing other than pure symbolic utility. Effectively dehistoricised, not yet written upon and therefore extremely malleable in the symbolic meanings which it may potentially assume, the object chosen as the receptacle for the storage of cultural values is in effect little other than a purely arbitrary token of a new form of cultural currency. The significance of this token is to be found, not in its nominal sign-values as these may have existed in some conventional system of objects within an older framework of sign-values, but rather in the fact that it has become the bearer of values which have emerged solely from its own radical symbolic *re-evaluation*. More accurately perhaps, it is the mode of consumption, and not the object associated with such consumption, which becomes the social sign of storage for cultural value. It is thus this mode of consumption, in its own signifying capacity of a superior difference, which is exchanged with other (inferior) modes of consumption and which ultimately valorises the capital of the group and may elicit for them cultural profits.

Asserted through its eclectic tendencies, this mode of consumption leaves in its wake the sense of a great cultural freedom. It gives the impression of a social group who have been loosed from the ties of the social field and from the normal conventions of social classification. It elicits, to return to Pfeil's conceptualisation of the group in question for a moment, 'the bliss of escaping from codification and definition altogether, by dispersing and scattering oneself through the codes and clichés (Pfeil 1990:111). To produce this impression in the eyes of all other social groups is thus the overriding purpose of this new mode of consumption. This perception is in itself enough to trigger the efficacy of this new and fluid cultural value-form. The mere bizarre juxtaposition and the unusual adjacency of the gathered-together objects of this pure consumption functions precisely because it represents a blasphemous disruption of the standard object categories. It constitutes a scandalous utilisation of the cherished symbolic objects and codes of all

other classes and tastes, and, by placing the perfectly familiar into unfamiliar arrangements, it renders the normally meaningful as impenetrable. Hence, by detaching symbolic objects and codes from their normative domains, this new mode of consumption has the desired effect of being able to subjugate all other taste formations as its cultural inferiors.

What all of this amounts to is essentially the emergence of a new form of cultural politics. This can be differentiated from the sort of cultural politics of an earlier stage of capital by the fact that it does not seek its self-valorisation by locking into a set of meanings and cultural values that are framed under a broad hegemonic umbrella (as was commonly the case with a dominant Fordist culture), but by asserting itself simply through its own radical difference and sense of otherness. In one of its more extreme expressions, the symbolic violence that is perpetrated by the deliberate mobilisation of this sense of cultural difference can be seen materialised in a magazine like *The Face*. For we find in *The Face* and its equivalents (*I.D.*, *Blitz*, *Arena*, *Esquire*, etc.) the conscious attempts to produce an almost unrecognisable sense of cultural otherness, a cultural otherness in which all contents – its graphic layout and the typographical styles initiated by Neville Brody, its subject matters, its advertising, its editorial content, its language and aesthetics in general – seem to define the magazine as a discursive practice existing somewhere upon the far horizons of conventional systems of meaning. This is the sort of symbolic tyranny that is produced when social meaning is deliberately enveloped by the haze of vague references, degraded images and half-remembered significances. For Dick Hebdige (1987):

> All statements made inside *The Face*, though necessarily brief are never straightforward. Irony and ambiguity predominate. They frame all reported utterances whether those utterances are reported photographically or in prose. A language is thus constructed without anybody in it (to question, converse or argue with). Where opinions are expressed they occur in hyperbole so that a question is raised about how seriously they're meant to be taken. Thus the impression you gain as you glance through the magazine is that this is less an 'organ of opinion' than a wardrobe full of clothes (garments, ideas, values, arbitrary preferences: i.e., signifiers).
>
> (Hebdige 1987:170)

Magazines such as *The Face* and other similar cultural forms (and here we may include the particular stylistic features of the new advertising formats that were discussed in the previous chapter) are indeed the perfect vehicles to carry the cultural values of this new counter-culture. So designed as to accommodate an economy of effort and intellectual capital on the part of their readers, they become the ideal platforms to parade the symbolic and cultural goods of the new intellectual classes. Yet the impression and effect that they leave behind is precisely the opposite of this intellectual economy: a readership who possess a knowledge that appears to surpass the most

advanced forms of learning and reading. To this extent, magazines such as *The Face* become the natural forms for those social groups who, as Bourdieu points out, are in the process of 'inventing an art of living which provides them with the gratifications and prestige of the intellectual at the least cost' (Bourdieu 1984:370).

The positive affirmation of the radical cultural difference that is expressed in the modes of consumption of the new consumer classes perhaps finds a natural home in those cultural forms which, in other contexts, have been defined as postmodern. In this respect, the value of postmodern goods can be found in the deep sense of uncertainty which tends to exist over their status and significance. This results from their eclectic composition, their flagrant transgressions of the normally well-policed boundaries between popular, middlebrow and highbrow culture, and their self-conscious, self-referential qualities. All of these features may serve to render the meaning of the postmodern text, and any relationship it may have with an audience, extremely ambiguous. For Pfeil, postmodern texts can be characterised by 'a certain quality or manner of utterance and performance – deadpan, indifferent, depersonalised, effaced – that effectively cancels the possibility of traditional audience identification' (Pfeil 1988:384).

This is the sort of aesthetic quality that we find in the de-emotionalised rock music of Talking Heads, the performance art of Laurie Anderson, the minimalist musical compositions of John Adams, Steve Reich or Philip Glass, or the prose fiction of Thomas Pynchon. Such texts are also often characterised by a subordination of their content to their form, of their meanings to their physical presence. This serves to predispose them towards the sort of detached reception that is required to valorise the pure gaze, making them generally unresponsive to conventional forms of decoding or reading. This invites a mode of consumption which claims to be so steeped in cultural capital that it is actually capable of 'making an art form out of nothing', as, for example, when the ECM record label, which specialises in esoteric European jazz, recently marketed itself with the slogan 'the next best sound to silence'.

Another common hallmark of such texts concerns the manner in which they often succeed in defamiliarising the perfectly familiar. The prose style of Kathy Acker, for example, succeeds in making strange the standard conventions of language and literary form (paragraphs beginning with colons, the overliberal and 'unnecessary' use of parentheses, a quasi-infantile mode of expression, the use of short, staccato sentences to disrupt the narrative flow, etc.). Similarly, the slightly skewed vision of the world that is depicted in the films of David Lynch presents us with the ordinary and commonplace as though it had been re-encoded via a production process that was not quite fully cognisant of the normal cinematic or televisual conventions of the form in question: the result is that the topography of the small-town American dream becomes remapped as the nightmare landscape of *Blue Velvet*, while the standard conventions of soap opera are manipulated to

produce the 'pure television' of *Twin Peaks*. Finally, many such texts can best be described as *decentred*: the non-linear, non-narrative music of Brian Eno, for example, is so designed, according to the claims of its composer, that it is possible for it to be joined by the listener at any point during its long and slow unfolding without its significances or effects being in any way compromised or diminished.

It is important to stress at this point that the attraction that such cultural products have for the new consumer classes can not be reduced merely to the result of some conscious, quasi-intellectual game-playing on the part of their producers or consumers alike (not least because this would be a great injustice to what are, in many instances, undoubtedly genuine experiments in aesthetic, political and cultural form). Rather, the attraction of such goods to the new consumer classes may stem originally from a profound feeling that they succeed in materialising a particular experience of the contemporary social world in which subjectivity has become parted from the many solid social structures which in earlier times would have given it meaningful shape and coherent substance. Such goods may indeed reflect that structure of feeling born of a certain existential uncertainty and conditioned by contingency. For the new consumer classes, postmodern goods thus represent a vital objectification of a habitus that has been forged from the material debris of long-forgotten, ancient cultural practices and severed social roots.

In this context we can begin to see the pivotal role that commodities may play in objectifying the life-spaces of the new consumer classes. Commodities are, as we have seen previously, objects from which all history has been erased. Social labour, the conditions of production, the social relations of production; none of these social facts is evident in the commodity as it appears in the market-place, those facts having been obscured through the processes of exchange. This makes commodities cultural instruments that are ideally suited to the objectification and valorisation of that structure of feeling belonging to a social class who themselves have seen the history, memory and heritage of their social origins erased from their consciousness. Commodities thus appear as 'pure utilities', not yet written upon or tarnished by the marks of existing social relations and the cultural customs and rituals that always accompany such social relations. They are adaptable and malleable, able to be shaped symbolically to signify a wide variety of meanings. For those individuals redistributed by their educational background and new occupational structures to a social space as yet without any fixed social bearings or co-ordinates, the commodity becomes an essential material form by which that unstable social space may be stabilised. Identity can begin to take material form in the shape of the commodity.

In many ways this gives to the new consumer classes the status of *ideal* or *perfect consumers*. Pioneers of a new culture of consumption, they stand on the threshold of a new age of capital which, as we have seen, requires ever more fluid forms of exchange and the ever more flexible

composition of needs. Ultimately, this can only ever accelerate the already rapid disintegration of established social ties and lead eventually to the breaking of the relatively enduring habits, customs and cultural practices that have originated from previous times. All that is solid melts into air; the words of Marx and Engels strike home at this point with a certain vengeance and irony.

The potential dangers that lie in wait from using such a fluid form as the commodity alone to objectify social consciousness are only too evident. Taken to their extreme, such dangers are vividly depicted in Bret Easton Ellis's disturbing and violent novel *American Psycho* (1991). While the literary merit of and the authorial motivation behind the novel may be very questionable indeed, *American Psycho* none the less presents a simple but profound thesis, a thesis that anyone who is concerned with the social impact of capital and the cultural implications of the deeper and more thorough penetration of commodity consumption into everyday life cannot, I believe, afford to ignore.

American Psycho depicts the life of Patrick Bateman, a 26-year-old, handsome, intelligent sophisticate. By day, Wall Street financier and archetypal yuppie, by night, violent, psychopathic serial killer, Bateman personifies the dark reality of the modern consumer culture when it is taken to its logical ends. For Bateman social experience is conducted almost entirely at the level of the commodity-form: his own identity is constructed through commodities, his perception of the Other is always contingent upon the commodities that Other owns, and almost all of Bateman's pleasures, with the exception of the obvious delight he takes in his brutal murders, are commodified pleasures. Written in the first person, the narrative will often simply list, in very precise detail, a succession of commodities and brand names – cotton shirt by x, silk tie by y, cap-toe leather shoes by z, etc. – as though these names were enough in themselves to inform the reader exactly of the character or situation that is being depicted. The suggestion in *American Psycho* seems to be that Bateman's consciousness itself is assembled from nothing other than fragments of the commodity-form; it is a consciousness from which all social meaning has been evacuated save that evoked by the endless succession of commodity-signs through which Bateman's experiences are channelled. This makes Bateman's subjectivity as unstable, transient and fluid as those commodity-signs themselves, and, it has to be admitted, rather implausibly provides the only explanation in the book for the motivation that lies behind the unspeakable acts of violence and sadism that Bateman inflicts on his victims. Nevertheless, the book serves as a chilling warning of the consequences which may transpire when social life and experience are reduced to little other than the level of commodity consumption, and subjectivity is allowed to break free from most forms of social constraint and the responsibilities of morality, ethics, conscience, decision, political belief and other forms of social affiliation.

CONCLUSION: NEW DIRECTIONS IN THE FOOTPRINTS OF MODERNITY

Throughout the pages of this book I have tried to sketch a picture of modern capitalism and its culture during a period of transition and change. The exact nature of this transition and change is far from certain, as are the implications for the future of capitalism and the patterns of social life that it may generate. The purpose of this book has in no way been to provide a definitive account of the meanings of contemporary social transformation. Rather, its aim has been only to pinpoint some of the more manifest social changes of recent years and to consider several aspects inherent to the logic of capital that may be used to help us understand and theorise those changes. Moreover, I do not want to suggest that the various changes that I have described represent at this point in history anything as dramatic as an epochal shift in the overall social organisation of advanced capitalist societies. Clearly it is extremely premature to label Post-Fordism as a new regime of accumulation (particularly in the face of the current world recession), and it is certainly premature to describe postmodernism as its accompanying mode of regulation, or, for that matter, even to call it the 'cultural dominant' of contemporary society. Regimes of accumulation and their modes of regulation are not born spontaneously, instantaneously or without severe complications which may indeed make their full emergence into the world stillborn.

A glimpse at the evolution of Fordism provides us with a salutary illustration of the problems which may be encountered in conceptualising contemporary social change. As early as 1920 the dominant mode of production in the USA had already adopted the principles of Taylorism, the technologies of mass production, and the concept of economies of scale. These represented the real foundations upon which the Fordist regime of accumulation could be built. But as a regime of accumulation, Fordism could not be defined only in terms of the principles and technologies that were adopted in Ford's early factories. Indeed, by 1930 the new mode of production was facing perhaps the deepest of all economic and social crises ever to confront capitalism up to that point in time. This was a crisis so severe and devastating that any suggestion that Fordism may possibly represent a viable economic future for modern capitalist enterprise would have surely seemed to most people at the time to be ludicrous. It was not for at least another 20 years, and not until the world had suffered the most enormous social and economic privations, as well as witnessing the greatest of all wars, that Fordism was eventually to emerge as a mature regime of accumulation with an accompanying mode of regulation. In short, something in the region of 40 years had elapsed since the time of its real origins before Fordism was allowed to mature fully as a regime of accumulation in the 1950s.

The slow and not unproblematic emergence of Fordism should alert us to the problems of being too hasty in characterising, at least with any degree of

certainty, the numerous changes to social life that have occurred throughout the 1980s. Long-established and solid social structures cannot be dismantled overnight, and distinctive cultural sensibilities and the well-worn patterns and routines of ordinary life can never be functionally dissolved, even in the face of the enormous edifice and powers of transformation of capital. We continue to live in the footprints of modernity: to work in the factories, offices and bureaucracies that were built under the Fordist regime; to support political parties whose contemporary character was forged by the promises to uphold the interests of the numerous conglomerations of big labour and big capital; to follow ethical and moral codes of conduct that date from the time of the Enlightenment; and to pursue cultural activities and live daily routines that in some cases pre-date Fordist culture itself. All of these features of contemporary life may, more than ever before, be in the processes of change or decay, but they clearly continue to hold tremendous sway over the composition of today's social life.

By the same token, however, the history of Fordism should also warn us against any undue or hasty dismissal of the significance of recent changes to the economy and culture, and we should be extremely cautious of treating such changes as some mere superficial realignment within the essential nature of the process of capital accumulation. To do this would indeed be to deny the very transformational impulse which lies at the heart of capitalism itself.

To understand the nature of this impulse more thoroughly and to appreciate some of the ways in which it might impose itself upon social life must, I believe, become one of the central concerns, if not *the* central concern, of contemporary social and critical analysis. For at a time when so much social and critical theory displays a staggering reluctance to engage with issues of economy and capital, and when so many of the intellectual Left stubbornly refuse to engage with the rich legacy of ideas and theories that were bequeathed by Marx himself, choosing instead to tread the path of the seductive rhetoric and fantastic hyperbole of postmodernism and consumer culture, then the essential questions of social change and the complex flow of social and power relations will go improperly scrutinised and inadequately theorised.

In some ways this book represents a call for the sensitive and necessary development of historical materialism. This involves a vital recognition that the economy matters; that it insinuates its influence deeply throughout all aspects of social life, that it regulates the composition of needs and gives us the appropriate means to satisfy those needs. It also involves a vital recognition that culture matters too; but not culture as perceived through the gauze of some romanticised idealism which sees it as an autonomous and independent sphere of subcultural expression and resistance to a tyrannical and homogenous 'system', but culture as the embodiment of social relations and struggles as they are expressed at the level of everyday life. Therefore,

this is not a call for a return to some crude base/superstructure model of social relations, but neither is it a call for an unchecked celebration of the subversive joys of modern culture and consumption. It is the call for a theoretical mediation between these two extremes, a mediation which can never be completed or deliver a final theoretical answer to the numerous questions that are posed by the modern capitalist society so long as we continue to live in such a society. This is because, by its very definition, the process of capital is itself never a completed process. Theory must therefore always be able to accommodate and account for historical change; it must, in the words of Stuart Hall, be a 'theorizing in the postmodern context, if you like, in the sense that it does not believe in the finality of a finished theoretical paradigm' (quoted in Nelson and Grossberg 1986:60). Ultimately, of course, its overriding aim must continue to be the exploration of the possibilities of an alternative form of economic planning, one in which the production of use-values is initiated solely on the basis of need satisfaction and not on the quest for profit. In the cultural sphere too, attention needs to be focused, perhaps more than ever before, on an exploration of the possibilities of a cultural formation capable of genuinely supporting diversity and difference without such diversity and difference being used as instruments of invidious distinction.

Bibliography

Adorno, T.W. and Horkheimer, M. (1972) *The Dialectic of Enlightenment*, Herder and Herder, New York.

Aglietta, M. (1987) *A Theory of Capitalist Regulation: The US Experience*, Verso, London.

Althusser, L. (1971) 'Ideology and the state', in *Lenin and Philosophy, and Other Essays*, Verso, London.

Ang, I. (1985) *Watching Dallas*, Methuen, London.

—— (1990) 'Culture and communication: towards an ethnographic critique of media consumption in the transnational media system', *European Journal of Communication 5*.

Armstrong, P., Glyn, A. and Harrison, J. (1991) *Capitalism Since 1945*, Blackwell, Oxford.

Arnold and Faurote (1972) *Ford Methods and the Ford Shops*, Arno Press, New York; repr. in Williams, *et al.*, 1987.

Bagguley, P. (1991) 'Post-Fordism and enterprise culture', in Keat, R. and Abercrombie, N. (eds) *Enterprise Culture*, Routledge, London.

Barbrook, R. (1990) 'Mistranslations: Lipietz in London and Paris', *Science as Culture 8*.

Barthes, R. (1975) *The Pleasure of the Text*, Hill and Wang, New York.

Baudrillard, J. (1975) *The Mirror of Production*, Telos, St Louis MO.

—— (1980) 'The implosion of meaning in the media and the implosion of the social in the masses', in Woodward, K. (ed.) *The Myths of Information: Technology and Postindustrial Culture*, Coda Press, Madison, WI.

—— (1981) *For a Critique of the Political Economy of the Sign*, Telos, St Louis MO.

—— (1983) *Simulations*, Semiotext(e), New York.

—— (1988a) *Selected Writings*, Polity, Cambridge.

—— 1988b) *The Ecstasy of Communication*, Semiotext(e), New York.

Beechey, V. and Donald, J. (eds) (1985) *Subjectivity and Social Relations*, Open University Press, Milton Keynes.

Belk, R.W. (1988) 'Possessions and the extended self', *Journal of Consumer Research* 15: pt 2.

Bell, D. (1973) *The Coming of Post-Industrial Society: A Venture in Social Forecasting*, Basic Books, New York.

—— (1976) *The Cultural Contradictions of Capitalism*, Heinemann, London.

Belsey, C. (1980) *Critical Practice*, Methuen, London.

Bennett, T., Mercer, C. and Woollacott, J. (eds) (1986) *Popular Culture and Social Relations*, Open University Press, Milton Keynes.

Berger, J. (1972) *Ways of Seeing*, BBC/Penguin, London.

Bernstein, B. (1977) *Class, Codes and Control*, 3 vols., Routledge and Kegan Paul, London.

Betz, H.-G. (1992) 'Postmodernism and the new middle-class', *Theory, Culture and Society* 9, 2.

Billaudot, B. and Gauron, A. (1985) *Croissance et crise: vers une nouvelle croissance*, La Découverte, Paris.

Bluestone, B. and Harrison, B. (1981) *Corporate Flight*, Progressive Alliance, Washington DC.

—— (1982) *The Deindustrialisation of America*, Basic Books, New York.

Bourdieu, P. (1972) *Current Research*, Occasional Paper, Centre de Sociologie Européenne, Paris.

—— (1977) *Outline of a Theory of Practice*, Cambridge University Press, Cambridge.

—— (1984) *Distinction*, Routledge and Kegan Paul, London.

—— (1986) Interview, *Theory, Culture and Society* 3, 3.

Bowlby, J. (1963) *Child Care and the Growth of Love*, Penguin, Harmondsworth.

Bradbury, M. and McFarlane, J. (1976) *Modernism, 1890–1930*, Penguin, Harmondsworth.

Brenner, R. and Glick, M. (1991) 'The regulation approach: theory and history', *New Left Review* 188.

Callinicos, A. (1990) *Against Post-Modernism*, Polity, Cambridge.

Campbell, C. (1987) *The Romantic Ethic and the Spirt of Modern Consumerism*, Blackwell, Oxford.

Clarke, J. (1991) *New Times and Old Enemies*, Harper Collins, London.

Clarke, S. (1988) 'Overaccumulation, class struggle and the regulation approach', *Capital and Class* 36 (Winter).

Condit, C.M. (1989) 'The rhetorical limits of polysemy', *Critical Studies in Mass Communication* 6, 2 (June).

Csikszentmihalyi, M. and Rochberg-Halton, E. (1981) *The Meaning of Things: Domestic Symbols and the Self*, Harvard University Press, Cambridge MA.

de Certeau, M. (1984) *The Practice of Everyday Life*, University of California Press, Berkeley.

Dichter, E. (1960) *The Strategy of Desire*, Boardman, New York.

—— (1963) *Handbook of Consumer Motivations*, Doubleday, Garden City NY.

Douglas, M. (1984) *Purity and Danger: An Analysis of the Concepts of Pollution and Taboo*, Ark, London.

Douglas, M. and Isherwood, B. (1978) *The World of Goods*, Penguin, Harmondsworth.

Edwards, C. (1987) 'Blueprint for a new consumer', *Campaign* 11 (September).

Ellis, B.E. (1991) *American Psycho*, Picador, London.

Ewen, S. (1976) *Captains of Consciousness: Advertising and the Social Roots of the Consumer Culture*, McGraw Hill, New York.

Featherstone, M. (1989) 'Postmodernism, cultural change, and social practice', in Kellner (1989b).

—— (1991) *Consumer Culture and Postmodernism*, Sage, London.

Fiske, J. (1987) *Television Culture*, Methuen, London.

—— (1989a) *Understanding Popular Culture*, Unwin Hyman, London.

—— (1989b) *Reading the Popular*, Unwin Hyman, London.

Galbraith, J.K. (1985) *The Affluent Society*, Penguin, Harmondsworth.

Gamble, A. (1981) *Britain in Decline*, Macmillan, London.

Gardner, C. and Sheppard, J. (1989) *Consuming Passion: The Rise of Retail Culture*, Unwin Hyman, London.

Gershuny, J. (1986) 'Time use, technology, and the future of work', *Journal of the Market Research Society* 28, 4.

Giedion, S. (1948) *Mechanization Takes Command*, Oxford University Press, New York.

Goffman, E. (1961) *Asylums*, Doubleday, New York.

Goldman, R. (1987) 'Marketing fragrances: advertising and the production of commodity signs', *Theory, Culture and Society* 4.

Gramsci, A. (1971) *Selections From Prison Notebooks*, Lawrence and Wishart, London.

Grossberg, L. and Nelson, C. (eds) (1988) *Marxism and the Interpretation of Culture*, Macmillan, London.

Gunn, P. (1991) 'Frank Lloyd Wright and the passage to Fordism', *Capital and Class* 44 (Summer).

Hall, S. (1980) 'Cultural studies: two paradigms', *Media, Culture and Society* 2.

—— (1982) 'The rediscovery of "ideology": return of the repressed in cultural studies' in Gurevitch, M., Bennett, T., Curran, J. and Woollacott, J. (eds) *Culture, Society and the Media*, Methuen, London.

—— (1988) 'Brave new world', *Marxism Today* (October).

—— (1990) 'The emergence of cultural studies and the crisis of the humanities', *October* 53.

Hall, S. and Jacques, M. (eds) (1989) *New Times: The Changing Face of Politics in the 1990s*, Lawrence and Wishart, London.

Hall, S, Clarke, J., Jefferson, T. and Roberts, B. (eds) (1976) *Resistance Through Rituals*, Hutchinson, London.

Harvey, D. (1982) *The Limits To Capital*, Blackwell, Oxford.

—— (1985) *The Urbanisation of Capital*, Blackwell, Oxford.

—— (1989) *The Condition of Postmodernity*, Blackwell, Oxford.

Haug, W.F. (1986) *Critique of Commodity Aesthetics*, Polity Press, Cambridge.

Hebdige, D. (1979) *Subculture: The Meaning of Style*, Methuen, London.

—— (1987) 'The impossible object: towards a sociology of the sublime', *New Formations* 1 (Spring).

—— (1988) *Hiding in the Light*, Routledge, London.

Henriques, J. and Sinha, C. (1977) 'Language and revolution', in *Ideology and Consciousness*.

Hobson, D. (1982) *Crossroads: The Drama of a Soap Opera*, Methuen, London.

Hoggart, R. (1958) *The Uses of Literacy*, Penguin, Harmondsworth.

James, A. (1979) 'Confections, concoctions and conceptions', *Journal of the Anthropological Society of Oxford* 10.

Jameson, F. (1984) 'Postmodernism, or the cultural logic of late capitalism', *New Left Review* 146.

—— (1985) 'Postmodernism and consumer society', in Foster, H. (ed.) *Postmodern Culture*, Pluto Press, London.

Jhally, S. (1987) *The Codes of Advertising*, Francis Pinter, New York.

—— (1989) 'Advertising as religion: the dialectic of technology and magic', in Angus, I. and Jhally, S. (eds) *Cultural Politics in Contemporary America*, Routledge, New York.

Jones, D. (1990) *Haircuts*, Thames and Hudson, London.

Kellner, D. (1989a) *Jean Baudrillard: From Marxism to Postmodernism and Beyond*, Polity, Cambridge.

—— (ed.) (1989b) *Postmodernism/Jameson/Critiques*, Maisonneuve Press, Washington DC.

Keynes, J.M. (1936) *The General Theory of Employment, Interest and Money*, Macmillan, London.

Kumar, K. (1978) *Prophecy and Progress: The Sociology of Industrial and Post-Industrial Society*, Penguin, Harmondsworth.

Lash, S. and Urry, J. (1987) *The End of Organised Capitalism*, Polity Press, Cambridge.

Leavis, F.R. (1930) *Mass Civilisation and Minority Culture*, Minority Press, London.

Lefebvre, H. (1971) *Everyday Life in the Modern World*, Harper and Row, New York.

Leiss, W., Kline, S. and Jhally, S. (1986) *Social Communication in Advertising*, Methuen, London.

Levidow, L. (1990) 'Foreclosing the future', *Science as Culture* 8.

Lipietz, A. (1985) *The Enchanted World: Inflation, Credit and the World Crisis*, Verso, London.

—— (1987) *Mirages and Miracles: The Crises of Global Fordism*, Verso, London.

Lyotard, J.-F. (1984) *The Postmodern Condition*, Manchester University Press, Manchester.

—— (1986) 'Defining the post-modern', *ICA Documents* 4.

Mandel, E. (1975) *Late Capitalism*, New Left, London.

Marcuse, H. (1986) *One-Dimensional Man*, Ark, London.

Marx, K. (1953) *Capital* (vol. 2), Lawrence and Wishart, London.

—— (1956) *Capital* (vol. 3), Lawrence and Wishart, London.

—— (1970) *A Contribution to the Critique of Political Economy*, Lawrence and Wishart, London.

—— (1973a) *The Eighteenth Brumaire of Louis Bonapart*, Penguin, Harmondsworth.

—— (1973b) *Grundrisse*, Penguin, Harmondsworth.

—— (1975) *Economic and Philosophical Manuscripts*, Penguin, Harmondsworth.

—— (1976) *Capital* (vol. 1), Penguin, Harmondsworth.

Marx, K. and Engels, F. (1974) *The German Ideology*, Lawrence and Wishart, London.

—— (1983) *The Communist Manifesto*, Lawrence and Wishart, London.

Mauss, M. (1990) *The Gift: The Form and Reason For Exchange in Archaic Societies*, Routledge, London.

Miller, D. (1987) *Material Culture and Mass Consumption*, Blackwell, Oxford.

Modigliani, F. (1977) 'The monetarist controversy or should we forsake stabilisation policies?', *American Economic Review* (March).

Morley, D. (1980) *The Nationwide Audience*, BFI, London.

Morris, M. (1988) 'Banality in cultural studies', *Block* 14.

Mulvey, L. (1975) 'Visual pleasure and narrative cinema', *Screen* 16, 3.

Murray, R. (1987) 'Life after Henry (Ford)', *Marxism Today* (October).

—— (1989) 'Benetton Britain: the new economic order', in Hall and Jacques (1989).

Nelson, C. and Grossberg, L. (1986) *Marxism and the Interpretation of Culture*, University of Illinois Press, Urbana IL.

Nevins, A. (1954) *Ford: The Times, the Man and the Company*, Charles Scribner and Sons, New York; repr. in Williams, *et al.* 1987.

OECD (1989) *National Accounts of Member Countries*, Paris.

Offe, C. (1985) *Organised Capitalism*, Polity, Cambridge.

Ogilvy, D. (1990) Interview, *Campaign*, 7 December.

O'Connor, J. (1984) *Accumulation Crisis*, Blackwell, New York.

O'Shea, A. (1989) 'Television as culture: not just texts and readers', *Media, Culture and Society* 11.

Packard, V. (1957) *The Hidden Persuaders*, Penguin, Harmondsworth.

Peláez, E. and Holloway, J. (1990) 'Learning to bow: post-Fordism and technological determinism', *Science as Culture* 8.

Pfeil, F. (1988) 'Postmodernism as a "structure of feeling"', in Grossberg and Nelson 1988.

—— (1990) *Another Tale To Tell*, Verso, London.

Piore, M.J. and Sabel, C. F. (1984) *The Second Industrial Divide: Possibilities for Prosperity*, Basic, New York.

Poulantzas, N. (1975) *Classes in Contemporary Capitalism*, New Left Books, London.

Preteceille, E. and Terrail, J.-P. (1985) *Capitalism, Consumption and Needs*, Blackwell, Oxford.

Radaway, J. (1984) *Reading the Romance*, University of North Carolina Press, Chapel Hill NC.

Robins, K. (1989) 'Reimagined communities? European image spaces, beyond Fordism', *Cultural Studies* 3, 2 (May).

Rosenblatt, P.C., Walsh, R.P. and Jackson, D.A. (1976) *Grief and Mourning in Cross-Cultural Perspective*, Human Relations Area Files, New Haven.

Sahlins, M. (1976) *Culture and Practical Reason*, University of Chicago Press, Chicago.

Sculley, J. (1989) *Odyssey: Pepsi to Apple*, Fontana, Glasgow.

Sennett, R. (1976) *The Fall of Public Man*, Cambridge University Press, Cambridge.

Social Trends (1990) no. 20, HMSO, London.

Sweezy, P. (1972) 'On the theory of monopoly capitalism', *Modern Capitalism and Other Essays*, Monthly Review Press.

Taylor, F.W. (1911) *The Principles of Scientific Management*, New York.

Tetzlaff, D. (1991) 'Divide and conquer: popular culture and social control in late capitalism', *Media, Culture and Society* 13.

Thompson, D. (ed.) (1964) *Discrimination and Popular Culture*, Penguin, Harmondsworth.

Veblen, T. (1953) *The Theory of the Leisure Class*, New American Library, New York.

Vološinov, V.N. (1973) *Marxism and the Philosophy of Language*, Seminar Press, New York.

Weber, M. (1978) *Selections in Translation*, Cambridge University Press, Cambridge.

Williams, K., Cutler, T., Williams, J. and Haslam, C. (1987) 'The end of mass production?', *Economy and Society* 16, 3.

Williams, R. (1962) 'Advertising: the magic system', in *Problems in Materialism and Culture*, New Left Books, London.

—— (1965) *The Long Revolution*, Penguin, Harmondsworth.

Williamson, J. (1978) *Decoding Advertisements*, Marion Boyars, London.

—— (1986) 'The problems of being popular', *New Socialist* 41 (September).

Willis, P. (1978) *Learning to Labour*, Saxon House, London.

Wilson, E. (1977) *Women and the Welfare State*, Tavistock, London.

—— (1985) *Adorned in Dreams*, Virago, London.

Index